# JACOB KRAMER

## CREATIVITY AND LOSS

# JACOB KRAMER

## CREATIVITY AND LOSS

### DAVID MANSON

Sansom &
Company

*For Hilda, Lesley, Claire, Nicholas and Andrew*

First published in 2006 by Sansom and Co Ltd
81G Pembroke Road, Bristol BS8 3EA

www.sansomandcompany.co.uk

ISBN 1 904537 57 X
ISBN 13 9781904537571

British Library cataloguing-in-publication data:
A catalogue record for this book is available from the British Library

Design and typesetting by E&P Design, Bath
Printed by Gutenberg Press, Malta

# CONTENTS

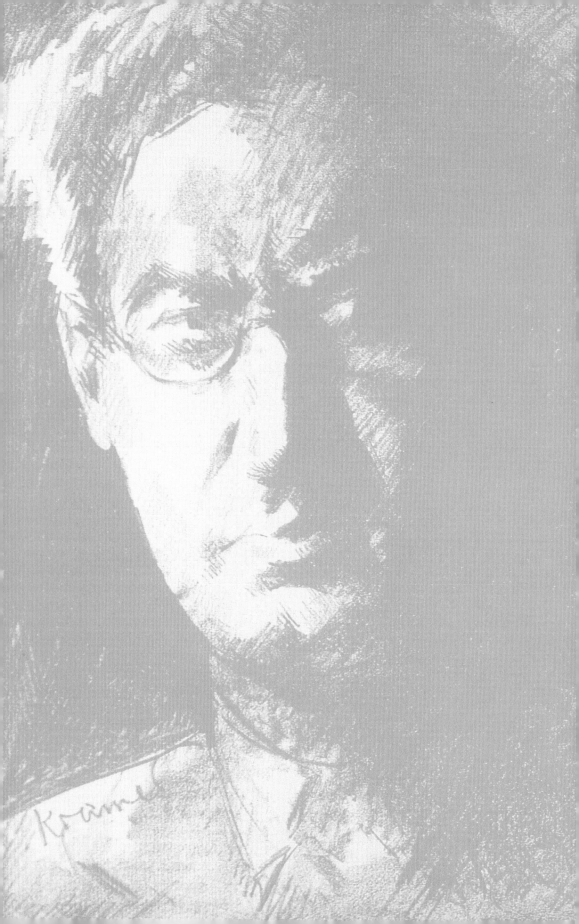

# PREFACE

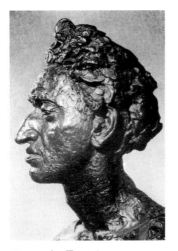

*Kramer* by Epstein

In the past few years biographies of several of Jacob Kramer's contemporaries have been produced and in these books Kramer is found as an exotic background figure, a Russian-Jewish giant. Summaries of his life are included in the notes to the many exhibitions of his work but otherwise he has received little attention, and has been almost completely ignored in books on the contemporary art scene, even by his early friend and champion, Herbert Read. When referred to in other art commentaries it is often simply as 'the Leeds artist, Jacob Kramer' as though he were, like many others, a local artist of limited merit and interest. The art historian, Frances Spalding, has described Kramer as an anomalous figure within the history of twentieth-century British art. Although too various to be classified within any stylistic school he was essentially, as Herbert Read defined him, an Expressionist.

Russian persecution of the Jews at the end of the nineteenth century had swept to Britain many people of talent, and in that wave were five young men, David Bomberg, Isaac Rosenberg, Mark Gertler, Bernard Meninsky and Jacob Kramer, all born within the years 1890–92, who were to meet through the Slade School of Art. The first four fought their way from poverty to achieve national and international fame; equally talented, Kramer was the exception, and when comparing him to these contemporaries the critic John Russell Taylor has described him as the odd man out. To many he is known only as the model for one of Jacob Epstein's finest portrait busts.

Kramer's work is held by many major British art galleries, including the Tate and the National Portrait Gallery, but his celebrity is centred largely on his home city, Leeds. There in that great industrial city he was perceived not only as an important artist and inspirational teacher, a representative of the modern movement, but as an ikon, his bohemian persona representing *the artist*. He was a unique figure held in affection and respect, not only by the local art world and the Jewish community of Leeds, but by the community at large, indeed in tribute to his considerable contribution to the cultural life of the city, the new branch college of art was named the Jacob Kramer College.

I have possessed some of Kramer's work for many years and was fortunate to have my portrait made by him. Alas, this was towards the end of his life when alcohol had taken its toll. In this account I have tried to trace the course of this tragedy, the destruction of his creativity, in order to illuminate this 'anomalous' figure.

# ACKNOWLEDGEMENTS

In the nineteen fifties my friend, Edward (Ted) Hyman, suggested that I might, like him, have my portrait made by Jacob Kramer. The recent revival of interest in this artist after years of neglect, and the fact that for many years I have lived with his work, stimulated me to investigate Kramer's singular life and work. In this project I was encouraged by Ted, Professor Norbert Lynton, Ben Read and Michael Paraskos, as well as by June Rose, biographer of Jacob Epstein.

*The Kramer Documents* (Valencia 1983), put together by John Roberts, Kramer's nephew, from documents in the Brotherton Library at Leeds University, have served as a spinal column to this biography, and I am immensely grateful to the William Roberts Society, which possesses the copyright to Jacob Kramer's work, and to its Chairman, Pauline Paucker, as well as to Michael Mitzman, for permission to use material from the estate of John David Roberts, and from Millie Kramer's wonderful book, *Jacob Kramer. A Memorial Volume.*

For their help in gathering information about Kramer's life I would like to thank David Hartshorne at the *Yorkshire Post*, Keith Feldman, the librarian of the *Jewish Chronicle*; Professor Rodney Livingstone and Karen Robson at the Hartley Library, Southampton, for help to access papers of the Jewish Education Aid Society; the Hyman Kreitman Research Centre at Tate Britain for letting me see correspondence relating to the 'Town Hall Fiasco'; Geoffrey Burnstone, Alan Bennett himself, and the archivist of the *London Review of Books* for the quotation from *Alan Bennett's Christmas Diary.*

In collecting illustrations I am immensely grateful to Alex Robertson at Leeds City Art Gallery and Hilary Diaper and her staff at the Brotherton Library, Leeds University, who gave me unstinting help in making available to me their Kramer collections, as did Melva Croal at Manchester City Art Galleries, Dr Tim Moreton at the National Portrait Gallery, Andrew Dalton and Jane Mitchell at Cartwright Hall Art Gallery, Bradford, Chris Stevens and Sarah Fahmy at Tate Britain,

Vicky Turner at the Cooper Gallery, Barnsley, Agi Katz of the Boundary Gallery, Irving Grose of the Belgrave Gallery, David Glasser at the Ben Uri Gallery, and Andrew Murray of the Mayor Gallery, who was kind enough to let me have information about his father, Charles Murray, and to let me include three items from his personal collection.

I am much obliged to those who permitted me to use Kramer works from their private collections, to the many people who allowed me to see their Kramers, and to all those who provided personal information about the artist, in particular Jonathan and Lilian Rosenthal, David Stross, Ron Lipman, and Pauline Paucker, close friend of Sarah Roberts, Katherine Fryer, Mrs V E Beale and Gertie Jackson. It was especially moving to meet Nellie Pickering, who befriended Kramer in the nineteen thirties, and is still with us.

Edmund Wigan, Rebecca Lowe and Chris Owen of the Leeds College of Art and Design provided historical information as did Tom Steele and the Leeds historian, Murray Freedman. I must also thank Frances Spalding and Rosalind Polly Blakesley for help with references, and Nana Jvitiashvily for guidance to Russian sources.

∞∞

Wendy Kirkby of UCL records office provided information about Kramer's time at the Slade School of Art.

I am indebted to Dr Michael Bearpark, Stella Gelber and Geoff Ferguson for expert advice about alcoholism, as well as to Dr Athol Hughes and Dr Katharina Seifert on child psychology.

Thanks must go to those who read the manuscript in whole or in part at various stages; Ted Hyman, Rachel Dickson, Tim Moreton, Alex Robertson, Agi Katz, Alison Rutherford, Vivienne McKennell and Irving Grose, and where necessary putting me right. I would like to acknowledge the help I have received from David Solomon, Corinne Miller, Jim Bright, Jenny Page of the Bridgeman Library, Nigel Walsh, Charlotte Grant of Christie's and Sarah Powell, who searched out the portrait of Gandhi in the *Heaton Review*.

I am also indebted to Michael Manson, Peter Hirschmann and Sir Ian Gainsford for their advice on publication, and to John and Clara Sansom, my patient publishers.

Finally I must express my gratitude to the Leeds Philosophical and Literary Society, the Leeds Art Collections Fund, the Burton Trust and the individual benefactors for their generosity in making this book possible.

D.M.

# 1    EXILE

The end of the nineteenth century was a terrible time for the Jews in the Russian empire. Under the regime of Alexander III anti-Semitic persecution of the Jews in both the Pale of Settlement and the big cities increased. On 29 March 1891 an imperial order was issued expelling all 30,000 Jews from Moscow under pain of imprisonment. The Russian government even engaged in negotiations to remove three million Jews to Argentina, ignoring protests from the British and American governments. Throughout Russia restrictions on Jewish movement were imposed and violence on the streets, a whipping for a Jew who did not show sufficient public respect for officials, and imprisonment, formed part of the conditions of life for Jews, unless, that is, they were influential or patronised by some important person. Fortunately the talented Kramer family enjoyed the patronage of Baron Guenzburg (Ginsberg), a very important member of a distinguished Russian-Jewish family of bankers, philanthropists and patrons of the arts, whose baronetcy had been granted in 1871 and made hereditary by Tsar Alexander II. Horace Guenzburg headed the Jewish community of St Petersburg and negotiated on its behalf with central government.

The Kramers came from Klancy, a small country town in the Ukrainian province of Chernigov, where Jacob was born on 26 December 1892. His father, Max, was a painter, who had trained at the St Petersburg Fine Art Academy under the most eminent Realist painter of the day, Ilya Repin. The Baron introduced Max to court circles, where, among other work, he designed scenery and costumes for *tableaux vivants*. Jacob's uncle, Cion, also a painter, exhibited as a court painter at the Chicago Exhibition of 1893. Jacob's mother, Cecilia, was the daughter of a farm bailiff, who founded a group of small theatre companies which toured country villages. When talking about his history, Jacob tended to put a more romantic gloss on his family than did his more down-to-earth sister Sarah. Although, for instance, Cecilia is reported as being an opera singer and an authority on Slavonic folk songs, it is more likely that as the daughter of a bourgeois family, she had had

piano and singing lessons and, possessing a good enough voice to sing with a provincial travelling opera company, she would have picked up a useful repertoire of folk songs.

St Petersburg was a divided city: on the industrial side a place of appalling overcrowding and squalor, and on the other the centre of the tsarist autocracy, with its magnificent palaces, museums and libraries. It was a city of great art galleries, theatres and concert halls at a time when Russian culture was dazzling Europe with the ballets of Diaghilev, the music of Borodin and Rachmaninov, and the writings of Tolstoy, Turgenev and Gorki. With a Jewish population of over seventeen thousand St Petersburg was a place where artists like Max and Cecilia Kramer were valued and respected, at least as artists, and afforded patronage.

The Kramers were not a strictly orthodox family, and although Sarah, their oldest daughter, describes Cecilia as 'sternly religious', she simply meant that her mother clung to form and ritual, reading her prayer book and keeping a kosher household, while Max did not care for religious observance. Unlike many religious Jews, however, whose literacy was confined to Biblical and religious studies, the Kramers were well educated, musical and artistic in the broadest sense, and deeply involved in the high-cultural activity of one of Western Europe's most important centres of culture. Furthermore, unlike the Jews of the *shtetls*, to whom the Gentile was alien, the Kramers worked with their Christian fellow artists, and a man in Guenzburg's position will have interacted with non-Jews and had non-Jewish friends and colleagues. The Kramers must have lived in comfortable, well-appointed apartments, and it is likely that the theatre, concerts and soirées, even servants, were customary ingredients of their lives. Compared with most Jews, whether in the *shtetl* or in the cities, along with other members of that Jewish bourgeoisie, they were well off.

For all their advantages, however, the Jewish artists lived on the margin of society, in precarious dependency. Outside their own community the atmosphere in which they lived and performed was entirely anti-Semitic. They depended on the goodwill of others as well as on their own ability to continue to perform to an acceptable standard. There is no record of the style or content of Max Kramer's work, but it seems likely that since much of it was commissioned by the Baron and his connections, it conformed to the Realism of his teacher, Ilya Repin, who had said that 'the artist must believe in what he paints,' that is, 'the poetry of everyday life.' We do not know what artistic reflections on Jewish life and faith Max allowed himself. The benefits of patronage brought constraints not present in the *shtetls*, where, as Chagall's work demonstrated, powerful expressions of faith

and ritual in the everyday life of these villages could compensate to some extent for poverty and hardship. That despite adverse conditions, the Kramers did not leave Russia until 1900 would seem to indicate that their patronage continued until about then. Jacob's friend, T A Lamb, in an essay on Kramer in the Leeds Arts Calendar of winter 1950, writes that Max's career was cut short by 'his revolutionary activities'.

The reforms introduced earlier by Alexander II could be resisted but not halted by his son Alexander III. Reaction to his tyranny came largely from the educated public, the liberal section of society, people in commerce and the growing professional class. Other European countries had already experienced these inevitable shifts towards a more liberal society, but in tsarist Russia such people were viewed as subversives and possible agitators. As an artist and a Jew, Max must have been sympathetic to the liberal movement, and may well have taken an active part. We have only Lamb's word to go on. Could the story of revolutionary activity be the loving son's projection of heroism onto his father? What we do know is that Max suffered from an eye problem and that his original decision to emigrate to the USA had to be dropped because he could never have passed the compulsory medical examination at Ellis Island. Could that eye problem have rendered his work as a painter difficult, jeopardising his patronage and connection with the Court? In the event, whatever the precipitating factors might have been, in 1900 they came to England when Jacob, their only child, was in his eighth year. If they had delayed for too long their immigration might have been difficult for the Aliens Act of 1905 was designed to limit the entry of the *Ost-Juden*. When writing 'Memories of Jacob' in *Jacob Kramer Reassessed*, his sister Sarah says of their father, 'he chose to go to Leeds through a friend who had connections there in a photographic business.'

Max, aged thirty-seven, and Cecilia, younger and pregnant again, faced the difficult plight of the refugee, leaving the familiar behind to face the uncertainties of a new life. As exiles from their homeland their identity as Jews had been confirmed and any duality of loyalty dissolved. But as with all exiles the innate identity remains confused; material baggage can be left behind but never the cultural burden. There is no record of any of this momentous transition. What we do know is that Jacob was losing his home, a home that he had shared with his parents as an only child and to which he would never return.

Hull was their port of entry to England after a three-day boat journey from the Baltic lands, and Leeds was a mere 61 miles by train from Hull.

# 2    LEEDS

Leeds of the early twentieth century has been described as perhaps
the ugliest and least attractive town in all England, with coal and the
railways, engineering and the tailoring industry as the pillars of its
commercial success. Herbert Read described the city as 'a wilderness
of stone and brick, with soot falling like black snow.' Despite its
prosperity the Medical Officer to the Privy Council reported that
in proportion to the importance of the town, public health in Leeds
was the worst that had come to the attention of his department.
Overcrowding, lack of sanitation and poor air brought disease and
death. Tuberculosis, scurvy and rickets were rife and tens of thousands
of children fell victim to the childhood scourges of scarlet fever,
diphtheria, whooping cough, poliomyelitis and diarrhoea. Nowhere
in Leeds were conditions worse than in the Leylands, the area of the
Jewish settlement, a *shtetl* implanted in a foreign land.

<div align="center">ooooo</div>

The Leylands was an area of Leeds just to the north-east of the city
centre. It was a crowded slum of narrow cobbled streets, back-to-back
houses, outside privies shared between neighbours, a filthy, occasionally
violent place, where the smell of horse manure vied with that of baking
bread and beer. Nearby, off Briggate, the main street of Leeds, ran alleys
and courtyards where public houses, prostitution and crime flourished.

 This then was the place of refuge that the Kramers, speaking Yiddish,
Russian and prayer-book Hebrew, had come to from the comfort,
prestige and respectability of St Petersburg. But they did not stay long.
Not only were they strangers in a foreign land, but they were also alien
to the conditions of life in the Leylands; so like many Jews who were
improving their conditions of life, they moved into the Chapeltown
area, to a house with four rooms at 15 Beecroft Grove off Leopold
Street. This was to be home for many years to Max and Cecilia and
to their children, who over the next few years increased to five. From
Chapeltown Cecilia had to walk about two miles to the Leylands

to buy strictly kosher food. Sarah writes, 'If by some mischance she suspected that the inside of the chicken did not conform, she would go again to the Rabbi.' However, this does not prove that Max and Cecilia conformed in every way to orthodoxy, with its emphasis on prayer and the regulation of all daily tasks.

On 29 July 1900 Sarah was born. Fortunately Max was earning a living at a studio in the promised photographic business. Photographs were prized. There was hardly a family that could not boast of one or two photographs hanging on the wall, or propped up on the parlour mantelpiece or piano, and as many of these were old and faded, out of focus or damaged, there was a very busy trade in enlarging, colouring, 'retouching', and even painting a portrait from a faded photograph. Skill was needed but it was not the kind of work that carried much prestige.

As Sarah reports in *The Kramer Documents*:

'During this period there was a group of men led by Mr. Gross who knocked at doors and asked if there were any photographs of relatives, dead or alive, and if they would like enlargements to hang on the wall. A gang of men were sent round Yorkshire to solicit these orders. These photos, many of them old and indistinct were then enlarged on cardboard in black and white or on canvas. Then they were finished by my father, the only one who could recover from the faded likeness the semblance of the portrait.

'For cardboards my father's payment was a shilling and for oils he got five shillings. There seemed to be hundreds of each. The mastermind then priced them according to his inclination from the comfortable home in Chapeltown from where Gross conducted his business. It was flourishing for him, and kept the rest of the company just alive.

'He even persuaded my father to sell him the Astrakan coat he had brought from Russia.'

Sarah had a sharp mind and barbed wit and it is unlikely that their circumstances were as precarious as this acid statement seems to indicate. Before the Great War a weekly wage of £2 was regarded by workers as high, and at the rates quoted by Sarah this might not have been too difficult for Max to achieve. But the work represented a come-down, a loss of dignity, and Max, the respected artist, working at something so inferior, could not have been a happy man. Totally unable to play any meaningful role in his new society, he was just one immigrant amongst many others. He was no longer a person of status enjoying aristocratic patronage, but a wage slave working for a man whom he no doubt regarded as his inferior. Living in the past, Max

must have invested all his hopes for the future in Jacob. Cecilia also had been deprived of status and the opportunity to exercise her own art, but the following years of child bearing provided happiness and fulfilment, a foundation for her being which could be only partly shared by her husband. No matter how courageous, resourceful and patient they were, accustoming themselves to enjoying the freedom of England, their young son will have grown up sharing his parents' sense of dislocation, relative poverty and diminished status.

In the Leylands Yiddish was the dominant language of the everyday, so at least Max and Cecilia did not suffer the difficulties of communication that many immigrants had to endure. Indeed, according to Nellie Pickering, a friend of Jacob's in later years, Cecilia never learned to speak English and Jacob always had a strong foreign accent.

By the turn of the century there were three schools in the Leylands full of Jewish children and Jacob attended one of these, Darley Street Council School, which had previously been a fee-paying Wesleyan day school. It had taken its first Jewish pupil in 1874, and by the turn of the century was almost entirely a Jewish school, where the children had established a reputation for good behaviour, cleanliness and hard work.

Early on, Jacob's talent at drawing and especially his gift for portraiture had been recognised by his headmaster, Harry Blackburn, and by his art teacher, Gertrude Poyzer, and at the age of twelve Jacob had an exhibition of his work at the school. However, his attendance record was even then cause for concern.

In an interview with the *Yorkshire Evening News* on 29 June 1928, Jacob confessed that he had always been restless, and restiveness and unreliability were characteristics that ran throughout his life. He told the reporter that he had run away from home on several occasions and it is reported that at the age of ten he had run away to Liverpool and gone to sea for six months. Although this episode is mentioned in the Leeds Art Gallery exhibition catalogue of autumn 1960, and more guardedly by Frances Spalding in her introduction to *Jacob Kramer Reassessed* of 1984, there is no hard evidence of such an escapade, and it seems possible that this story was the fruit of Jacob's imagination. According to his sister Millie, in 1906 after his time at sea Jacob left the ship at Liverpool and went to Manchester, where he attended evening classes at Manchester Art School. However, in a talk that Jacob gave in 1922, he said he left home to find work first as a labourer in the Liverpool docks and then on public works in East Lancashire.

When asked how he earned his first shilling, Jacob replied 'I earned my first shilling after I had run away from my elementary school, the

Darley-street Elementary School. I was at the Leeds Midland railway station when I saw a commercial traveller with some parcels of hats. I was rather strong and big for my age and offered, for the fun of the thing, to carry them for him. I took them for him to a place somewhere behind the General Post Office, and he rewarded me with a shilling. My parents were rather strict and would not have approved of the escapade. I spent the shilling at a music hall. The music halls with their colour and rhythm, always attracted me. I was always restless and ran away to Middlesborough, where I worked in a municipal garden as a boy assistant, earning a few odd shillings. Then I went to Manchester, where I got a job doing photographic enlargements. I was then about thirteen. My next adventure was at Blackburn, which I just managed to reach without a penny in my pocket. There I saw this horrible-looking shop with one or two photographs stuck in the window. I asked the proprietor if I could be of service to him and told him my story. He asked if I knew how to do retouching work, and I said "Yes," though I had never done any before. Rather surprisingly I did the work properly when he gave me some samples to try my hand on. I stayed there only a week, however, for my employer, who lived alone, fell ill and wanted me to do house work for him, and I found this disagreeable. After another brief stay in Manchester, I came back to Leeds, got a job with a printing firm and managed to do rather well with them.'

All this apparently took place before the age of fourteen, when he won a scholarship to Leeds School of Art. But for all these adventures we have only Jacob's word. What is more, by 1928 when Jacob was thirty-six, he was already alcohol dependent. However accurate these reports of Jacob's adventures they do demonstrate that he was a boy of considerable independence, courage and resourcefulness as well as physical strength. They also demonstrate wilfulness, self-absorption and lack of concern for his parents' feelings. It is also difficult to reconcile this cool and straightforward account with his statement that his parents were strict. Even the most benevolent or distracted parents would not easily have allowed such unacceptable and thoughtless behaviour. Significantly the newspaper interview makes no mention of running away to sea.

In the newspaper interview Jacob continued:

'In the belief, then, that I had some little talent I now put in my evenings at classes at the Leeds School of Art, where Mr. Parsons [sic], now Art Master at the Bradford Boys' Grammar School, suggested that I should go in for a Junior Art Scholarship.' He was encouraged in this enterprise, in 1907 at the age of fourteen, by both Haywood Rider, the Head of the Art School, and Sidney Pearson.

FIG. I
Jacob aged 15

A photograph of Jacob at fifteen (fig. 1) shows a boy with striking Jewish features, a large aquiline nose and a splendid head of dark wavy hair, wearing a painter's jacket and holding a well-used palette and paintbrushes. It is a strong face, pensive but with an expression of quiet determination to fulfil the expectations of his parents, his teachers, and no doubt the local community. 'I promised to try for [the scholarship], never for one moment expecting to win it. I did win it, however, and stayed for two years at the School of Art, having won another scholarship in the meantime [that was the Senior Art Scholarship]. I must admit that I didn't conform altogether to the routine of the School, but my dear late headmaster, Mr. Haywood Rider, who was really rather proud of me, was very tolerant. This did not prevent him from threatening me many times with expulsion.' The runaway was now a truant, once again rejecting dependency and discipline, but knowing exactly what he wanted. This is exemplified in a story told by his art master, Frank Simpson, who, on a class visit to a museum, provided Jacob with a half-Imperial drawing board and paper and told him to draw a stuffed gorilla. After about twenty minutes Jacob had not put a line on the paper because, he said, the paper wasn't big enough. Given the biggest piece of paper they could find Jacob set about drawing the gorilla with the firm, sweeping Kramer line and the generous Kramer gestures. His claim that he believed he had some 'little talent' smacks of false modesty. It is more likely that even at this age he considered himself special.

With the birth of Sarah, the first of Jacob's four siblings, Jacob ceased to be an only child, a privilege he had enjoyed for almost eight years. Any jealousy he may have suffered, however, might have been eased by the fact that the second child was a girl. Jacob's love for his first sister was later to be most clearly demonstrated in his work, but some emotional conflict must have been inevitable. Jacob's dependence on his mother had to be shared with baby Sarah. Then in 1904 Miriam (Millie) was born, to be quickly followed by two more children. A boy, Isaac, is described as having died in infancy, yet the two drawings of 'My brother Isaac,' dated 1915 (fig. 2) and the gentle, possibly elegiac,

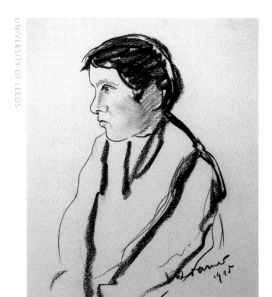

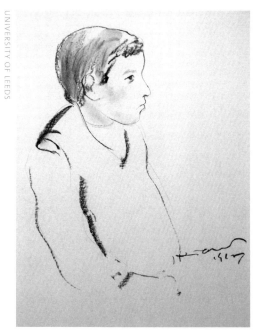

FIG. 2
My brother Isaac
*charcoal: height 55.9cm*
1915

FIG. 3
My brother Isaac
*pencil & black chalk:*
*height 55.9cm*
1917

portrait of 1917 (fig. 3), are of a boy of about nine to twelve years old, who may therefore have been born around 1905, the year after Millie. The third girl, Leah, was born 'simple-minded', as it was then termed, and needed care. As an adult she was unable to be independent and earn a living, and in later life was supported by Millie. Thus within five or six years of arriving in England the only child gained four siblings, all fed at their mother's breast, an important image in Jacob's early work, as it was in that of his contemporary, Bernard Meninsky. Any attention Jacob craved was now bestowed on his siblings, and finally by running away he demonstrated that he did not need his parents' care.

In *Jacob Kramer. A Memorial Volume* there are two group photographs of students at Leeds Art School taken when Jacob was about twenty. In one he lies nonchalantly on the floor at the foot of the group and in the other, while most of the students are hugging a large plaster statue, Jacob sits at its base from where he has adopted a pose looking up at the others, rather than at the camera. In both photographs he seems to be *with* the group rather than *of* the group, and as a giant Russian Jew of six feet six inches he was certainly the odd man out.

There is no doubt that he was fully aware of his talent. His draughtsmanship was regarded highly by his teachers, and generously encouraged. Like most young artists his early work portrayed, as it did for many years, the world he knew best: his mother, looking much older than her years, sewing (fig. 4), and weary in the kitchen (fig. 5),

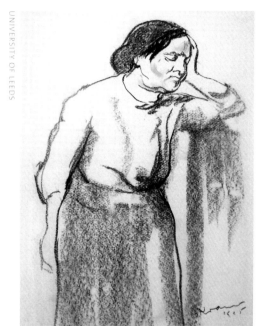

FIG. 4
Cecilia Kramer
sewing
*charcoal: 76 x 53.5cm*
1913

FIG. 5
Woman leaning
against a shelf
*charcoal: 39.4cm*
1915

and his favourite model until she left home to live with William
Roberts, his beautiful sister Sarah. The free line and subtle colouring
of his many delightful drawings and paintings of Sarah as a gypsy or
as herself (figs. 6 and 7), demonstrate the influence of Augustus John,
who enjoyed a wide reputation by the time Jacob went to art school.
To Jacob, John became the model of what an artist should be, the
bohemian and outsider, and the gypsy, the eternal outsider and
wanderer. Later in life Jacob carried an attaché case containing his
special 'recollections', the most precious being a photograph of John
with his family taken outside a caravan.

While at the art school Jacob became friendly with Tommy Lamb,
who was a compositor at the *Yorkshire Post* and an occasional writer
of articles. He wrote a small book of stories entitled *TNT Tales* for
which Jacob did a dust wrapper as well as making a small portrait of
the author. Tommy was a regular Friday-night visitor to the Kramer
home to partake of the Sabbath supper, and on Passover he would
be 'the stranger', the symbol of hospitality, at the special Seder Night
dinner and service.

While Max was alive Fridays were also the family's concert evenings.
Sarah said that one of Jacob's specialities was imitating a train coming
in from a distance, waiting at the station, and then going off again into
the distance. But Jacob could also play the piano: in the words of the
music critic, Ernest Bradbury, 'Jacob was not a trained pianist; but he
was a memorable one for all that.' With Max as their audience Cecilia

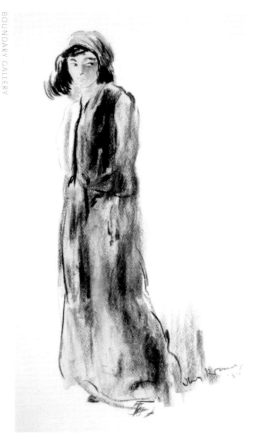

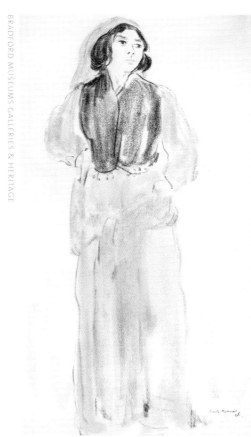

FIG. 6
Sarah as a gypsy
*pastel on paper:*
*61 x 41cm*
*1915–16*

FIG. 7
Dark Jewish girl
in headscarf
*chalk on paper:*
*40 x 30.5cm*

would sing folk songs and excerpts from operas, Millie would dance
and Sarah recite. The evening always ended with Jacob doing the
Kazatsky, that energetic Russian dance requiring considerable athletic
prowess. Life at the Kramers was not all unmitigated gloom, and such
entertainment on the eve of the Sabbath manifested their increasing
separation from orthodoxy.

∞∞∞

Jacob's talent, his ambition to go to the Slade, and his wayward nature
were recognised when some wealthy Jewish families set up a fund to
provide talented Jewish boys from poor families with a pound a week
to help them pursue their education. Two boys from Leeds obtained
these bursaries, Jacob Kramer and the brilliant Jeremy Raisman.
The trustees of the fund asked Jeremy Raisman to look after Jacob's
money for him. The future was to prove this decision a singular piece
of insight: in 1939 Raisman was knighted as Finance Member of the
Viceroy of India's Executive Council. Jacob could never be bothered
with money and week after week he would come to Raisman to
borrow half-a-crown against the next week's earnings. In return

Jacob drew a sketch of Jeremy determinedly smoking a pipe, a portrait foreshadowing the important man he was to become.

Early on Jacob had recognised that coloured chalks and pastels gave a deeper sense of form, and these were media that he was to use in much of his work. Also like pencil, ink and charcoal they allow the rapid sketching that he needed to do when he began making portraits of actors backstage. As a child he must have been backstage many times with both his parents when they were working, Cecilia as a singer and Max designing scenery, and Jacob was inevitably drawn to the theatre and music hall which flourished in Leeds. While most adolescents would have found that territory foreign and the actors awesome, the theatre and its celebrities presented no fears for Jacob. Years later Sarah was to write in *Jacob Kramer Reassessed*, 'he was so bitten by the theatre that early on [he decided] that it should be my career, although my father wanted me to be a schoolmistress.'

'After a time,' as Jacob continued his story in the *Yorkshire Evening News* interview, 'I was again troubled with restlessness, and ran away again. It was then that I did my first real work. The late Weedon Grossmith, playwright, was at the Leeds Grand Theatre at the time, and I did a portrait of him behind the stage. Grossmith's manager invited me to London, and I decided to accept the invitation. One of the first things that I did when I got there was to seek out Mr. George Clausen, R.A. whose work I much admired, and he kindly showed me his work and around his studio. That was my first experience of meeting a real artist, and it was a happy one. Whilst in London I did sketches of Sir Gerald du Maurier, and of August van Beine, the 'cellist, who died suddenly on the stage at Blackpool a week later.'

Throughout Jacob's life and in all posthumous reports people remarked on his friendly and engaging personality, and there could be no better testimony to this than the above account. These were famous people that Jacob seems to have had no difficulty in approaching and persuading to sit for him for their portraits. If his restlessness demonstrated some deep anxiety this was in marked contrast to the boldness of his behaviour.

As always Jacob is not a reliable source of accurate information; he obtained the Senior Scholarship to Leeds School of Art in 1911. The year before, he had been 'adopted' by the Jewish Education Aid Society, the organisation that was providing support for many other poor Jewish art students, including Mark Gertler, David Bomberg, the poet and painter Isaac Rosenberg, and the American Jacob Epstein. It was one of the many charitable organisations formed both locally and nationwide to support people in need, and in Leeds ten

such organisations had been formed by the turn of the century. The JEAS invested in those students whose potential was evident, and its support for Jacob is testimony to the quality of his work at that time. But the JEAS gave loans, not bursaries, with the expectation of repayment.

<center>ooooo</center>

By 1909 when Jacob was seventeen, he had a good body of work to show. On the JEAS grant application form of 5 November, Jacob described his father as a retoucher earning twenty-five shillings a week, of which seven shillings and sixpence went on rent for the four-room house. Jacob entered that he had four siblings, all at school except for the baby, and that he spoke Yiddish, Russian and English. His application had the support of Haywood Rider, the Head of Leeds School of Art, who described Jacob as very quiet, earnest and industrious and, disregarding Jacob's regular truancy, described his conduct as in every way without reproach.

On 10 January 1910 an agreement was drawn up between Robert Waley Cohen, then Chairman of the JEAS, Max and Jacob, and witnessed by Jacob's contemporary, the Leeds painter, Philip Naviasky, 'binding Jacob to keep the Society informed of his place of residence and of his circumstances and occupation.' His reputation for unreliability and his tendency to truancy were recognised, but perhaps tolerated in the belief that unreliability went hand in hand with genius. Nevertheless, it seems that not everyone was convinced. When the JEAS secretary, Mr Ernest Lesser, asked a committee member, Dr Mayer Coplans, if he would act as Jacob's 'guardian', the doctor refused on the grounds that he was too busy. Support was doled out in small sums and the total amount spent on Jacob's maintenance for the half-year January to June 1910 was £10. Repayment of these loans was to be made in instalments when the artist could afford it.

In 1911 Jacob's work was accepted for the Bradford Spring Exhibition, and through the JEAS, Sir Michael Sadler, the recently appointed Vice-Chancellor of Leeds University, came to meet Jacob. He was to be Jacob's most important patron, advisor and provider of financial support. Sadler was an enthusiastic and eminent art collector, a keen supporter of the 'modern' movement, and according to his son, Michael (who changed his surname to Sadleir), his father's appointment to Leeds stimulated his collecting: '... his operations in the art market from the summer of 1911 to the autumn of 1912 were not anaesthetic but unrestrainedly enjoyable.' Sadler took an interest in many young artists, especially in Jacob and his contemporary, Bruce Turner, and Jacob was to benefit immensely from Sadler's enthusiasm.

# 3    THE LEEDS ARTS CLUB
## JACOB'S UNIVERSITY

By the beginning of the twentieth century the Education Act of 1870 was bringing education to millions of children. They were now artisans, involved in commerce and the professions, and very prominent in teaching. The discussion and questioning of received ideas and the social order flourished in such organisations as the Workers Education Association, and in socialist, Fabian, and theosophical societies, which sprang up all over the country. Among these was a group of immense importance to Jacob's development, this was the Leeds Arts Club (LAC), founded in 1903 by Alfred Orage, a primary school teacher, and Holbrook Jackson, a lace-maker and freelance journalist. It organised lectures and debates, advocated social reform and self-improvement, and attracted a mixed group of men and women, many the product of that Education Act, a new bourgeoisie, described by Paraskos as educationally advantaged but socially disadvantaged. They included students like Jacob and his friend, Bruce Turner. The Club met at 8 Blenheim Terrace, Woodhouse, not far from the university, and shared premises with the Leeds Fabian Group and the Theosophical Society. A foreigner like Jacob could be comfortable in such mixed and progressive company. The LAC was in striking cultural contrast to the francophile Bloomsbury Group, who were members of the English middle class, privately educated, economically and culturally powerful, and therefore seen as representative of art in England. They were people who flirted with radicalism in their art, their politics and their social relationships, while in their art Jacob and Bruce Turner flirted with nothing; they were earnest, experimental but never dilettante.

The formation of the LAC followed that of the Bradford Arts Club formed in 1902 by Bradford-born William Rothenstein, who, as Tom Steele reports, was 'shocked by the impoverishment of English provincial life by the progressive concentration of civilisation in London and he struggled to arrest it.' Rothenstein, like Sadler, believed in the redemptive powers of the arts, and by this time Leeds, despite the depredations of industrialisation and the philistinism of

many city fathers, had become the centre of much cultural activity in which the university and its teachers played an important role.

The LAC was Jacob's university and his most important teachers were Michael Sadler, who followed Orage as leader, and Frank Rutter, who had been an art critic for *The Sunday Times*, and was appointed in 1912 as Curator of the Leeds Art Gallery. Sadler and Rutter made a contrasting pair: Sadler was a romantic Expressionist, while Rutter promoted the formal approach of Cubism and Abstraction. He was a powerful advocate of 'self-expression' in art, an idea that he propounded in his magazine *Art News*, which brought German Expressionism to the attention of English artists, and to the exhibitions of the Allied Artists Association (AAA), which Rutter founded. Together Rutter and Sadler formed the Leeds Art Collections Fund, which brought to the City Art Gallery new types of art, Japanese wood block prints, painters like the Pissarros, father and son, and London Underground posters. Rutter introduced members of the LAC to Kandinsky's ideas about the emotional effects of the basic pictorial elements, that is that marks, shapes and colours provoke their own feelings, irrespective of pictorial content. At the end of the nineteenth century the association between colour and music had been much discussed and a 'colour organ' devised which displayed coloured lights when a keyboard was played. At one meeting Rutter had members of the LAC make abstract drawings while listening to musical sounds. Kandinsky, who was an accomplished musician, associated colour with music, tone with timbre, hue with pitch, and saturation with the volume of sound, and as he wrote, 'I applied streaks and blobs of colour onto the canvas with my palette knife and made them sing with all the intensity I could.' Music, he said, is divorced from the problem of representation, and denies its true function when it attempts to be descriptive. Music and art have 'justification when they bring consciousness into mystical union with the inner transcendental essence of reality.' These ideas had a powerful impact on Jacob, and the colour-music relationship was to form the theme of many of Jacob's lectures in later years. Kandinsky's notions had been spelled out half a century earlier by one of the great nineteenth-century philosophers, Schopenhauer, whose ideas about the connection between the appearance of things and the underlying 'reality', the spiritual, corresponded with Jewish and Russian mysticism and strengthened its influence on Jacob. What reality is and how it can be portrayed were questions that exercised Jacob in much of his work.

ooooo

As well as being a source of education on current affairs, literature and art, the LAC was a focal point for the gathering of interesting people of the day, including Herbert Read (fig. 8), who came from a poor

FIG. 8
Herbert Read
*charcoal*
1914

family, was educated to be a bank clerk, and was now an undergraduate at Leeds University. Like Hayward Rider, Frank Rutter and Sadler, Read was to be extremely important to Jacob. He was one year younger and always said that Jacob was the first real artist that he had ever met. They met at the LAC in 1912 and the relationship between these two very different personalities, Read, a poet of considerable erudition and intellect, and Kramer, intuitive and passionate, lasted all their lives. In fact in 1915 Read wrote a poem called 'Etude' for Jacob, who, throughout his life, won the affection and respect of his many friends. One of these, Frank Lawson, a fellow artist, made a portrait of Jacob; drawn with great sympathy it shows him sitting, relaxed but rather introspective, a young man wondering about himself and looking older than his years. Before 1912, when Jacob left Leeds for the Slade School of Art, his life was split between powerfully contrasting elements: on the one hand the crowded space of Beecroft Grove, warm, even claustrophobic, with the intensity of a loving Jewish family, and on the other the busy working day of the art school and the LAC, offering vistas of the outside world, to which Michael Sadler, more than anyone, opened doors.

At Oxford Michael Sadler had been strongly influenced by John Ruskin, the writer on art and social problems. Sadler believed that 'education and culture would save the working class and hence his own, from the nightmare of anarchy and revolution.' He was evangelical in his dedication to promoting all things 'modern', an educationalist and a generous benefactor to many causes, as well as patron to up-and-coming young artists. He thereby added to his large and important art collection, which included Turner, Constable and Gauguin, as well as German Expressionists such as Marc, Klee and Kandinsky. In 1913 he acquired his first completely abstract work by Kandinsky, which he must have shown to Jacob.

On first meeting in 1911, Sadler was immediately struck by the energy of Jacob's drawing and painting, and probably also by the impressive

nature of this Jewish-Russian giant who might be capable of great things. Sadler took Jacob under his wing, offering criticism that Jacob was always ready to acknowledge, and generosity which Jacob was always very happy to receive.

Although Sadler rejected many of Jacob's offerings, some years later, on receiving some pictures that Jacob had sent him, Sadler commented, 'No finer imaginative work has been done in Leeds within living memory.' Such admiration provoked Steele to write, 'If Kramer was to be Leeds's Giotto was Sadler its Medici?'

# 4 STARTING OUT

Sadler was not Jacob's only regular patron at that time. William Pilkington Irving, the district manager of the County Fire Office of the Leeds and Alliance Assurance Company, and a committee member of the LAC and its offshoot the Leeds Playgoers Society, bought many of Jacob's works, and may well be the subject of a portrait of a man with a large white moustache painted in about 1917 (fig. 9). In that year Jacob exhibited six drawings at the Bradford Art Gallery, and in the following year a painting and one drawing at the Leeds Art Gallery and six drawings at the Doncaster Art Gallery. These were mainly figures and portraits. His reputation was growing, and Sadler, along with William Rothenstein and Dr Coplans, then a staff member of Leeds Medical School, encouraged Jacob to apply for a place at the Slade School of Art. Jacob was inspired by Rothenstein's earlier paintings of Jews at prayer, which Rothenstein had explained in an interview with the *The Jewish Chronicle* in 1906, as being motivated by 'the devotion of the Jew [and] the spirit of Israel, not the outward trappings of the ritual.' This was a sentiment that resonated with Jacob's own feelings, and Rothenstein recognised the promise in this young artist, who seemed to be much more involved in the *spirit* of Judaism than other young Jewish artists.

With his increasing popularity Jacob's need for a space in which to work became more urgent. It was difficult to work in the small and crowded family home at Beecroft Grove, and the art school afforded neither privacy nor the right atmosphere. By now Jacob had his own ideas about the purpose of art and what he wanted to do, and that did not conform to the traditional Naturalism of art-school teaching. Fortunately Jacob's earnings had grown to the point where he was able to rent a cottage fitted with a studio in the countryside near Leeds, a half-penny tram ride from town. There he could paint, and Sarah has talked of her visits to Jacob where she and a friend could smoke cigarettes that she had stolen from her father. This is the cheeky Sarah we know from an early photograph of Cecilia and her daughters, serious Millie aged about six and a smiling Sarah, a bright and knowing ten-

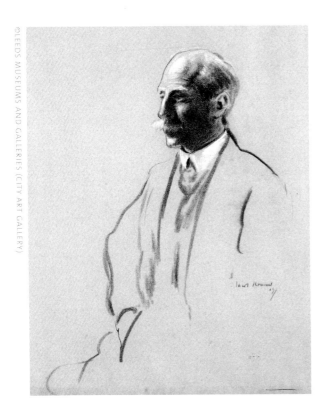

FIG. 9
Portrait of a man
(possibly William
Pilkington Irving)
*charcoal & chalk:*
*59.2 x 44 cm*
1917

year-old. The little rebel and her big brother were in league, two of a kind bent on being modern in the new world. It was a time of increasing secularisation among young Jews, but whatever reservations Sarah and Jacob had about formal religion they were devoted to their parents and respected their beliefs.

Despite the space that the cottage allowed him Jacob more often than not returned to work at his home in Beecroft Grove. He retained this restlessness into old age and seemed to find peace in the solitude of old churches and other large, empty spaces. When Jacob finally left his cottage along with its contents, they included some landscapes, the only remnants of Max's painting days. Jacob still spent time helping his father in the photographic studio, and at the end of the day they walked home together, Max smoking a cigar and looking forward to a game of chess.

Jacob's future training was of concern to his friends in the theatre as well as to his advisors in the art world. Weedon Grossmith favoured the Royal Academy school, writing, 'Anyone may belong to the Slade by paying for a term. Send your drawing up to the RA.' But with the backing of Rothenstein and Haywood Rider, and the financial support of the JEAS, Jacob was accepted by the Slade for one academic year, 1912–13. The news that Jacob was going to London quickly got around amongst his theatrical friends. From the Theatre Royal Newcastle, the actor, Edward Compton, sent a postcard dated 18 October 1912: 'The above will be my address all next week. I wish you a great measure of success in the Great City. Thanks [presumably Jacob had written to wish him luck]. "*Everywoman*" has played to big houses every night this week in Bradford.' Weedon Grossmith wrote, 'I was indeed sorry not to meet you. We have been worried to death.'

ooooo

On news of his admission to the Slade, Jacob received the first of many letters from Michael Sadler, who wrote, 'Dear Kramer, I am delighted

to hear your news. This is a great and deserved chance. This may make all the difference to you. If you really wish to give me one of your drawings, I shall value it.' In recording this letter John Roberts (*The Kramer Documents*) comments that despite the fact that Sadler was always ready with encouragement and sage advice he never started his letters, 'Dear Jacob'. Roberts seems to think that despite the obvious warmth Sadler felt towards Jacob some distance needed to be kept, perhaps that of the master to the pupil, but it may also have reflected Sadler's awareness of Jacob's possible dependence.

By March 1912 the JEAS had spent fifty-one pounds and fifteen shillings on Jacob's maintenance, and his time at the Slade meant further dependence on the Society. The strings to its generosity were evident in a letter to Jacob from R M Sebag-Montefiore, the Honorary Secretary, dated 19 October 1913. It is worth reproducing at length:

'With reference to your recent application to the Education Aid Society, I have now to inform you that after very careful consideration the society have decided to accede to your application to the following extent. They are prepared to your coming to London and attending the Slade School of Art for three terms, and no more. They will pay your fees at the School and, in addition, make such allowance for maintenance etc., as may appear to be necessary, when they have ascertained how much your family are in a position to contribute, and on condition that your family will undertake to furnish their share regularly, during your stay in London.

'Upon this latter point you will be duly informed by Mr. Ernest Lesser, with whom you should communicate as soon as you arrive in London. This you should arrange to do with the least possible delay, in as much as the Session 1913–14 at the Slade has already begun, and every day spent there is of value to you.

'The Society have been given to understand that you have not always worked at Leeds with that seriousness and assiduity which is expected of their students, and which is essential if you are to achieve ultimate success. They trust that they will hear no complaints on this score during your short stay in London but that you will make up your mind to utilise to the best possible advantage the opportunity for further progress now offered you. It is only fair to point out to you that any report to the contrary, besides indicating extreme foolishness on your part, would result in the immediate withdrawal of the Society's support and assistance. On your arrival in London you had better make a point of at once calling at the office between 10 a.m. and 1 or 2.30 and 4.40 when I will arrange for you to see Mr. Lesser.'

Jacob was almost twenty-one when this letter was sent to him, chastising and warning, and with its obvious reference to his earlier erratic behaviour; it might have been sent to a delinquent schoolboy. In fact Jacob proved to be more of a responsibility than the JEAS had envisaged. Although their funds were meant to support his academic activity, minutes of 1912 note the need for both a set of false teeth and respectable clothing so that Jacob could spend that Christmas with Weedon Grossmith suitably dressed.

Jacob continued to be busy making portraits, usually in pastels, of people in the theatre, and Fred Terry wrote from the Theatre Royal in Nottingham: 'Thank you for the drawing of Mr. Hodges, I like it exceedingly. I consider your pastel drawings quite remarkable; it makes me regret that I hadn't the time to sit to you for a coloured pastel myself. P.S. I am returning the drawing by this post.'

# 5 THE SLADE

In the autumn of 1912 Jacob entered The Slade School of Art, where the leading modernists were Frederick Brown, head of the Department of Fine Arts, his assistant Henry Tonks, a formidable man who had been a surgeon and anatomist, and the head of painting, Philip Wilson Steer. Influenced by the Impressionism of Walter Sickert and Whistler, these men, members of the New English Art Club, thought of themselves as part of the English *avant garde*. But in this period of considerable experiment and change they were soon to be outmoded by Post-Impressionism and Cubism. That Gauguin had a profound influence on Jacob is manifest in a strong drawing simply entitled 'Head' of a girl with Mongolian features against an abstracted striped background (fig. 10).

In November 1910, Roger Fry, painter, critic, lecturer in the history of art at the Slade, and the most powerful English exponent of the modern movement, had organised the exhibition 'Manet and the Post-Impressionists' at the Grafton Gallery, showing work by these great masters, also that of younger and even more innovative artists, including Picasso, Signac, Derain and Matisse. A conservative Edwardian England regarded any cross-Channel import as subversive and the great British public thought the works an outrage and a joke. The art critic William Blunt wrote, 'The exhibition is either an extremely bad joke or a swindle. I am inclined to think the latter for there is no trace of humour in it. Still less is there a trace of sense or skill or taste, good or bad, or art or cleverness… the drawing is on the level of that of an untaught child of seven or eight years old.'

The writer Desmond MacCarthy labelled the show 'The Art-Quake of 1910', and when, in a discussion about art that Fry had with Edward Elgar, Fry drew an equivalence between music and the visual arts, Elgar insisted that while music was inspired from the heavens the visual arts were 'damned imitation.' At that time imitation seemed to be the only thing the public appreciated.

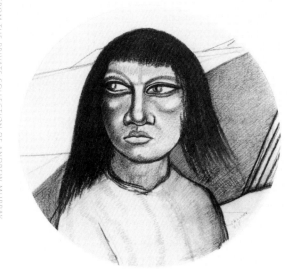

Even the progressive members of the New English Art Club were divided. Tonks and Steer worried about the effect of this 'virus of the new art' on students; Tonks admonished his students not to look at Cézanne, and William Rothenstein, now knighted, expressed his unease. But young artists found the idea of expressing their own feelings in richer colours and simplified form encouraging and liberating. Vanessa Bell wrote, 'It is impossible to think that any other single exhibition can ever have had so much effect as did that on the rising generation.'

FIG. 10

Head

*charcoal*

1918

By the time that Fry organised the second Post-Impressionist show in 1912, there was greater acceptance of this kind of work, and this exhibition included work by young English painters, contemporary with Jacob Kramer, including Stanley Spencer, Duncan Grant, Vanessa Bell, Wyndham Lewis and Eric Gill.

In a powerful defence of the new movement Roger Fry wrote:

'… it is not the object of these artists to exhibit their skill or proclaim their knowledge, but only to attempt to express by pictorial and plastic form certain spiritual experiences …. In fact they aim not at illusion but at reality.' This reality, now being expressed in Cubism and by Abstraction, was the reality below the surface veneer that Jacob strove to portray.

In his treatise of 1912, 'On the Spiritual in Art', Kandinsky wrote that, 'the relationships in art are not necessarily ones of outward form, but are founded on an inner sympathy of meaning … In tracing spiritual relationships only inner meaning must be taken into account.' Kandinsky called this inner meaning the 'Inner Necessity'. Although Jacob did not see Kandinsky's book until 1920 (on loan from Sadler), he will have been familiar with these ideas through Sadler and the LAC, and in his own writings and lectures Jacob was to repeat this message over and over again.

When he entered the Slade, Jacob's address was 24 Cotleigh Road in West Hampstead, London, even today a crowded area of bedsitters, but little more than three miles from the Slade in Gower Street. His guardian was given as Ernest Lesser, then secretary of the JEAS,

who lived in the much smarter area of Holland Park. Jacob shared his lodgings with fellow Leeds painter, Philip Naviasky, who was about the same age, but not a Slade student. These young men were now in the great city, the centre of Britain's cultural life where most of the art world's *avant garde* lived and worked. This was an exciting and challenging place, utterly different from the overcrowded immigrant ghetto of Leeds. Here were established figures of the new art such as Augustus John, who held court regularly at the Café Royal, and Jacob Epstein, already something of a celebrity, as well as many young Jewish contemporaries including Gertler, Bomberg, Rosenberg and Meninsky. None of these conformed to an orthodox Jewish life, and whatever remnants there were could be easily abandoned for this was a place where one could make one's own life, swim one's own course in a sea of creativity and experimentation. Furthermore, unlike the Jewish areas of Leeds, Manchester, Liverpool and Birmingham, London was a place where anonymity and privacy allowed people to live by their own standards and inclinations. Even so, Jacob like the others could not discard his Jewish identity or turn his back on his childhood in Russia or youth in Leeds where he had spent his formative years. Gertler was busy becoming an English gentleman, but of all Jacob's contemporaries only Meninsky was deliberately to avoid any Jewish references in his work.

Mark Gertler was the first to enter the Slade with JEAS support, in 1908 (by William Rothenstein's recommendation, although he was not on the JEAS committee), and was followed by David Bomberg, Isaac Rosenberg and Bernard Meninsky. At the Slade Gertler's draughtsmanship was thought to be equal to that of the precocious Augustus John, so when Jacob entered the school he followed a line of talented Jewish students who had demonstrated their ability to achieve the high standard necessary to obtain the support of the JEAS. Before Jacob arrived, and contemporary with Gertler, were such future luminaries as Paul Nash, Stanley Spencer, Charles Nevinson, William Roberts, Dora Carrington and Edward Wadsworth.

Instruction at the Slade started in the Antique Room where students, armed with charcoal sticks and chunks of bread for rubbing out, spent long weeks copying plaster models of Greek, Greco-Roman and Italian Renaissance sculpture, learning to model roundness and solidity by varying the densities of shading. Drawing correctly to represent nature was the essential requirement.

On entry students presented their drawings to Professor Frederick Brown or the formidable Henry Tonks, thought to be the best teacher of figure drawing in England. It was said of this 'cruel, rude and uncompromising man,' that 'Tonks was the Slade and the Slade

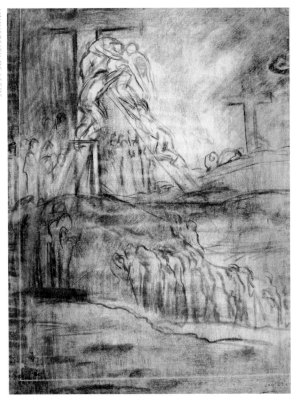

FIG. II

Deposition.
The descent
from the cross
*charcoal & pastel:*
*55.9 cm*
1916

was Tonks.' He insisted that understanding the skeleton was essential to mastery of the contours of the body, especially the female, and after the Antique Room the chosen men and women, who were segregated, entered the Life Room. In the life classes students made rapid sketches of models holding five-minute poses terminated by the shout, 'Change.' Painting classes came later under the supervision of Philip Wilson Steer.

That Jacob started his studies satisfactorily is demonstrated by a letter from Sadler on 1 December 1913, which reads, 'I am happy to hear that you are getting on well at the Slade. I shall be meeting several of the Professors there in the course of the next month and will ask them about you.'

Sadler was already collecting 'Kramers', which he said he valued very much, and it appears that Jacob was actually making gifts to Sadler. This was revealed in a letter where Sadler apologised for not thanking Jacob for 'your very kind gift when I last wrote,' and which he explained was 'Through an accident [which meant that] I missed reading a whole page of your kind letter of Nov. 29.' Jacob was to prove both a copious letter writer and, despite his foreign accent, a highly articulate proponent of his ideas about 'modern art'.

At the end of his one year at the Slade Jacob obtained certificates in drawing and in perspective, and Sadler wrote, 'I am very glad to hear of your success at the Slade and congratulate you on having won this encouragement. Those of us in Leeds who know your work will always be happy in hearing of your good fortune. I should much like to see your study for the Entombment if you happen to have it with you when you are in Leeds.' Jacob's 'Entombment' must have been a powerful piece, because three months later Sadler wrote, 'if your study of the Entombment is not otherwise disposed of, I should like to make an offer for it.' There is no record of a drawing under this title, but it seems possible that it was subsequently renamed 'Deposition' (fig. 11). The subject seems strange for a young Jew to want to capture. He may have seen the Michelangelo painting in the National Gallery, but as Jacob

was later to explain, the fact of his being a Jew did not exclude him from feeling an interest in other religions, especially Christianity. Those were times full of foreboding and given the title of Jacob's work it seems tragically apt that at the end of June, Archduke Franz-Ferdinand, heir to the Austrian throne, was assassinated and war was expected.

Sadler's good opinion of Jacob's work was not entirely shared by his teachers at the Slade, because after the one-year course there is no record of him being encouraged to enter the painting classes as Gertler, Bomberg, Rosenberg and Meninsky had done. The JEAS also seems to have had some reservations about Jacob's future as the rather formal letter from Sebag-Montefiore, dated 22 June 1904, indicates.

'I am directed by the Committee of this Society to write to you on the conclusion of the course of instruction to which the Society has assisted you ... the Committee have every hope that you will succeed in making a successful career for yourself in the profession you have chosen [and] will always be pleased to hear how you are getting on and to use in your favour any influence they may possess. I should be obliged if you will keep us informed from time to time of your whereabouts, and of how you are getting on.'

In reporting this in *The Kramer Documents* John Roberts adds that the last seven words were repeated in ink, 'as if to soften the severity of the letter.'

The fact was that Jacob did not fit into either the teaching programme or the social milieu of the Slade, where Britain's class structure was manifest. The common struggle of the impoverished scholarship- and charity-funded students drew them closer together but further from the children of the middle-class, fee-paying parents. Gertler made every effort to fit into the Bloomsbury Group with its middle- and upper- class connections and attitudes, but William Roberts, a scholarship boy with poor parents, found a common bond with the poor Jewish students, who were very sociable and drawn to left-wing politics. Sarah, who became Roberts' wife, said that her husband was fascinated by the Kramer family's interest in music and literature as well as the visual arts.

However well he tried to integrate into the social and cultural milieu of the Slade and the bohemian set, with his powerfully characteristic physical features and broken English, Jacob remained to others 'the big Jew'. More significantly, Jewishness came to dominate his vision as an artist. Unlike his Jewish contemporaries he did not pass through this stage but remained intent on exploring what it meant to be a Jew. Perhaps it was the trauma of family exile and deprivation, the fall from

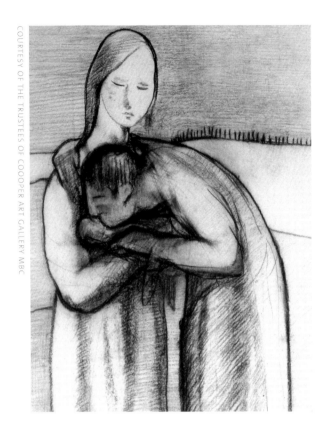

FIG. 12

Sorrow

*charcoal on paper*

1914

grace not suffered by the others, the becoming an alien, or simply the fact that he was almost twenty-one before he left Leeds for the Slade, that underlay this frame of mind and focused his identity and his creativity. As an artist and therefore an observer in Leeds he will have found the intensity of the city's Jewish spirit a powerful stimulus. However, while this focus drove his creativity it was to circumscribe his work.

Sadler continued as patron, benefactor and critic, and was persistent with requests and advice. On seeing Jacob's work in July 1913 at the end of the Slade course, he wrote to Lesser saying that he thought Jacob had turned over a new leaf and suggested that perhaps the Society could accept repayment made in pictures. He added that, 'Judged by London standards, he is exceptionally gifted.' But Haywood Rider had reservations and expressed his dissatisfaction at Jacob's failure to make the best use of his opportunities at the Leeds School of Art. Nevertheless, he added that he traced a good deal of Jacob's weakness to unsatisfactory home conditions. In October Sadler asked Jacob if he had any more drawings of Leeds. 'If so, please send them. I will buy £5 worth of those and other drawings and enclose notes for that amount in advance, as you say that it would be convenient for you to have it.

'The drawings that you have sent, with one exception, I propose to send back, as well as the oil sketch. May I urge on you the importance of carrying them a little further? I think that the treatment of the face and the head is in danger of getting mannered.

'I like one of the charcoal drawings, the two embracing figures (fig. 12) a great deal, though I don't think that it belongs to your finest work. I shall be glad to take this and put it in my collection at one guinea. I wish I felt it was worth more than this.' 'Sorrow', an awkward drawing of two women, one weeping over an apparently dead infant, the supporting figure scarcely involved in the tragedy, is hardly one of Jacob's finest works. Sadler continued in this extremely revealing letter, 'I am doing what I can to interest people in your Leeds and

other drawings, and think that a number of clients are being formed for you. I should not think it wise to show any of the drawings you have forwarded today.'

One guinea may sound a pittance by today's values, but when one considers that the average weekly working wage prior to World War I was no more than £1 10 shillings, a guinea at that time could go a long way if carefully spent. In December 1913 and subsequently at regular intervals Jacob received £6 from Lesser. That Jacob was immensely grateful for this support is shown by the words he wrote to the Society in July 1914: 'I find it difficult to express my deep sense of gratitude towards the Society …'

Sadler's son, Michael, was also deeply involved in the art world, and in Sadler's endeavours on Jacob's behalf he asked him to deliver some of his drawings to his son's house in Holland's Park, where they would be seen by a large number of people. But Sadler is also admonitory when he writes, 'I hope you won't give Mr. Lesser the impression that you are dilatory in taking lessons in painting. I would strongly recommend you, if possible, to begin at once. I think you need stringent teaching in colour. A postponement of the lessons would make Mr. Lesser and his Society suspect you of slackness, and I think it is much to your interest as a painter to get under all the best teaching influences you can find. Please acknowledge the £5 and let me know whether you accept one guinea for the charcoal drawings.' Jacob's reply to Sadler's letter was found written in pencil on the back of that letter. It is possible that this was Jacob's actual reply to Sadler; if so it would not have been well received by his meticulous patron, and it seems more likely that this was a preliminary draft of the reply proper in which Jacob wrote, 'I have received your letter and notes for £5 for which I thank you. I also thank you very much for your criticism of the small drawings and pleased to hear that you like the one with the two embracing figures for which I will gratefully accept the amount you offer. You are right about the lessons for painting and I will see Mr. Lesser about beginning as soon as possible.'

Sadler replied immediately, 'When you have done your Leeds drawing, will you kindly send it to me to look at?… I have heard from Dr. Coplans about your work. I gather that Mr. Lesser's committee think you ought to be a whole time student and not to be working for clients at all. I have written to urge them to reconsider this view. It seems to me that, though you will gain very much from good teaching in colour, you are wise to be working "on your own" as well.'

This exchange of letters clearly exposes the relationship between Sadler and his protégé. Jacob continues to be seen as unreliable both in managing his affairs and in his attitude to his work, which, if Sadler's

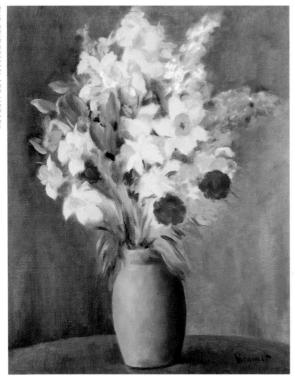

FIG. 13
Still life with spring
flowers in a vase
*oil on canvas:*
*61 x 50.9 cm*

judgement is to be relied upon, seems at this time to be very uneven, requiring persistent urging to improve his painting skills. Even Dr Coplans expressed his anxiety about the JEAS's attitude to Jacob, writing 'I hope the committee will not cast him adrift.' With Sadler's advice the Society agreed to support Jacob for another six months. Yet at this time Jacob does not seem to have been dilatory in repaying the JEAS: in April 1914 their account rendered was for £184, but in December it was down to £118.4.0.

Despite Sadler's anxiety about his painting skills, proof of Jacob's successful use of colour was to be amply demonstrated in his still-life work, such as the 'Still life with spring flowers in a vase' (fig. 13), and in his beautiful 'Japanese Maiden' (fig. 14) painted in 1918. Jacob painted several pictures of Japanese women; who they were is not recorded, they were perhaps imaginary. It is possible that in choosing this subject, Jacob, like his hero Van Gogh, was influenced by the direct and strong effect of the coloured Japanese prints that had so influenced European art in the nineteenth century.

There is little certain record of any of the work that Jacob actually executed at the Slade, but in his essay 'Jacob Kramer 1892–1962' in the *Jewish Quarterly* (1962), the writer Joseph Leftwich recalled, 'Goldstein brought out some of Kramer's life drawings done at the Slade, that he had kept. They were like old masters or Augustus John. In front of us all Kramer tore them to pieces. That was not the kind of work he wanted left to indicate his quality in art. His whole group was in revolt.'

During his course at the Slade Jacob was splitting his time between London and Leeds where he spent time drawing Sarah who was then thirteen. She was a very attractive and vivacious girl, the perfect model, and Sarah recalled that she sat up late into the evenings, even 'as late as ten o'clock' dressed as a gypsy. 'He did lots of pastels which were bought as they were done by a firm in Bradford called Matthews and Brooke and the proceeds from these seemed to keep all of us although they were only about a pound a time. Jacob was easy to sit to and the

FIG. 14
Japanese Maiden
*oil on canvas:*
*76.2 x 63.3 cm*
1918

sittings did not last long; but though so many were produced they are now difficult to find.... [It] was no help to my schooling as my homework suffered. This meant that I had to present a note to the Headmistress of Thoresby High School. As my parents only wrote Yiddish or Russian, someone else had to write the note, which one of them signed.'

Evidence of Jacob's hard work during his time at the Slade was later demonstrated at an event of great importance to him, his exhibition with Fred Lawson at Leeds School of Art when he showed well over fifty drawings, most of them figure drawings.

During her school holidays in that year Sarah would come to London to stay with her brother. On one visit they arranged to meet at the ABC teashop in Tottenham Court Road, 'a favourite place for hard up students, especially for the lumps of farmhouse cake, fruity and large,' and Jacob arrived with two young men, Bomberg and William Roberts, who were good friends. Jacob was obviously very proud of his young and beautiful sister, and as Sarah wrote, 'He showed me off like a jewel … it was very embarrassing.' and 'So it was then that I met my future husband. It was then that I first saw the drawing of Jacob by Bomberg.' This was shown in the 1984 exhibition, 'Jacob Kramer Reassessed' at the Ben Uri Gallery and Leeds City Art Gallery. But while Bomberg was portraying the Jewish urban environment, Jacob was more concerned with personal character and mood such as we see in his studies of heads and the charcoal portrait of Herbert Read.

During his time at the Slade Jacob exhibited in Doncaster again and had four drawings shown at the Whitechapel Art Gallery, but the fact that Jacob's time at the Slade had not been dedicated entirely to art was confirmed by Sarah in an interview with the gallery curator, Agi Katz, when preparing for the Ben Uri exhibition.

Sarah, then in her eighties, reported that her brother had been 'a very naughty boy' during that time, and Jacob himself confessed to Ron Lipman, then a young Leeds artist, that he and his fellow students were

'wild.' Neither Lipman nor Sarah went into details. There is no record of Jacob's relationship with women at that time; he certainly smoked and drank a great deal, but Sarah implied that this naughtiness had included fighting, and she added that there must be lots of little Jacobs around.

At this time anti-Semitism was endemic in society and the Slade was not immune. As Irving Grose recorded in his introduction to the exhibition, 'Jewish Artists of Great Britain 1845–1945,' 'Isaac Rosenberg suffered anti-Semitic assaults, physical and verbal, at the hands of Alvaro Guevara. Bomberg had refused to submit to similar torments and had blacked Guevara's eye. Kramer, apparently tired of seeing the non-violent Rosenberg humiliated, one day beat Guevara up and Rosenberg was troubled no more.' Jacob loved to box and all his life went to boxing and wrestling matches. According to the poet Roy Campbell, Jacob had the biggest fists that he had ever seen, fists that appeared a few years later when Epstein used Jacob's hands and feet for his statue of Christ. In all the many tributes to Jacob in *A Memorial Volume* his gentleness is emphasised repeatedly, but his temper was labile and it might not have taken extreme provocation to bring those giant fists into action. In the build-up to the war anti-Semitism was rife and such provocation was all too common. Jacob fought with many of his fellow artists, many very right-wing and anti-Semitic, such as Wyndham Lewis and Henri Gaudier-Brzeska, as well as the American poet, critic and bohemian, Ezra Pound. He was one of the most powerful promoters of 'modernism' and wrote enthusiastically about both James Joyce and T S Eliot, but he was to be a pro-fascist broadcaster from Italy in the Second World War.

Inevitably the artists made portraits of each other. Gaudier-Brzeska made portrait busts of Wolmark and Brodzky, and the latter made a rather bucolic crayon drawing of Epstein at the Café Royal, as well as a pencil sketch of a pensive Jacob. As testimony to their friendship, Bomberg made one of his very few portraits, a charcoal one of Jacob, and some years later Epstein was to make his famous sculpture portrait bust of Jacob. The painters mixed with Jewish writers such as Israel Zangwill, poet, thinker and author of *The King of the Schnorrers* as well as other acclaimed novels about Jewish society, and Joseph Leftwich, translator of Yiddish works, at such hothouses of social and artistic revolution as the Whitechapel Library, Toynbee Hall and the Ethical Society, where matters of political, literary and artistic consequence were fiercely debated. Fabianism, Socialism, Bundism (Jewish Socialism), Communism and Zionism were only a few of the 'isms' that had their devotees and protagonists, but for the young painters the various artistic movements of that time will have dominated discussion. Years later Herbert Read was to write about this time of ferment:

'You must try to recover the creative enthusiasm of those years immediately preceding the First World War. Cubism had just effected a complete break with the artistic traditions of the past. In Paris and Munich great artists, Picasso, Braque, Leger, Kandinsky, were arousing our enthusiasm with their daring innovations. The excitement reached England.

'Such was the atmosphere in which Jacob and I first met and joined in lively discussion [at the Leeds Arts Club]. I, in my youthful enthusiasm had been swept into the vortex; Jacob had his own firm position on the edge of it and was not to be seduced by any manifestos that ran contrary to his nature.'

But how was Jacob to express that nature? As he completed his time at the Slade Jacob was searching for his own mode of expression; how was he to find a personal meaning in his work in the ferment of ideas and styles to which he was exposed? He admired the boldness of Gauguin and Van Gogh, who, he said, 'expressed in their own way what they felt … to produce the fullest symbolism.'

At the end of that auspicious year Sadler sent Jacob £6 and gave his movements over the Christmas holidays so that Jacob could see him in Leeds.

# 6 MOTHER AND CHILD

In 1914, through his contacts with the other Jewish artists, Jacob was included in the Jewish section of the Whitechapel Art Gallery exhibition, 'Twentieth Century Art: A Review of Modern Movements'. It is significant of social attitudes of that time that Jews were seen as separate even within the art scene. Bomberg had previously accompanied Epstein to Paris to select prominent European Jewish artists, but the Modern Movement was not well received in some circles. A review in the *Jewish Chronicle*, describing the group as in revolt, said about Gertler that after a brilliant career at the Slade he had his moments of rebellion, that Bomberg's work was merely a waste of good pigment and wall space, and that 'if his intention was merely to startle the public he had certainly succeeded', and Kramer, with his simplification of colour and line 'gave a lumpish earthy quality to his people'. A crucial stage in Jacob's career was reached when he exhibited as a non-member at the New English Art Club winter show of 1914–15. By then the Club was in decline and soon to be replaced as the vanguard of British painting by the London Group, a disparate association of small groups dominated by the Camden Town Group with such luminaries as Walter Sickert and Spencer Gore.

Chance played a part in the next stage of Jacob's career. As he reported it, 'The first "big" money I earned was when I sold a small Reynolds portrait of William Hazlitt, which I found in Hunslet [a poor part of Leeds] of all places, to a wealthy student, for £4, and with the proceeds I bought a huge canvas on which I painted one of my best and one of my first big pictures.' It was his first major work, the controversial 'Mother and Child' , which, through the efforts of Augustus John and Jacob's teacher, Ambrose McEvoy, and against much resistance from other members of the New English Art Club, was shown. Jacob produced several versions of the theme. One preparatory charcoal drawing has the central figures of mother and infant; the young mother's face, positively Mongolian, is weary, the infant at the breast minimally drawn. There is another small stooping figure in the distance (fig. 15). The final oil painting is defiantly Post-Impressionist (fig. 16). Jacob

FIG. 15
Mother and Child
*pencil on paper:*
*60.2 x 48.4cm*
1914

has simplified form and eliminated detail to create a powerful expression of the theme of motherhood. In the foreground is the monumental figure of a young peasant mother cradling her baby at the breast, perhaps pregnant again. Her Mongolian features, eyes closed, present a picture of placid contentment. In a bright blue jacket she seems to be isolated from the simple background, a wheat-field (Ukrainian perhaps, a recollection from childhood), a symbol of fertility, its colour the yellow of serenity and contemplation. There is a synthesis in the flesh of the mother's breast and the baby's face and hand, together with the mother's face and hand, the unity of the mother with the new-born infant, which makes it an image of motherhood that shows no deference to the genteel tastes of the day. Painted with the strength of simple line and strong contrasting colours it must have seemed alien to many in the Club; no wonder the NEAC resisted its hanging. Lucien Pissarro commented that the picture of the mother openly breastfeeding her infant lacked taste. But with four siblings born since he was eight years old, it was an image burnt on Jacob's memory.

One year later, in June 1916, a reproduction of the painting appeared in the art magazine *Colour* but without any mention in the text. However, in *Colour* of January 1918, the critic 'Tis' wrote a very sympathetic review:

'To the mind of deeper sympathy and insight the picture reveals a simple dignity of arrangement… really touches some tender chords in the hearts …. He "speaks"in simple lines and colours; yet the impression is not flat; the figure has solidity and weight, and is "in air". To a certain degree its colour is more than colour, it has psychic significance…'

In looking back on this work the *Yorkshire Post*'s art critic, William Oliver, suggested that it must have been 'one of the first Post-Impressionist paintings to emerge in this country.'

Jacob described the picture as 'my first real work' and his friend Tommy Lamb, in his essay on Jacob Kramer for the Leeds Arts Calendar of

winter of 1950, recalled that about twenty years after painting 'Mother and Child' Kramer 'rediscovered' this early work in the Wakefield Gallery, to which it had been loaned by a private collector and hung in the West Ridings Artists' Exhibition. Jacob described it 'as remarkably free from sickly sentimentality; roughly it is meant to portray the growth of things.'

At that time it was almost obligatory to pay a visit to Paris, the capital of European art. In 1913 Bomberg and Epstein with Mark Weiner, one of the 'Whitechapel boys', had made the trip and met Picasso, and in the introduction to the catalogue to 'Exhibition of the work of Jacob Kramer' at Leeds Art Gallery in October 1960, there is a report that Jacob 'paid the inevitable visit' to Paris. There is no confirmation of such a visit at this time, but when Jacob returned to France in 1932 to paint Delius, the report indicates that he met many old friends. Although Jacob seems to have resisted the urge to follow Bomberg, Roberts and Nevinson in their experimentation with Cubism, in one way or another Cubism did enter his work, as in 'Shylock' (fig. 17). This is a strongly stylised, Cubist figure against an Abstract background. It is a very disturbing image of shame, guilt and submission, the angle of the head easily seen as that of a hanging man against a background of rectilinear shapes. It is the product of anguish, not Shakespeare's Shylock, a courageous and stubborn man, but the Hanging Man of the Tarot pack. In this small composition we seem to be looking at the roots of some of the figures in his famous work, 'The Day of Atonement'. Jacob's 'Shylock' also reflects his awareness of the Jew's alienation in contemporary Britain, which is expressed in a poem, 'The Jew', by the poet-painter, Isaac Rosenberg:

> *Moses, from whose loins I sprung*
> *Lit by a lamp in his blood*
> *Ten immutable rules, a moon*
> *For mutable lampless men*
>
> *The blonde, the bronze, the ruddy*
> *With the same heaving blood*
> *Keep tide to the moon of Moses*
> *Then why do they sneer at me.*

Shakespeare's line in *The Merchant of Venice*, 'If you prick us do we not bleed?' is not far away, and so much of Jacob's work in the next few years expresses the trials and tribulations of his people.

A charcoal drawing of a Rabbi is even more simplified than Shylock, indeed it is reduced almost to cartoon form, perhaps another early

attempt to reach 'the form' behind 'the shape' that was to be the theme of Jacob's article, 'Form and Shape,' which appeared in 1919 in the magazine *Renaissance*.

According to Frances Spalding, if anyone influenced Kramer at this time it was Mark Gertler, who although he had left the Slade before Jacob arrived, was nevertheless a friend; indeed Gertler was able to ask his patron, Edward Marsh, Churchill's secretary, to buy one of Jacob's pictures for £5 so that Jacob could return to Leeds. Gertler wrote, 'He is almost penniless and wants to go back into the country to see his people for next week, which is the Passover.' Spalding writes that, 'Gertler had begun to employ harsh angular modelling to emphasize the poverty of his East End Jewish sitters. Kramer must have realized that this reductive style well suited the expression of hardship or of stark mental states.' Simplification could reveal feeling that would be lost in elaboration. Gertler and Kramer were not alone in this approach; other artists were searching for a means of expressing something fundamental behind the appearance of things. In trying to portray his 'machine-age environment' Bomberg wanted to find 'an Intenser expression' and said, 'where I use Naturalistic Form, I have stripped it of all irrelevant matter.'

Although discipline at the Slade had not been rigorous it provided a framework that ordered Jacob's life, and leaving the Slade marked the end of a fairly well structured time for him. The summer of 1914 had been a time for making difficult decisions: should he pursue further instruction in painting, as Sadler believed he should, or must he leave London and return to Leeds and to his family? Jacob even considered trying to bring the family to London, but that would have been very difficult if not impossible. Although only fifty-one Max Kramer was not in good health, Jacob's sisters, Sarah now fourteen and Millie ten, and Isaac, possibly about nine, were still at school, while little Leah, being mentally handicapped, needed constant care. As many of Jacob's drawings of his mother demonstrate, Cecilia in the years of their exile had been worn down by the conditions of their life. When the JEAS tried to contact him at his London address, 18 Howland Street, off the Tottenham Court Road, in January 1915, Jacob finally replied that he had been in Leeds because both his parents had been seriously ill. Further letters to Howland Street were returned unopened.

The family filled their little house in Chapeltown and this further compounded the problem for Jacob. He was needed in Leeds but he needed space, both personal space and a place to work. London had provided these necessities, so how could he return to Leeds? But return he did. This was a dilemma which Jacob shared with many painters from the provinces, whose attachment to their

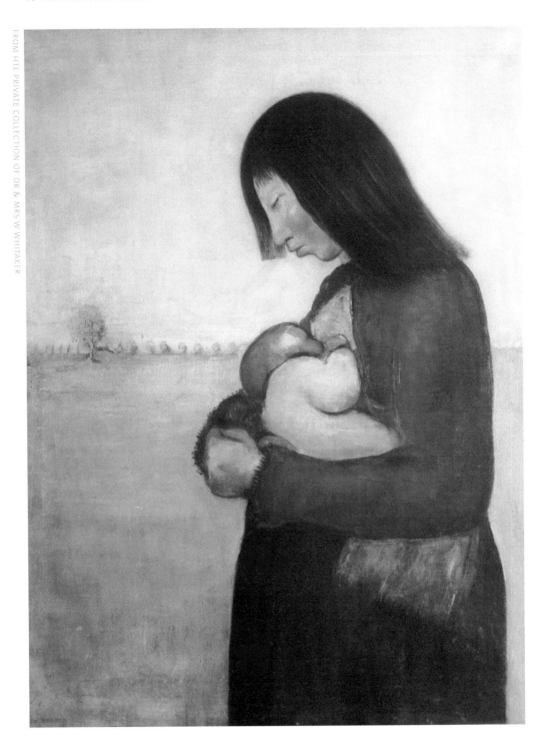

FIG. 16
**Mother and Child**
*oil*
1915

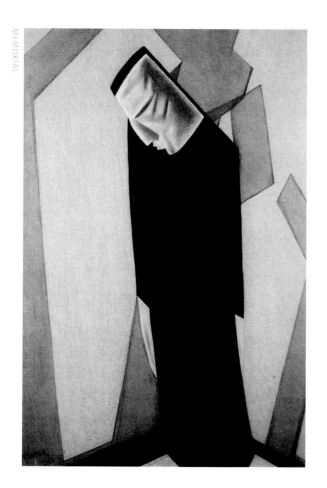

FIG. 17
Shylock
*pastel study for oil:*
*24 x 16½"*
C 1914

origins conflicted with the opportunities that the wider world offered. Gertler and Bomberg seem to have had the strength of purpose to make the break with the past while at the same time using Jewish themes and references in their work, Rosenberg was killed in the war, and Meninsky made a clean break with Judaism, at least in his work, but Jacob, possibly the least secure of all his Jewish contemporaries, having lost one home never seems to have found another. He lived in rented accommodation all his life.

Jacob has been described as a bohemian by Epstein and many others, indeed that is what he came to be. This was a persona, whether achieved unconsciously or contrived, with which he was comfortable. The bohemian life that Augustus John had adopted, as well as the gypsy theme of his drawings, acted as models of lifestyle and art object for Jacob. Also his restless temperament promoted an irregular and unconventional life, and on his return to Yorkshire he settled into that unsteady pattern of living that persisted throughout his life. Fortunately Jacob's reputation as a portraitist was getting around to the local celebrities of Yorkshire.

# 7 THE WAR

On 28 July 1914 Austria declared war on Serbia and war between
Britain and Germany was declared on 4 August amid great excitement
and manifestations of ardent patriotism. When Edward Grey, Foreign
Secretary of Great Britain, watched from his window as the lights went
out in Whitehall, he said, 'The lamps are going out all over Europe.
We shall not see them lit again in our lifetime.' But the perspective of
the man in the street was more optimistic and patriotism brought over
a million men to enlist by the end of 1914. Inevitably foreigners were
identified with the enemy, there was a 'spy fever' and as soon as war
was declared all Germans living in Britain were arrested.

Immigrants were easy to recognise and in the Jewish areas of London,
Manchester and Leeds outbreaks of violence against Jews were common.
Jacob with his size, obvious Jewish features and foreign accent could
hardly escape being recognised as alien. Although by now hardly a
practising Jew and making very infrequent visits to the synagogue –
as Sarah said, 'After our youth, when he trailed to the synagogue in
the Leylands [probably only to please his parents], I don't believe he
went to a proper service' – Jacob was immensely proud of being a Jew
and would not have responded to insult by turning the other cheek.
Anyone making anti-Semitic remarks would have met with a swift
and unexpected response. As Wyndham Lewis was to say about
Jacob's relationship with Augustus John, although they were friends,
their friendship 'was not immune to fist fighting.' Indeed the whole
community of artistic bohemians, poets as well as painters, had a
reputation for brawling, especially when in drink, and Jacob himself
was credited by many, including Wyndham Lewis and the poet Roy
Campbell, with being a fine boxer. Jacob's painting of a boxer and
vigorous charcoal drawing of wrestlers shows his admiration for these
sports (fig. 18). At this time of considerable anti-Semitism self-defence
was a common interest for the young Jewish men in the East End
of London, and there were many Jewish professional boxers, one of
whom was Bomberg's brother, 'Mo'. Later the formation of the Jewish
regiment clearly established which side British Jews were on.

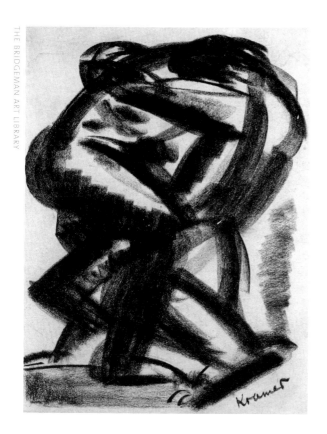

FIG. 18
The Wrestlers
*charcoal on paper:*
*40.5 x 29.1cm*
1928

Many artists, inspired by patriotism and ideas of adventure and heroism, volunteered for service in the first months of the war. Some, such as the brothers Paul and John Nash, were already members of a peacetime group, the Artists' Rifles, and made expert infantry-men, other artists joined the Royal Army Medical Corps. Early in 1915 Isaac Rosenberg and Bernard Meninsky volunteered for the infantry, the latter joining the Royal Fusiliers which was mainly a Jewish regiment, and later in that year Bomberg enlisted in the Royal Engineers. Their motives were mixed: they joined up partly because they had no work, were hard up and needed the army pay, but also because it meant that they were doing their bit. Jacob might well have felt some guilt at not being with them in the Forces; although he was technically a Russian he could have volunteered.

Unlike the Vorticists, in particular Wyndham Lewis, who viewed war as a necessary part of human activity, the idea of war was abhorrent to Gertler who declared himself a pacifist. Herbert Read, who, as a student at Leeds University, was a member of the Officer Training Corps, joined up in 1914 to be commissioned early in 1915. In that year the liner *Lusitania* was sunk by a German submarine, German shops were looted and the performance of German music was banned; however, Sir Henry Wood insisted on playing Wagner at his Promenade Concert. Interestingly at this time the nation's high levels of alcohol consumption were so worrying that Lloyd George, then Minister of Munitions, believed that they were seriously affecting munitions production. Perhaps the war induced a feeling of devil-may-care, but also many people involved in the war effort were probably earning more than they ever had done.

London was suffering air attacks, some from those awesome ships of the air, the three-hundred-feet-long Zeppelins. London Underground stations were used as air-raid shelters, and so rapid had been the German attack on France that within five or six weeks of the outbreak

FIG. 19
Page of studies
of bearded man
with two studies
of hands
*black chalk*
1916

of war the German army was at the River
Marne on the outskirts of Paris. Soon after,
the killing fields of the Battle of the Somme
were to start, yet in none of Kramer's work
is there any reference to these dreadful
events. As Sarah wrote of her brother, 'Jacob
believed his life was a world that was to be
arranged to suit none but himself,' and at
this time his world was full of Jewish images.

'Tense, haunting, strange and compelling':
the adjectives Frances Spalding uses to
describe them might be applied equally to
images of war, but Jacob's obsession was for
the spirit of Judaism and the suffering of the
Jewish people. The only relief from this lay
in portraiture. This was a time when other
painters – Duncan Grant, Vanessa Bell, the
members of the Camden Town Group – were
painting the urban landscape and interiors, the banalities of domestic
life highlighting individual mood and loneliness. Jacob's work seems
singular in that in almost all of his paintings and drawings the central
image is alone without a setting. Details of the kitchen held no magic
for him, and in attempting to catch the 'spiritual essence' of the sitter,
background would have been an irrelevant distraction. This was a
time when Freud's work on the unconscious was becoming known
and the focus of interest for many artists. The psychological state of
the individual subject was being portrayed, and although this might
be the same as the 'spiritual essence', it is likely that Jacob would
argue that he was after something even deeper than the psyche.

Artists were constantly forming groups of the like-minded and
then re-grouping, and in 1913 the Camden Town Group of painters,
formed in 1911 under the presidency of Spencer Gore, amalgamated
with other small groups to form the London Group, a name suggested
by Jacob Epstein. Subsequently this group absorbed the short-lived
Vorticists.

In 1911 the Futurists, an Italian movement that promoted art
representing the dynamism of the machine, movement and the
transience of the modern industrial world, had issued their Painting
Manifesto. As a response to this, on 21 June 1914, Wyndham Lewis,
who had his own ideas about what art of that time should express,
produced his first issue of the magazine *Blast*, with its satirical
comments on British institutions, puncturing pomposity and
complacency, particularly in English art. This issue published the

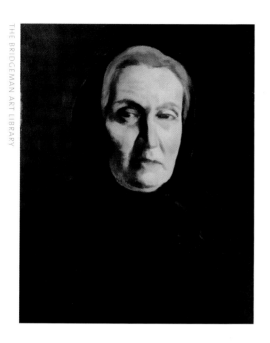

FIG. 20
Portrait of the
Artist's Mother
*oil on canvas*

manifesto of the 'Great London Vortex', signed by 'the Vorticists', amongst others, Charles Nevinson, the only English Futurist, William Roberts, Wyndham Lewis, Edward Wadsworth, the sculptor Henri Gaudier-Brzeska, and the poets T S Eliot and Ezra Pound, both American. Pound was an aggressive and articulate journalist, who, in emphasising the complications of modern life, wrote that 'The Vortex is the point of maximum energy.' London was indeed the vortex drawing its energy from the periphery, the centre to which those from the provinces were drawn, but David Bomberg and Jacob Kramer did not sign. Although both of them, and especially Bomberg, were influenced by the movement, they were to make their own individual and very different journeys. Their roads did not follow the short and eccentric path of Cubism-cum-Futurism-cum-Expressionism that was Vorticism, full of energy, hard edged and angular. Nor did Epstein join, although his sculpture 'Rock Drill', an ode to inhuman mechanisation (despite the embryo in its ribcage), met all the Vorticists' criteria, and was to be described by Augustus John as 'altogether the most hideous thing I've seen.'

The first exhibition of the Vorticist Group opened on 10 June 1915 at the Doré Galleries in New Bond Street proclaiming its aims as '"Activity" as opposed to the tasteful passivity of Picasso, "Significance" as opposed to the dull or anecdotal mode of the Naturalists, "Essential Movement" and "Energy" as opposed to the imitative cinematography of the Futurists.'

Although not a member Jacob was perceived as being in sympathy with the aims of the group, and in *Blast 2*, Wyndham Lewis included Jacob's very crude satirical cartoon, 'Types of the Russian Army'. He was also invited to exhibit four works called 'Man and Woman', 'Pebbles', and two drawings called 'Dance of Death' and 'The Heart', all of which have been lost. But his connection with the movement was brief. It was a style that required an aggressiveness of which Jacob was not capable. (It is no surprise that William Roberts, perhaps the most dedicated Vorticist, should become an angry and curmudgeonly old man.) Lewis promised Jacob that some of his work would be included in *Blast 3*, but this was not to be. As Lewis wrote, 'All of Europe was at war and a bigger blast than mine had rather taken the wind out of my sails.'

Earlier in 1915 Jacob's application for membership of the London Group was accepted. Significantly, Gertler, Roberts and the Rothenstein brothers, William and Albert, were among those rejected. The secretary of the London Group, Edward Wadsworth, who was enthusiastic about Kandinsky's ideas, sent a postcard to Jacob dated 22 February telling him the good news. Wadsworth also wrote that the next exhibition would be held at the Goupil Gallery on 6 March. Sending-in day was to be 1 March when four works could be sent but would not be hung unless the £1 subscription had been sent beforehand. Wadsworth also made it clear that an eight-foot limit on picture size would be strictly enforced. Jacob's inclusion in the London Group was a great step forward, a recognition that he had something to offer to the modern movement.

At this time when in London he was living closer to the centre, off the Tottenham Court Road at 18 Howland Street, a short electric tram ride from Trafalgar Square and the National Gallery. He was as impecunious as ever and he wrote immediately to Sadler for help. Within days Sadler sent him a cheque for £10 'in view of your difficulties,' and asked him to send a receipt.

To the London Group exhibition Jacob sent a picture entitled 'Earth' which received qualified, even mystified, responses from Frank Rutter and Wyndham Lewis. Rutter wrote, 'Controversy will, doubtless, rage around the second exhibition of the London Group which has just opened at the Goupil Gallery (5 Regent-street) for it contains many provocative canvases. On entering the first room attention is at once compelled by Jacob Kramer's "Earth". This mad medley of dancing figures indicating different races, may be to some extent expressive of the madness which rules the world for the moment; but its powers would not have been impaired by its having a more coherent design.'

FIG. 21
The Blind Beggar
*etching: 10.1 x 15.2 cm*
1918

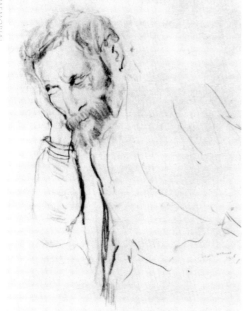

FIG. 22
Artist's Father
(Asleep)
*pencil*
1916

FIG. 23
Portarit of the Artist's
Mother (Asleep)
*charcoal*
1917

In his review in *Blast*, Wyndham Lewis approached the picture with
some caution: 'Mr. Jacob Kramer shows us a new planet risen on our
horizon; (he inaptly calls it the Earth, which it is not). It is still rather
molten, and all sorts of objects and schools are in its melting pot.
It has fine passages of colour, and many possibilities as a future
luminary. Several yellows and reds alone, and some of its more
homogeneous inhabitants, would make a fine painting. I have seen
another thing of his that confirms me in this belief.' Perhaps in this
last phrase Lewis was referring to the Mother and Child painting, and
in 'a future luminary' to Jacob's potential so manifestly demonstrated
in that painting.

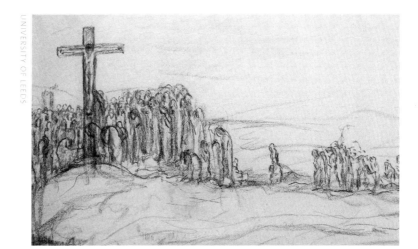

FIG. 24
Crucifixion
*charcoal & chalk:*
*63.5cm*
1916

FIG. 25
The artist's mother
'de profundis'
*pencil: 46 x 38.5cm*
C 1925

FIG. 26
Study of Christ
*charcoal: height 63.5cm*
1915

In Yorkshire Jacob was on safe ground and among his six exhibitions in 1915 was one of eight drawings at the Yorkshire Union of Artists, images of the familiar, almost exclusively the people around him. These were executed in economic materials, mainly charcoal, coloured chalks and pastels on paper or cardboard. As always he drew his sisters, Sarah and Millie, seated, standing, dancing, even Sarah as a gypsy reading a book, always vital and gay, and the pictures are, as Ben Read has described them, 'free, charged with emotion and the epitome of Bohemian outsiderness.'

Several elderly Jews were asked to sit for one pencil study of heads in the manner of Leonardo (fig. 19, page 52), one of whom, a Jewish beggar, was frequently invited to join the Kramer family for a meal. This man could well be the same beggar who figured in later drawings under different guises, such as a 'The Blind Beggar' (fig. 21). The many portraits of Cecilia depict a sad and ageing woman (fig. 20). Max was not an old man, at fifty-five he was in middle age, and one of Jacob's most moving drawings is that of his father sitting asleep with his head resting on his right hand (fig. 22). The pencil strokes seem gentle on the paper as though Jacob did not wish to waken the sleeper. It is a picture of a weary and vulnerable man drawn with great affection and tenderness, and with Jacob's 'Portrait of the Artists' Mother (Asleep)' (fig. 23) of 1917, ranks among the most beautiful and sensitive of all his drawings. Jacob knew what the fifteen years as a refugee in Leeds had taken out of his parents, especially his father. Max had been spiritually crushed and Jacob was determined to avoid that fate.

FIG. 27
Head of Christ
*charcoal: 31.8cm*
1934

The times were not conducive to the patronage of artists, but Sadler was always ready with support. However, such support was always given with caution. In June he wrote to Jacob, 'I am glad to do what you ask. Enclosed is a cheque. Please sign and return to me the enclosed acknowledgement. When you come to Leeds, I shall be glad if you will bring with you a good selection of your drawings, etc. I am glad to hear that you have some commissions in Yorkshire,' and he went on to say, 'The war is a hard time for you, but you will be glad to find that your work has been favourably noticed by many who have seen it.'

Jacob was always preoccupied with the identity of the Jew, and as for most other Jewish artists of the time, the idea of identity was largely illuminated by two thousand years of persecution and suffering, and stories of recent tragic years, told and re-told to Jewish children by grandparents, parents and neighbours. There was little of the courage, strength and flexibility that made for survival, characteristics that were to be found in the work of Jewish artists of later years, after the foundation of the State of Israel.

In several important works Jacob made images of suffering, as in 'Crucifixion' (fig. 24), and using his mother as model, the suffering of the Jews during the pogroms (fig. 25). Although this drawing has been given the unlikely date c1925, this picture of anguish is much more likely to date from the time of his pre-occupation with Jewish suffering culminating in 'Here Our Voice, O Lord Our God' of 1919. Other images were of Christ, a subject that was to pre-occupy him for most of his life. When in 1914 Jacob's first drawing of Christ was returned to him from exhibition in London, he tore it up, saying, 'It is not good enough.' A second attempt to portray Christ, a benign old bearded man with large soulful eyes, failed to satisfy him (fig. 26) and a third started seven years later remained unfinished. Years later when questioned in a newspaper article about a Jewish artist's interest in Christ, he replied, 'You think that it is strange that I, a Jew, should spend nearly all my mature life trying to express Christ … and yet, why not? I am not an orthodox Jew. I have a respect for all religions. My Christ is to be a – a symbol of – what shall I say? – of the problem of suffering; a theme universal to all mankind – Jew, Christian, Mohammedan alike.' Jacob had read and studied the Gospels, and according to his friend, the Reverend Elborne, he came to believe that

Christ was the greatest Jew ever born. Nevertheless he was never happy with his attempts at portraying Christ, perhaps because, as a Jew, Jacob could envisage Christ as a great rabbi, but hardly as divine. In a later charcoal line drawing, Christ's head is seen as simple and strong, even heroic, filling a light-blue rectangle rising out of a less clearly defined mass of people (fig. 27). In the catalogue to the Centenary Exhibition of Jacob Kramer's work, Ben Read describes this image as being like the '"Nietzschean superman" rising above and eventually shepherding the masses.' This may be so but the drawing appears to have had a more banal and simple origin, that is a cinema audience watching a huge screen onto which the head of Christ has been projected. Jacob was very keen on all sorts of popular entertainment, such as boxing and wrestling, and especially the theatre, and although he did denounce the possible corrupting influence of the cinema on the young, it is more than likely that this modern theatrical form, the picture show, enthralled him.

In 1915 Jacob had enjoyed a very busy and rewarding year, dividing his time, as he was to do for the next few years, between Leeds and London. His work was improving but not consistently enough to satisfy Sadler, who wrote to him in December, 'I am glad to hear that you are quietly settled in the country and able to get on with your work. The picture which you left for me to look at is a beautiful work but I do not feel able to add it to my collection. P.S. If you will send for the picture, it will be given to you.'

# 8 'THE JEW'

In his poem, 'Peace', composed in 1915, Rupert Brooke wrote:

> *Now God be thanked Who has matched us with His hour*
> *And caught our youth, and wakened us from sleeping.*

The poem captures the spirit of national revival and resolve in the face of a hated enemy; but it is also an expression of the purpose found in combat by many educated young men who had found little meaning in their lives before the war. The Gallipoli fiasco in the autumn of that year, in which casualties from the forces of the British Empire amounted to over 200,000 men, and the colossal waste of human life in one of the greatest tragedies in British military history, the battle of the Somme – which on the first day cost the British army 60,000 casualties, 20,000 dead, and an overall toll of over a million German and Allied casualties – must have challenged that heroic purpose. The dreadful reality of war, in cruel contrast to Brooke's romantic notions, was brought home to everyone. Feelings of heroic patriotism that prevailed at the beginning of the war were followed by disillusion and despair, clearly expressed by the poet, Charles Hamilton Sorley, when he wrote:

> *When you see millions of the mouthless dead*
> *Across your dreams in great battalions go*
> *Say not soft things as other men have said …*

From every wall posters shouted, 'Your country needs you,' and the men came in their hundreds of thousands. But the voluntary tide of human fodder was insufficient and on 24 January 1916 compulsory military service was introduced, to be extended in March to married men. One Cabinet Minister called for conscription for men up to the age of sixty. It was a fateful year for so many families, including the Kramers.

Jacob was twenty-three and many of his contemporaries were in the forces, some in the medical teams behind the lines. Nevinson was already at the front painting dramatic pictures of the wounded as in

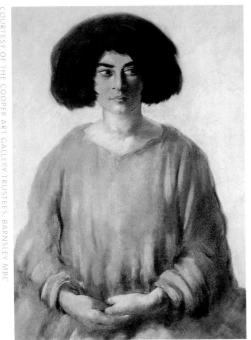

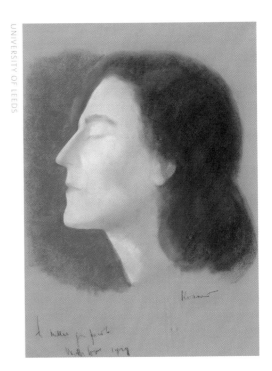

FIG. 28

Sarah

*pastel & wash*

1917

FIG. 29

Millie, the

artist's sister

*pastel*

1929

the sombre and geometric 'Night Arrivals'; Stanley Spencer was to paint the extraordinarily haunting 'Troops arriving with Wounded at a Dressing Station'. Bomberg would draw the Vorticist work, 'Sappers at Work', while Meninsky was drawing heavily burdened soldiers always waiting to go to some unknown destination. Gertler, like Bruce Turner, was a conscientious objector, and lucky not to be imprisoned as Turner was, an experience that almost destroyed him. Jacob would never have followed that path. As a foreigner he was at that time unacceptable to the Services, and to be in limbo at such a time must have been bewildering, even painful. The situation forced on him questions of identity, a Ukrainian Jew at home in England, a country now at war and allied to his old country, Russia. How could he define himself? He was scarcely a practising Jew, but as Isaiah Berlin wrote:

'All Jews who are at all conscious of their identity as Jews are steeped in history. They have longer memories, they are aware of a longer community than any other which has survived. The bonds that unite them have proved stronger than the weapons of their persecutors and detractors.'

Jacob was steeped in the history of his people, in its mysticism and sadness, as well as in his own history. If he had anything to say it was not to be about the carnage of war; in his work there is no portrayal related to such a theme. Somehow, at least in his work, he seems to have been able to divorce himself from the world around him, a world

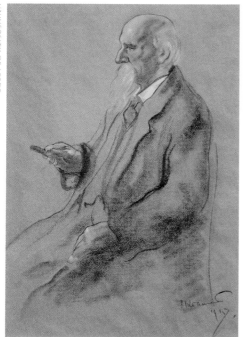

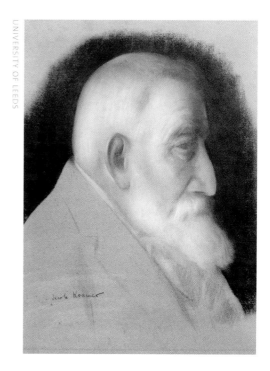

FIG. 30
Old man with a cigar
*chalk & pastel: 37.8cm*
1915

FIG. 31
Head of Old Jew
in Profile
*chalk & pastel: 47cm*
1916

of focused purpose, toil in munitions factories and death in the
trenches. Jacob created his own cocoon in which he devoted himself
to his preoccupation, what it is to be a Jew. Perhaps he saw the Jewish
story as an allegory for the history of mankind, which in its futile cruelty
and stupidity was being played out in Flanders.

Jacob was still dividing his time between London and Leeds, where
he continued to draw on his family as models, including his parents
on occasion, although Sarah remained his main model: Sarah sitting,
standing, dancing, as a gypsy or as herself, in vigorous charcoal and
pastel drawings, attractive in their immediacy and fairly easy to sell.
Jacob's most spectacular painting of Sarah is of a girl in a blue dress
with a huge bush of hair (fig. 28). By contrast his later pastel drawing
of his sister Millie (fig. 29) shows a plain and thoughtful girl without
the vivacity that he gave to Sarah. The future was to demonstrate the
sisters' very different relationship with Jacob. While keeping in touch
with Jacob, Sarah was to transfer most of her affection and devotion to
her husband, William Roberts, while Millie, unmarried, was to make
many sacrifices for her adored big brother. The years 1915–1917 marked
intense activity and the beginning of Jacob's regular exhibitions in
Leeds and Bradford. In February 1916 Jacob was one of eleven artists
to exhibit at the Alpine Club Galleries in London's West End, but
portraits of local people were his bread and butter (fig. 30), especially
as his family depended increasingly on his earnings. Alas, his portraits
were often more 'modern' than many of the sitters liked and –

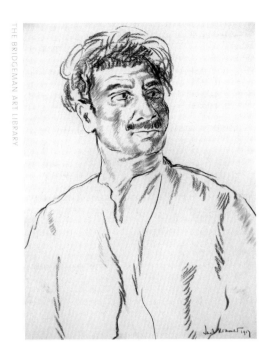

FIG. 32
A Russian Peasant
*pencil on paper:*
*58 x 44.2cm*
1917

unsympathetic to Jacob's attempt to catch the 'spirit' rather than the superficial appearance of the sitter – they complained that Jacob had portrayed them as old or ugly. However, his traditional portrait, 'Head of an Old Jew in Profile,' (fig. 31) is a sympathetic representation that would be recognised and valued by any of the sitter's loved ones. This picture when seen against the heavily stylised work that he was doing at the same time demonstrates Jacob's versatility; he had certainly not settled into any fixed style. He made frequent references to his Russian background, real or imagined recollections, as in his 'A Russian Peasant' (fig. 32), which is remarkably like a dramatised self-portrait and 'Two Jews' (fig. 33), his parents scarcely disguised as peasants. But his most effective work on a Russian theme is 'A Russian Funeral' (fig. 34).

This powerful charcoal and pastel drawing depicts a funeral procession with mourners carrying the coffin on their backs, and in its theme and horizontal composition it reminds one of Samuel Hirszenberg's dark and sombre 'Black Banner' of 1905.

Despite all the exposure that Jacob received at this time the sales in Yorkshire were not adequate to alleviate his financial burden. The war made money tight and recourse to Sadler's help was again necessary. But his money problems did not deter him from his main concern:

FIG. 33
Two Jews
(artist's parents)
*charcoal & chalk:*
*42.2cm*
1916

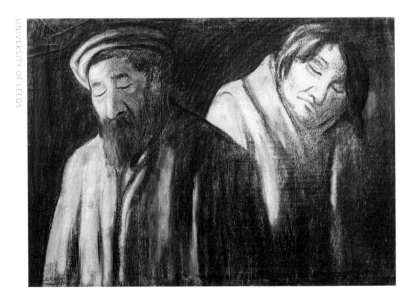

how to capture the spirit of the Jew? The result was to prove as provocative as his 'Mother and Child'.

The early preparatory sketches had been of a very simple figure in charcoal on a plain background, almost a silhouette. These were followed by an ink drawing on a yellow wash, a larger pastel work, then the final larger oil painting on canvas 'Meditation: The Jew' (fig. 35, page 66). In this the seated figure drawn in profile is almost two-dimensional in front of a flat background of yellow. The man wears the customary black gaberdine of a *Rebbe* or teacher, his back is slightly bent and the hands, which like his face are reduced to a few lines, rest on his knees. The head, skull capped, and the beard are black, the eyes closed or hooded. The figure is contained, all is still, evoking a mood of melancholy pensiveness, even of waiting, the man wrapped up in his own thoughts. There is no flesh and blood in the figure, nor is there any substance in the background. Perhaps Jacob felt that the history the image provokes was enough background, and that this was embodied in the man. The critic, Lewis Hind, in the March 1917 issue of *Colour* magazine, expressed great enthusiasm for the work likening Jacob's art to that of the Egyptians and Syrians and the 'unknown men who carved the statues on Easter Island' and continued, 'Kramer's Jew is a man yet not a man. Against a golden background a contrast, for yellow is the colour of action not reflection, this uncouth massive figure, chin bent forward, sits reflecting on what? On the thoughts that stir the deep brain of Rodin's 'Penseur' (1880) on the mystery and the radiance of life, on the only thoughts.... this silent, solitary aged-old Jew sets the emotions stirring, then the mind working. So art is shown to be part of life, in life, pervading life.' The language may be florid, though of its time, but the word 'uncouth' is completely out of

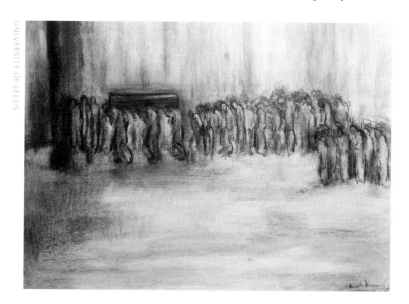

FIG. 34
A Russian Funeral
*chalk & pastel*
1916

place and not effective in its attempt to explain this enigmatic figure to a sceptical audience. In the final painting of 1916, the contrast between the figure and its background is sharp. Jacob has simplified the painting and made the background a flat yellow. Although the figure has been described as 'sculptural', it is wooden, while by contrast in the pastel drawing, presumably drawn before the oil painting, the softer, more textured and glowing background makes for a more cohesive and effective picture, in which the style is more appropriate to the subject, and its mystery is enhanced. One writer in an unintended compliment said of 'The Jew', 'it looked as if God had just moulded him out of the earth.' Eighty-six years later the critic, Brian Sewell, described 'the stark and extreme reduction of the silhouette' in the oil painting, and commented summarily 'that style overwhelmed the subject.'

The picture was sufficiently powerful to stimulate the poet, Meredith Starr, to write, in its reference to alcohol, a strangely portentous verse:

*'The Jew'*
*A Portrait by Jacob Kramer*

*He meditates the light*
*Unseen of mortal sight*
*His ways are dark as those*
*Who love the Ruby Rose.*
*He drains Celestial wine*
*From the Eternal Vine.*
*Light as lark's refrain*
*His soul is lifted up*
*To heavens beyond the brain*
*Where gods abide and sup*
*On manna that bestows*
*The secret of the Rose.*

Innovation abounded in all the arts: in music, with Stravinsky but especially Schoenberg, as well as in art and poetry. 1917 was the year in which T S Eliot's *Prufrock and Other Observations* appeared, and after Fry's exhibitions of 'modern art' in 1910 and 1912 Cubism and Abstraction were catching on in Britain. However, not everyone saw 'The Jew' in a sympathetic light; it was sufficiently alien to provoke the inevitable outraged response. This rumbled on for months and when after the picture had been reproduced in the *Evening News* and *Colour* magazine, it then appeared in the August 1917 issue of *Jewish World*, it provoked the respected Jewish artist, Frank Emanuel, a generation older than Jacob, to a lengthy response. Under the heading, 'Anarchy and Twaddle in Art', he complained of the 'constant and widespread "booming" of the infantile works of those who, if not totally

incompetent artists, must be prostituting their art for the certain praise of the claque of critics of similar taste and calibre to their own.' In exasperation at the whole of the 'modern' movement, Emanuel continued with his wonderfully inventive but very long piece of invective:

'As a matter of fact, these tom-fools of the art and literary world are simply carrying their destructive, revolutionary and anarchistic lives and ideas into the peaceful realms of art and beauty…. With few exceptions the newspapers entrust their art criticism to one or another of those persons, and the latter misuse their role as art advisers and art instructors to the full. Editors seem to have no idea of the extent to which the farcical views and preferences of their "art men" exasperate their readers….

'I cannot believe that anyone can perceive anything Jewish about this professed "symbol of the type". The unwholesome caricature might just as well be that of an Anabaptist being throttled, a bible Christian attacked by Elephantiasis, an Atheistic lunatic suffering from adenoids, or just an ordinary cockshy representing a disgruntled "nut".'

Emanuel continued with a sideswipe at Sadler, collector of those insane Kandinskys 'Knowing who is at the head of art affairs in Leeds', before taking on Hind, who 'informs us that "this silent solitary aged-old Jew is reflecting on the thoughts that stir the deep brain of Rodin's 'Penseur'". Good golliwogs, Mr. Hind! A cardboard Jew reflecting on the thoughts of a stone sculpture, re a variety of abstruse and poetic things!'

The editor of *Jewish World*, no doubt feeling that he was in deep water, pleaded in reply, 'we are not in the least authorities… on Art… so many different points of view… exclude the possibility of… a definite standard.' But no doubt wanting to be regarded as someone open-minded and progressive, he continued, 'With deference to Mr. Emanuel and braving all his terse and fine-spun verbal missiles, we will repeat that we regarded Mr. Kramer's "Jew" as artistic, as judged by what we conceive to be the only true standard of Art…'

The editor does not make clear what he believes are the true standards of art, but others were more certain about these matters, and when Jacob sent Sadler the press cutting with Emanuel's attack, Sadler immediately came to Jacob's defence. In a letter to *Colour* magazine, under the heading, 'Mr. Kramer as artist,' he wrote:

'… As in regard to religion, so in regard to art; there are differences in sensitiveness, in inbred fineness of perception, and in power of reaction to new and unexpected stimuli among the men and women who by their lives, experience and discretion claim our respect. Hence, difference of

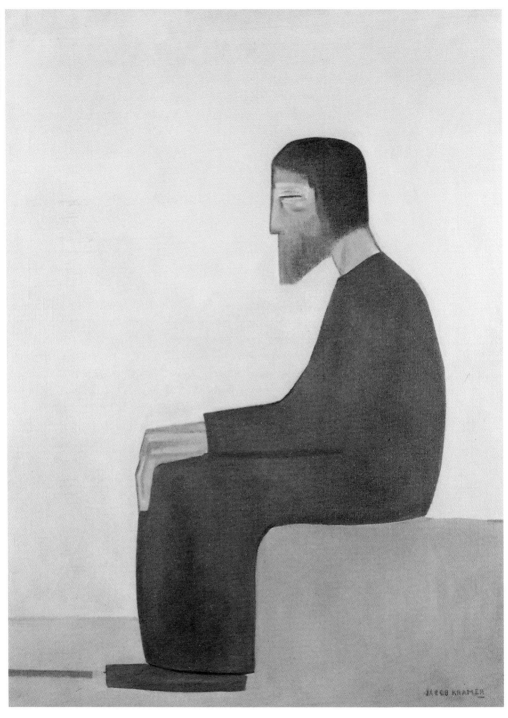

FIG. 35

Meditation: The Jew
*oil on canvas: 101.5 x 76.2cm*
1916

judgement, varieties of reaction, and sharp conflicts of opinion. Each of us is bound to keep his mind sensitive to new forms of truth; open to new appeals from significant form, colour, and tone; fastidious and yet humble; appreciative and yet critical; tolerant and yet severe; honest but not impatient. In this way only, through simplicity and self-discipline, can he keep his spirit ready to receive messages of new truth, which may come to him in strange forms and through unexpected channels.

'I admire Mr. Emanuel's drawings so much and I have learnt so much from them, that it is with deep respect for his own gift of interpretation that I deprecate his judgement on the work of Mr. Jacob Kramer. The latter I have had the privilege of knowing intimately for some years, and I can only say that the longer I live with his pictures and drawings the more they mean to me, and the more intensely do I feel the power of his creative insight. Day by day I compare them with the great painters of other schools, and find that they and Mr. Kramer's imaginative pictures and drawings, however much they may differ in method of presentation, in pattern and in colour, have in common the supreme qualities of sincerity, vision and truthfulness to personal conviction. Mr. Kramer is still young, and the gift of genius is sometimes withdrawn as years advance. But he has already done much which those who know him admire deeply, and which is a presage of perhaps greater things in the future.'

Years later these words were to be echoed by Richard E Beattie, writing in the *Yorkshire Illustrated* of September 1952, 'If genius is the ability to convey truth and beauty in a pencil's line Kramer possesses genius in no small measure.'

By coincidence in the same issue as Sadler's letter, and therefore composed before he had knowledge of Sadler's views, Emanuel continued his attack on editors, critics and Hind. '…If as you, Sir, suggest, it is impossible to appraise merit in art then all criticism must be superfluous and valueless, and I must admit that Kramer's "Jew" is as great as Rembrandt's "Rabbi" – certainly if Mr. Hind says so.'

However, embedded in this vitriol Emanuel touches on a matter of fundamental importance when he mocks Hind's interpretation of the yellow background in the painting, 'for yellow is the colour of action, not reflection,' by retorting, 'for yellow is surely more truly the colour of mustard – a quality that Jews are reputed to possess.' Then in *Colour*, the critic 'TIS' refers to the background colour as that of sunshine against which appears 'the profiled figure of a Hebrew, seated like an Egyptian statue but bent and weary with an aeon of oppression.'

In his wonderful book, *The Art of Color*, Johannes Itten shows the fifteenth-century painting, 'The Synagogue' by Konrad Witz. It is a beautiful painting in which the synagogue is symbolised by a female figure in a golden dress holding a Hebrew Tablet of the Law, against a grey background. Itten makes the point that 'The yellow of her dress symbolises the rational, logical thought and philosophical learning of the Jews,' and perhaps this is what Chagall had in mind when in 1914 he painted the yellow background for his 'Feast Day' ('Le rabbin au citron ou jour de fete'), which seems to suggest the mysterious ritual of the Kabbala. Unless the Witz painting was exhibited at the National Gallery it seems unlikely that Jacob would have seen it, but yellow was a colour that Jacob used in many of his pastel works and paintings. At this time his colour palette was fairly restricted and if the yellow is to have anything other than an aesthetic significance, perhaps it reflects that contemplative quality necessary for logical thought and philosophical learning. Certainly Jacob was a thinker, and if a spiritual reality behind the surface appearance was to be symbolised then contemplation had to be part of the necessary discipline to making images. But it is reasonable to ask, which yellow? Which of the many variations of that colour: the colour of the sun, the primrose, or the drab colour of the Star of David the Nazis would force the Jews to wear?

The aesthetic was primary to artists like Emanuel, and he was not alone in his views. When another respected painter, Mark Senior, made a further attack on 'The Jew', Jacob demonstrated that he was well equipped to defend himself. In a letter in the *Yorkshire Evening Post* he wrote, 'Many modern artists have striven – and surely succeeded – to express spiritual values. They have sought to get beyond mere technique to the "hidden essence" to which technique is subordinate. In the process they have eliminated a good deal of the technical complexity of traditional art, its crowded detail, its multiplication of the trees which prevented it seeing the wood. They have leaped at reality, and reproduced it with as little complexity as possible…. But modern art is no longer pioneering only. It has achieved, it has created. It is vital and spiritual, and provides a great contrast to the mere academy type of picture, with its niceness, its prettiness, its craven fear of reality and beauty, its frills and flounces.'

It is difficult to see how Jacob could have survived without Sadler's backing, so involved was the older man in most aspects of Jacob's life. In May Sadler wrote,

'It was a pleasure to see you again yesterday [presumably in Leeds] and to hear how good your prospects are. I am delighted that you are finding so much support in Yorkshire. Encouragement in London will certainly follow after a time.

'Thinking over what passed between us in our conversation yesterday, I feel that your wisest course would be not to set up a studio in Leeds but, if need arises (as I hope it may) to get temporary accommodation for your sitters in Bradford or at their homes.

'You asked me to let you know how much I had advanced you. This is the statement –

Oct. 21 1914 ...................................£5
less price of drawing £1 ...............£4
Nov 25 1914 .............................. £6
Feb 26 1915 ..............................£10
June 8 1915...............................£10
                                    £30

'Do not let this worry you. I am glad to have been of service to you in the difficult days when you were beginning your work. Sometime or other you will be in a position to repay the advances but there is no hurry at all. And I daresay that I may suggest taking part of what is owing in works of yours.'

It is evident that Sadler realised that Jacob's only regular source of income was to be from portraiture, and that this could easily be carried out in the sitter's home without the burden of rent. 'Mother and Child' went into a private collection, and Sadler came to possess 'The Jew'.

Then on 18 April one of the most critical events of Jacob's life occurred. While sitting for Jacob (or so it is believed), Max died. He was only fifty-three. Sarah writes that her 'father smoked a lot, and also inhaled the fixative which had to be blown on the photos through a tube. His cigarettes were Russian and half cardboard. The smoking and the fixative were probably lethal.' But sixteen hard years had also taken their toll.

According to Sarah, 'Jacob took a long time to recover from Father's death.' Jung has written that 'The father may well be the representative of spirituality.' Certainly the father is a conduit to the past, and Max was Jacob's immediate connection not only to his Jewish history but to art and to the spirituality that he felt must be the essence of that reality he wanted to capture in his work. For a time Jacob must have felt that his very roots had been severed.

It is curious that in *The Kramer Documents* there is only passing mention of Max's death, and no reference to letters of condolence from Sadler. In an introductory note John Roberts writes, 'I have presented my uncle's documents with very little comment, for they tell their own story.' It is inconceivable that Sadler did not write to Jacob on his

MEMORIAL

FIG. 36

Death of my Father

*oil*

1916

father's death, or remark on the inevitable and noticeable hiatus in Jacob's work. So one must presume that Jacob lost, or more likely destroyed, any such letter. Just as he was in the habit of destroying evidence of his past artwork, proof of his past ability and limitations, so he might have destroyed the proof of what he could not face, the death of his beloved father, his first teacher and his first role model of what an artist should be. Jacob had worked with his father at the photographic business, early in the morning they walked together to the studio where piles of photographs were waiting to be enlarged or touched up. Sometimes the photographs were so faint that they had to be completed by imagination, and this was work to which both of them as artists could apply their skills in satisfying the customer. Side by side they must have enjoyed many a joke enhancing a faded image. Jacob's pencil drawing of his father asleep (fig. 22, page 55) is in every line testimony to his love for his father, and, as stated, with the later drawing of his mother (fig. 23, page 55), they are two of Jacob's most beautiful works. Now Jacob was alone and the family breadwinner.

In 'Death of my Father' (fig. 36) Jacob painted one of his starkest works. Other than the head and feet the shrouded figure is reduced almost entirely to a white coffin-like rectangle lying diagonally across the picture space. Except for the nobility in the bearded face all corporeality is extinguished to a much greater degree than is the case in 'The Jew'. It seems possible that the picture was derived from a sketch that Jacob had made at his dead father's bedside, later imposing his feelings as well as his ideas about how death could be effectively portrayed. He achieved this by reducing the detail except for the beloved face to produce the final, extremely stylised image. To try

to count the number of meanings condensed into this simple rectangle is a truly Freudian exercise.

A critic in the *Morning Post* wrote: 'To me it is infinitely touching, simple with the august simplicity of death, and in its remote beyond-these-voices manner – beautiful. It remains with me. The artist's emotion has been communicated.'

The picture appeared in several exhibitions, including that of the London Group, of which Jacob was now a member. Frank Rutter, who reviewed that show said of it, 'Another moving example of the tragic in art is Mr. Kramer's "Death of my Father", tremendously impressive and simple in design. Like almost all Russian art Mr. Kramer's painting is hyper-emotional, and since he has probably never yet felt anything more deeply, we can understand why this is the very best painting this young artist has yet produced.' This picture, an icon of death, was also acquired by Sadler.

It is hardly surprising that Jacob returned to the subject of Christ, the Crucifixion, and several versions of 'Descent from the Cross'. He was never satisfied with his images of Christ. As he said in 1933, 'I must live longer; I must experience pain, tragedy, suffering; I want my picture of Christ to be symbol of all the world… a theme universal to all mankind, Jew, Christian, Mohammedan alike. I want to represent Christ as an expression of human nature, as an ordinary man like you and me.'
It was a journey that he was never to complete.

That Jacob's images remained elusive to most people is demonstrated by a letter that the editor of *Colour* magazine, A Barrett, wrote to Sadler, saying that he would like to publish some of Jacob's work, but 'You must not mind, nor he, if I choose those that are "easiest", for our public as a whole… which is many headed (and some of the heads are very wooden).' However, he was appreciated by many of his fellow artists, for in 1916 he was represented in nine exhibitions, three being one-man shows.

Jacob was now spending most of his time in Leeds and was immensely busy, so much so that he was able to exhibit over fifty works in the November exhibition at Leeds Art School. Despite the dreadful conflict on the other side of the Channel the general mood in Britain was one of 'business as usual'. The theatre and music halls played to good audiences, and with the example of Sir Henry Wood the concert season continued as before. These were all forms of entertainment that Jacob enjoyed. Indeed for many people who were not touched by personal loss or disaster, or working in munitions factories, the war was a long way off, only occasionally making itself known to people in the Channel towns by the sound of heavy gun-fire. Jacob's work

seems to ignore the war, and at this time when his work was receiving increasing attention there is no indication that the war influenced him to any great extent. Indeed the only time that Jacob seems to have become physically close to the conflict is an almost comic incident described in John Rothenstein's autobiography, *Summer's Lease*. It seems that Jacob and artist friends had been bathing on a secluded stretch of seashore, when Jacob was carried half a mile by the heavy sea to be deposited on a populated sandy beach. Unfortunately the swell had carried along in his wake a huge, horned German mine, and Jacob's emergence from the sea, 'naked and breathlessly incoherent,' accompanied by this huge explosive device, must have caused great excitement and hilarity.

Sadler wrote in October, 'When I was in London on Tuesday I called on Mr. Wilson Barrett, the editor of *Colour*… and spoke of your pictures. He told me he would be glad, if you cared, to insert in *Colour* another of your works, but that he had mislaid your address. If you wish to go further will you kindly write to him direct.'

But Sadler was also anxious that Jacob obtain some form of financial security and was keen to recommend him for a job teaching art to students of education at the university. Apparently through a misunderstanding Sadler's efforts were short-circuited when one of his colleagues wrote directly to Haywood Rider at the art school to ask for a recommendation. This Haywood Rider did, but it was not Jacob, leaving Sadler to write to Jacob to explain the situation. 'This was a mistake on his part as the matter had been left to me, but unfortunately the letter which he wrote directly committed us to someone else, and I think it unwise to cancel these arrangements.' But Sadler continued, 'I am keeping the matter in mind because I should like very much the students to have the advantage of coming under the influence of your work. Possibly the way may open for this, but I cannot speak certainly at present.'

There is no doubt many people were beginning to realise that Jacob offered something not only different but even singular and worthwhile, which would open students' eyes to the possibilities of expression available to the artist. Indeed one can imagine Jacob teaching that in art lay not just possibilities but also responsibilities that the true artist must face.

The exhibition of works of art by Jacob Kramer and Fred Lawson at Leeds School of Art was opened on 18 November 1916 by Sadler, and again on the following Monday by Frank Rutter. In a long review by Jacob's friend, Tommy Lamb (quoted in *The Kramer Documents*), he writes that Sadler was eloquent in his praise for Jacob's work and his

contribution to the cultural life of the citizens of Leeds. 'Among the many things Mr. Kramer has done for them was this: he had interpreted for them the humanity, the romance, and pathos of life in their city. There lay behind some of the drawings an intensity of family feeling, and a recollection of old far-off unhappy things, which gave to the work a depth of meaning which more and more appealed to them as they knew the drawings well.'

Tommy Lamb waxed eloquent about Jacob's fifty works on show: 'He reaches his highest powers in the studies of old folk. The modelling of the hands of time (his mother's) are drawn with extraordinary power and depth. Care-worn looks and approaching peace are expressed with force and serenity. Dancing girls are replete with abandon, movement and suppressed grace. 'The Descent from the Cross' drawings are marked by breadth of treatment, an impressive depth of feeling and vivid sense of spirituality', and special praise went to the mysterious 'Job'. Lamb concluded with the words, 'There is in Mr. Kramer's work a sublime combination of the spirituality and poetry of Russia and the East, and the freshness and vitality of the West.'

Sadler, it seems, had said to Lamb that if he had anticipated being stoned on his way to the exhibition, he would nevertheless have attended. Lamb also reported that Jacob had been commissioned to paint a commemorative panel in Belgium on a war theme. Alas, there is no other evidence of such a work.

It is evident that Tommy Lamb was in awe of his friend, this big Russian who was unique in so many ways: in his physical presence, his vivacity, the generosity of his friendship, and in his work of astonishing originality. It was work that did not fall in with current values but brought something compelling, albeit alien to most people, to the art scene of Yorkshire. Even that sophisticated connoisseur of modern art, the Vice-Chancellor, was very impressed.

In that year, which saw the dissolution of the London Group, Jacob exhibited at several mixed shows in London, and finally in December he had his first one-man show at the Bradford Arts Club where he exhibited twenty-three items. These included portraits of local people and the pictures 'Chess Players' , 'Crucifixion' (fig. 37), 'The Prophet' (fig. 38), 'Descent from the Cross', and 'Christ before the People'. Before a galaxy of local celebrities, Mr W H Brocklehurst, Chairman of the Libraries, Art Gallery and Museums Committee, opened the exhibition by saying:

'This collection struck one as being in the nature of a challenge to the critical.... to the art student particularly the one-man show provided

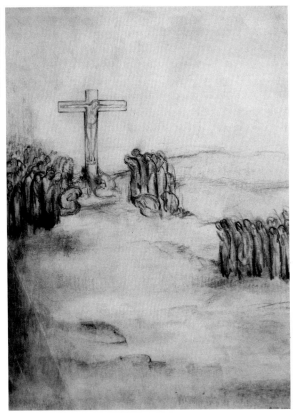

FIG. 37

Crucifixion

*charcoal & chalk:*
*height 43.8cm*
1916

opportunities, for it enabled him to see at a glance the range of the artist's attainment and to discover what particular message the artist had for the world. The life history of Mr. Kramer was very short. Mr. Kramer suffered the handicap, a handicap which many of them would gladly share, of being young. He was born in the country of our great ally, Russia, but came at an early age to Leeds, in which city and in London his career had been both rapid and successful, in that he had soon discovered his vocation…. it was a little strange, though very gratifying, to find large industrial centres like Leeds and Bradford producing artists of note. An ugly city like Bradford, which lacked both dignity and beauty, must result, and had very largely resulted, in an ugly people, satisfied with ugly surroundings.'

In his long introduction Brocklehurst went on to say that he longed for and hoped to see the city beautiful, but the beautification of our towns and the making of life tolerable and pleasant in them would remain an unrealised dream until all who could contribute in any measure to the result – artists, craftsmen, social and religious workers, and public representatives – were convinced that the problem was one for no one man or group of men, but for all. Bradford, however, was rich in the artists it had produced.

It was a speech to which Sadler and William Rothenstein would have added 'amen'. Except in the outlying suburbs, formed as the cities encroached on the surrounding villages, both Bradford and Leeds were ugly and dirty places demeaning the lives of their people, who suffered, as D H Lawrence was to write, 'the disintegrated lifelessness of soul' resulting from the dehumanising industrialisation in the early decades of the twentieth century. Nevertheless some saw the promise of beauty in the industrial landscape and row upon row of little houses, and people like Rothenstein and Sadler, both of whom had enjoyed privileged backgrounds, were keen to bring cultural leavening to the raw and mean lives of the citizens. In Jacob Kramer they saw one artist who might fulfil such promise.

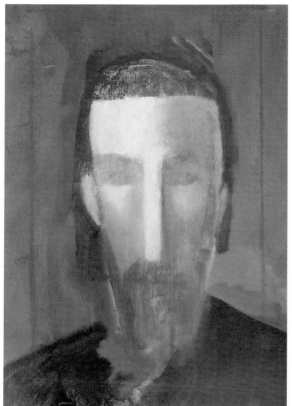

FIG. 38
The Prophet
*oil on canvas:*
*54.6 x 38.1cm*

Perhaps Mr Brocklehurst had not heard the latest news from Russia. In February 1917 the Tsar, Nicholas II, abdicated to be replaced by a provisional government, the revolution was under way and the war with Germany was over for the Russian people.

Then in October the Bolsheviks overthrew the provisional government, but in fact the first act of rebellion against Tsar Nicholas II came in 1916, when a group of nobles assassinated the monk Rasputin, a powerful figure in the royal household. With the Soviets in power Jacob must have been delighted and even more aware and proud of his Russian origins. The Foreign Minister, Kerensky, and then Lenin were to be subjects of his portraiture even though he never met them in the flesh.

Jacob's year finished with a postcard from Lewis Hind in Cavendish Square, London, to whom Jacob had sent a photograph of 'The Jew'. Hind wrote, 'I value the photograph of your "Jew". I wish you would jot down for me a few details about your art life in the sequence of years beginning with birth, just a few words, as sometime I shall be writing about you more fully. *Colour* has asked me to print what I said about the "Jew" in the *Evening News* under the reproduction. Have you a photograph of your, "My Dead Father"? I should much like to see it.'

It had been a tragic year but had ended well. Jacob's creativity had made loss fruitful and his expectations were high. The country also had hope when on 7 December Lloyd George became Prime Minister.

# 9    JOB

It is possible that many members of the London Group had had to resort to a map to find where Leeds was located, but now Jacob had put that provincial city on the map of the English art world. The Spring Exhibition of the Group was to be held at Heal's, an eminently respectable store founded early in the nineteenth century and purveyor of the most modern furniture, then Art Nouveau. The store was on the Tottenham Court Road, scarcely a stone's throw from where Jacob lived when in London. The painter McKnight Kauffer was responsible for organising the show, and sponsorship was needed. On 1 January 1917 Kauffer, no doubt believing that the prosperous citizens of Leeds might support a cultural event, wrote a flattering letter to Jacob about this.

'It is not always easy to get people interested in modern art. So far we have about ten lay members but of course London has people in it that are willing to back up the London Group. It is more easily understood that Leeds would not yield many if any lay members and after all Leeds hardly knows the L.G. I look forward to the Spring Exhibition as being the best yet. Certainly the gallery is ideal. It is very encouraging to me to have my fellow artists appreciate my efforts. I think we should be more closely allied because most of us have a great deal in common.Naturally there comes into art societies as in all societies, *snobbishness*. Therefore you can understand that I am happy to have received your friendly letter. Your work in the London Group struck me by its big simplicity. You can take big spaces, treat them simply yet retaining a sense of volume. It is easy to go to a poster effect but this you never do. I shall look forward to seeing more of your things. I hope we shall meet soon.'

Jacob was in demand. Despite the many differences in their origins, personality and work, presumably the reasons for that snobbishness, the art establishment was casting prejudice aside and taking him on board. This attitude was confirmed when Lewis Hind wrote to him to thank him for some biographical notes he had received and continued: 'Some day I shall be writing a little book on "20th Century Art", which of course began with Giotto.'

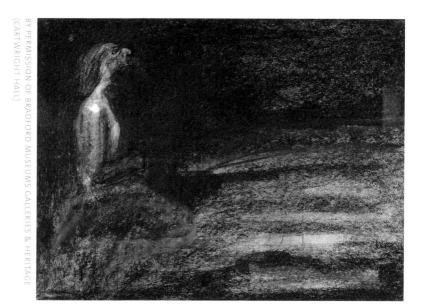

FIG. 39
Judas in hell
*charcoal & chalk*
1917

Why was he telling Jacob this? Did Hind believe that Jacob's work was bringing to the twentieth century the kind of innovation that Giotto di Bondone had brought to fourteenth-century art? Did Hind see a continuity in the humanity that Giotto had given to his fresco figures, and the spiritual depths of that humanity Jacob strove to capture? Perhaps he was just defining himself to the young artist, but the letter also had a more practical purpose for he asked Jacob, 'Do you know any Englishman resident in Petrograd, or a Russian who speaks and writes good English, who could do a fortnightly Art Letter, taking a broad and impartial view of the arts movements in Russia old and new? It would mean a nice little, moderate income for a suitable man or woman.' Had he heard about Jacob's financial problems and was offering him a job? If so Jacob would have been completely unsuitable. He had no contact with Russia; indeed at that time it was difficult for anyone to have contact with the country, in the turmoil of revolution. Also there is no hint in Jacob's work that, despite his keen interest in the political revolution, he had any interest in the revolutionary changes in the art scene there at that time.

The London Group was not the only art group to woo Jacob. Frank Rutter, as Chairman of the Allied Artists Association, wrote to say that he was delighted to hear that Jacob was joining the AAA. Having left the Art Gallery in Leeds Rutter was working a long day at the Admiralty, and before leaving Leeds he had suffered an attack of mumps so that he could not say goodbye to his friends, of whom Jacob was one. He warned Jacob that as there was a rush of contributors to the exhibition he had better send his £1.1s subscription to his sister, and 'I will have a place reserved for you.'

It seems that Rutter had arranged to sit for Jacob, but as he wrote in a postscript, 'Am afraid the sittings will have to be on Sundays in London or "after the war".'

Sadler was keeping in touch and wrote that he was sorry to have missed him but, 'Tomorrow morning I shall be here [Leeds], if you have the leisure to come. The pictures [no doubt 'The Jew' and 'Death of my Father'] move me deeply.' Almost immediately Jacob, impetuous in generosity, responded by giving Sadler, his surrogate father, a present of the two pictures.

Jacob pursued the representation of Biblical figures other than Christ who suffer through the will of God. These included Judas in hell, one of Jacob's most extraordinary images of isolation (fig. 39), and a charcoal and crayon drawing of Job (fig. 40), whose kneeling figure is one of supplication, his long arms angled across the picture. The arms and the face and neck tinged with green are the only points of illumination against a dark background, to produce an image of mystery in which Job is asking God the great Biblical question, why he, a good man, must suffer the dreadful punishment that, to test his faith, God feels it necessary to mete out to him? In this intensely Expressionist work there is a very personal element to this question. This was the year after his father's death, and as there are no more drawings after 1917 of his brother Isaac it is likely that his death too had been visited on the Kramer family at this time. Diphtheria, scarlet fever, poliomyelitis and childhood diseases of childhood were common and often fatal. As described earlier, the 1917 portrait of Isaac is a softer, less substantial drawing than the portrait of 1915, suggesting that this might be an elegiac image (figs. 2 and 3).

This was a period of great emotional crisis for Jacob. Not only had he been abandoned by his father and brother, but also by many of his friends who were in the Armed Forces. Jacob was like Job, like Judas in hell, isolated in his misery and anguish, and there can be few works by any artist that express this torment so vividly. His unreliability from his early days and his running away demonstrate his anxiety and lack of emotional stability, and bereavement must have been followed by a deep depression. But this bereavement coincided with a period of considerable innovation, artistic success and elation, and mood swings, high and low, which will have been assuaged by the comfort that alcohol offers. One of his very few pure abstract paintings was made at this time (fig. 41).

This picture of Job is in striking contrast to one painted at about the same time, the mythic image of 'Ruhala' (fig. 42), an immensely powerful portrait of a woman with streaming earth-red hair, the face

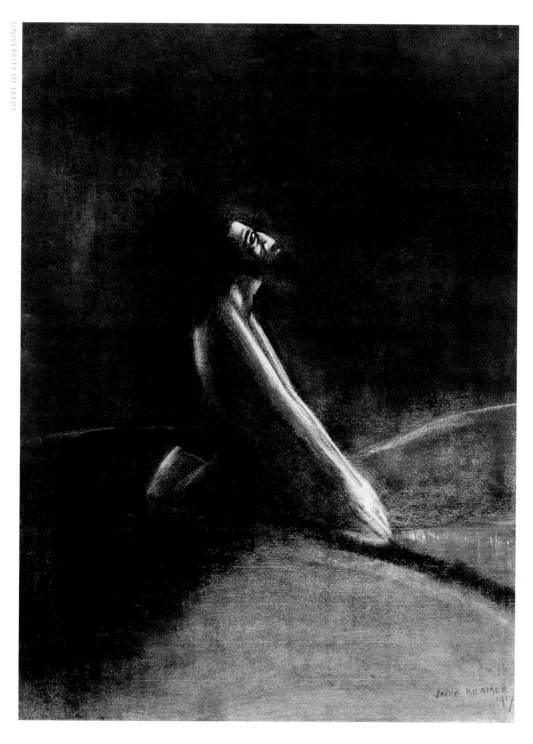

FIG. 40
Job
*charcoal & crayon*
1917

and all its angles seeming to fly left out of the picture frame held in [only] by the right shoulder and the angle of the right arm. With the head in profile and body facing forward it is reminiscent of the figure drawings of ancient Egypt and specifically of the sun-god Ra, creator of the universe. It is hardly surprising that this was followed by 'The Sphinx' (fig. 43), a surreal and uneasy image painted two years later. The figure, also in red, is placed diagonally as though ready to fly out of the picture frame, the face under a helmet of black hair is thrust forward, and in the nose and lower face of both this portrait and Ruhala is a resemblance to his great support, his sister Millie.

Jacob was supporting his family largely by making portraits of local people, as well as of well-known people such as Jacob Epstein's wife, Peggy (fig. 44), of whom he made a woodcut in 1918. But his efforts to reach something behind the appearance were, as frequently happened, not appreciated by everyone. Sitters and their loved ones complained that the work was far 'too modern.' One of these was Louis Teeman, a friend of Jacob's, who complained, 'Kramer painted my sister. We were all terribly upset. She was only a young girl, and he painted an embittered, middle aged woman. As the years went by, that is what she became.'

Another unhappy sitter was Sadler himself. He put his criticism delicately:

'When you look again at your portrait of me, will you kindly consider whether a line indicating that there is a wave in my hair above the ear would be consonant with your composition? I do think that some indication that the hair is not straight would please those who want the portrait not to miss being exact on this point.'

One of those to please was Sadler's wife, Mary, who hated the portrait and left Jacob in no doubt about how she felt:

'I agree that there is a good deal of character and strength about Mr. Sadler's portrait, but I can't say I think it much like him or at all a pleasant representation of him, not one that ought to go out as *him*. It seems to me that the chief character of his face is freshness and a lovely genial expression, but this picture gives me the impression of a tired old man with a bad temper.'

She invokes the opinion of old friends who agree that Jacob has missed the sunniness which is one of Sadler's chief characteristics, and she suggests that Jacob could have it reproduced simply as 'a portrait' without any name. 'I should not like this grim old man to go out as Mr. Sadler… You will understand that I am not wishing to express any

opinion as to the artistic merit of the picture. I have no doubt that it
is very good from this point of view; my concern is entirely with the
presentment of a man whom I know very well. I do not think this
does him justice or expresses his character.'

These words would be echoed by many of Jacob's sitters, including the
famous Leeds surgeon, Sir (later Lord) Berkeley Moynihan, Professor
of Surgery at Leeds General Infirmary, whom Jacob painted in military
uniform. As always the critic in *Colour*, 'TIS', wrote sympathetically
about Jacob's current work. 'Kramer, I feel… is really getting to the
heart of things: his simplification seems an outcome of genuine
simplicity of purpose…. Kramer's Jew is not an individual; he is
not even a type; he is a symbol of a type; he is something that exists
not in life but through abstraction. He therefore exactly shows what
modern art aims at, namely, the expression of an idea in the terms of
the material art of which and in which it is made manifest. As he has
painted excellent portraits in the more conventional style, the accusation
of technical incompetence… cannot legitimately be levelled against him
by the old-fashioned-est of painters.' TIS finished his panegyric by
looking to the future, with the wish 'to see what he is capable of when
he reaches the age of 51, at which Rembrandt painted his "Rabbi".'

To link Jacob with Rembrandt was like a red rag to a bull for many
painters and critics, and the furore about Jacob's work continued,
very clearly manifesting the difference between London critics and
reviewers in the provincial newspapers.

The reviewer in the *Yorkshire Post* started his scathing attack by
demonstrating Jacob's ignorance in the fine matter of titles. Alas,
Jacob had entitled the portrait of the great surgeon 'Sir Berkeley
Moynihan, Bart', 'although he was not yet a Baronet but a Knight.
Next, it may be objected that this portrait may resemble some other
person, but it does not represent Sir Berkeley Moynihan as known
to his friends. One misses every quality which gives distinction to
the face of the original, there is no life or expression in it — nothing
but flatness; and from this point of view it must be regarded as a
complete failure.' And in commenting on the woodcut of Mrs
Epstein, 'we hope… that Mrs. Epstein will not want to obtain
damages from Mr. Kramer on account of this portrait. We confess
to a distinct preference for Rembrandt's conception of his work,
quite apart from his skill in execution.'

There is no record of Jacob Epstein's response to the portrait of
his wife. The two Jacobs had become increasingly friendly and it
is possible that at this time the sculptor introduced the painter to
African tribal masks, which so influenced the former's work. Lamb

FIG. 41
Abstract composition
*red & black chalk:*
*29.5 x 22.5cm*
C 1917

and 'TIS' were not the only parties to defend Jacob's work. The critic Lindsay Procter wrote a long letter making the point that 'If you and others prefer the reality to Mr. Kramer's portrait of Sir Berkeley Moynihan, that is not a question of art development, but of personal taste,' and about Mrs Epstein's portrait, 'You may say that… it is a monstrosity. It is a woodcut and also a realisation of the person supposed to be portrayed…. You may not like Kramer's work but you won't forget "The Jew".'

By now the patience of both the reviewer and the editor was wearing thin, and expressing the former's point of view the latter concluded, 'The proper place for youthful experiments, he thinks, is in the studio.'

Moynihan insisted that his portrait could not be exhibited unless it was altered and 'rescued from the flames.' This was something Jacob was reluctant to do and in defending his work, he wrote to Moynihan, 'I am also confident that "no man knows himself". You I am sure know your patients better than they know themselves.' He nevertheless hoped that he could show the picture simply as 'Portrait of a Surgeon'. However, not only were some people satisfied with Jacob's work, they were also enamoured with his personality. In December the actress Mary Merrill wrote breathlessly from the Theatre Royal, Nottingham, 'I do think it was charming of you to make me a present of that beautiful study of yours – I shall value it tremendously and really – I can't thank you sufficiently – it was simply too kind of you – I do hope I shall meet you again – if you should happen to be in town – my address is 312 Regent St. w.1. It would give me much pleasure to meet you again… I wish you all good luck – I should like to know the results of your Tribunal – I do hope all goes well with you. Again many thanks – I am so delighted with my own studies – you did of me.' And when, forty years later, his devoted sister Millie was preparing the *Memorial Volume*, and made contact with people who had known her brother, the many replies demonstrated the affection with which Jacob was remembered and the value put on his work. Many paintings that in earlier days they had failed to appreciate and even initially disliked were now treasured.

FIG. 42
Ruhula
*oil on canvas: 91.5 x 71cm*
1917

By now many of Jacob's contemporaries were official war artists, prominent amongst them Paul Nash, Nevinson and Spencer, and in 1918 Bernard Meninsky was also recruited to their ranks. Bomberg was now established as an artist with the Canadian forces, and was subsequently to be commissioned to do a painting celebrating the successful blowing up of German defences by Canadian sappers. He painted his first and strongly Vorticist version of 'Sappers at Work', but this was rejected by the army authorities. A second and much more realistic painting was accepted. Earlier in the year, encouraged by the idea that he too should become a war artist, Jacob decided to enrol. Inevitably he sought Sadler's assistance, and as always Sadler did what he could by contacting a Colonel Scovell at the War Office, no doubt explaining that the volunteer was a young Jewish artist and Russian national. Sadler informed Jacob that he had done so and subsequently sent Jacob a copy of Scovell's reply.

'… with regard to the case of Kramer. Our hands are dreadfully tied nowadays in these matters, and we have to turn a deaf ear on all applications of the kind which you have written to me about. I have, however, been able to do something, and that is this. Colonel Patterson who has just been given the command of the new Jewish regiment, has been in to see me and I shewed him your letter. He will look after Kramer to the best of his ability if the latter agrees to make an application to be posted to this special unit, and if you will provide him with a letter to give to Colonel Patterson on joining.'

Scovell went on to explain that it would be a simple matter for Jacob to ask the Recruiting Office in Leeds for a special enlistment form requesting that he be posted to the Jewish regiment. 'This will come here to be sanctioned and is certain to be granted.' No doubt the sanctioning body was the Tribunal that Mary Merrill later referred to.

Sadler had done his bit, but could give Jacob no further help as in October in wrote to say that he was going to India and would not be able to help Jacob further 'with regard to military service.'

We know that Jacob did not go into the Jewish regiment but late in the following year was posted from a distribution camp in Ripon to South Wales, and to the 9th Russian Labour Battalion. Although there is no detailed record of his army medical examination, we know that he was categorised B2. Jacob reacted badly to stressful situations, and it is very likely that the army doctor would not have classified this anxious and agitated giant as suitable material for a fighting unit. Nevertheless he was obviously strong and therefore right for a labour unit. The idea of being part of a Russian army unit must have satisfied that part of him which remembered his youth.

However, months were to pass before he was enrolled, and in the meantime Jacob had other matters to attend to. After so much criticism he felt the need to explain his work, and he got the opportunity when he was invited to speak to the Leeds Art Club on 21 January 1918. This event marked the beginning of what was to become almost a second career. To a large and sympathetic audience he talked about the work of the younger artists of whom he was now a prominent representative. His theme was that all great art is an expression of spiritual feeling, but he confessed that he found it difficult to express in words what exactly conformed to the spiritual idea in his mind. To illustrate the lecture he had prepared twenty or thirty drawings to demonstrate how colour, line and mass-form could represent such spiritual feelings as beauty, passion, feminine gracefulness, the sensation of seeing a woman smile, a combination of the natural and spiritual, and other intangible spiritual or mystic ideas.

'Great art,' he said, 'is expression. Beauty is not the aim because that already exists. Expression happens.... If the expression is guided by very deep emotion, I have invariably noticed that I produce a replica of the subject of reality.' He went on to say that it was his endeavour to produce a purely spiritual form as it was only in that way that he could conform to his conception of expression, but that the scope of most art, as exemplified in the work of the conventional artist, was not sufficiently broad to include the more mystic tendencies. In his own case, all his previous studies led him to perceive that only through symbolism could he express all the ideas that 'accumulated in the ordinary channels.... Reproduction was not expression, and because many people did not recognise the difference they found so-called art critics employing absolute standards, whereby they judged the quality of the work which they were incapable of understanding. There were several critics who did understand the spiritual propensities, but they did not exist in Leeds.' This remark was received with considerable laughter. Then he made a statement likely to confuse most people who were unaware of Plato or Schopenhauer, that is that symbolism and realism were almost interchangeable terms and that in his own work he expressed the *absolute* reality as he perceived it. 'When I look upon my subject I realise the existence of two distinct characteristics – the natural and the spiritual, but always the latter element impresses itself upon my mind because it is in exact relationship with my soul development.' He could well have quoted Schopenhauer's statement that 'the artist can hit a target that the non-artist can't reach but the artist of genius can hit a target that the non-artist cannot see.'

Jacob went on to explain that in the picture 'Death of my Father' he had tried to symbolise tranquillity and repose and the tragic fate of

FIG. 43
The Sphinx
*oil on canvas*
C 1919

man in pursuit of happiness and contentment which finally eludes his grasp.

In defence of the portrait of Mrs Epstein, he said, 'I felt in this portrait a rare emotion which I fully interpreted by a combination of the human and spiritual elements and kept as closely to the natural form – it had of necessity to be simplified for the purposes of reproduction as a woodcut – I feel it exactly coincides with my conception of the personality of Mrs. Jacob Epstein.'

In conclusion he remarked on the attacks on his work by critics: 'The attacks directed against artists who endeavour to interpret the spiritual side of life are a proof of inability to understand what constitutes a genuine conception of art.'

Jacob had just turned twenty-five, an age of passionate conviction, and his certainty in what constitutes a genuine conception of art allows no room for debate, or for the possibility that his view might be too narrow. He demonstrated the mindset of an evangelist, and it was in this mood that he wrote an eighteen-page letter to Herbert Read, who was in the front line.

Essentially the theme of his letter is that of his talk to the LAC, but it is worth summarising in order to appreciate Read's reply. Jacob wrote:

'As you know... the degree of expression in a work of art is the measure of its greatness.... a spiritual discernment is more essential than the reproduction of the obvious.... it is my endeavour to create a purely spiritual form.' He went on to say that the only way to express emotion was by the use of symbols:

'only through symbolism could I express all the ideas accumulated in the ordinary channels.... When the natural and spiritual elements impinges itself (sic) upon my consciousness, a terrific struggle invariably

ensues, and it is by the greatest effort that I am ultimately able to translate the base substance of the detailed naturalness into the essence of spirituality. The latter always predominates, owing to its essential vigour and direct appeal…. When you know that the spiritual element is in the ascendancy it will culminate in a completeness which incorporates both in a manner which is calculated to produce an entire oneness; and in that way both elements are mutually dependent and merge into one another.'

Jacob calls this synthetic compromise of the physical reality with the spirituality the 'expression, which is art.' As Michael Paraskos points out, the phrase 'Art is expression' is the precise phrase that the Italian philosopher Croce uses, and it implies a philosophical outlook parallel to the German Expressionist idea of the artwork being almost self-born through a supreme act of will, the will to create.

Jacob ends his letter to Read by expressing his dissatisfaction with the impermanence of the vision implied in Cubism.

At that time Read was in the trenches with the 2nd Battalion the Yorkshire Regiment, having been awarded both the Military Cross and Distinguished Service Order, but his nine-page reply of 6 April 1918 (Isaac Rosenberg was killed on the third of that month) demonstrates his composure under his precarious situation, as well as that intellectual rigour which was to be the hallmark of his later writing on the psychology of art and creativity. Read wrote:

'I'm afraid I haven't had time to answer your letter before now. I've been mixed up with the big fight and it has taken me all my time to keep alive and out of Germany. But we have a bit of peace and quiet now,' and he continued with an important account of aesthetic theory:

'I wondered when reading your letter, that if you had been an Englishman and familiar with all the "nuances" our words acquire whether you would have used so freely the words "spirit" and "spiritual". At any rate I risk wasting my time in explaining what I think to be rather an important and essential difference between these words and words like "mind" and "intuition". I tried the experiment of re-reading your letter and substituting the latter words for your 'spiritual' etc, and found that I could understand and agree with you much better. To an Englishman the word "spirit" has a metaphysical and theological connotation which it is difficult to disassociate in aesthetic or general use…. it is another fallacy to imagine that you can distinguish the spiritual or mental from the actual. The actual is the mental – the intuition… is it not that you express the beauty in your mind, rather than distinguish or separate a beauty in the actual.'

Read then proceeded to provide a neurological description of mental processes to explain Jacob's 'spiritual' experience, continuing, 'What I insist on… is that the spiritual quality is not inherent in the works of art but in the mind of the artist, or in the mind of the spectator.' This is the essence of his belief. He would have nothing to do with metaphysical notions, those ideas that Jacob had found in Kandinsky's work, and in so much of spiritualism, a potent influence at the Leeds Arts Club. Essentially Jacob was expressing the gnostic view that truth is revealed by divine inspiration, a view that the cerebral Read could neither contemplate nor imagine. Nevertheless, as Tom Steele points out, 'for both Read and Kramer, the absence of naturalistic representation was necessary for the expression of reality.'

FIG. 44
Mrs Jacob Epstein
*woodcut: 13 x 9"*
1918

Read finished his letter by saying that he did not expect to be in England for at least two months and hoped to see Jacob then. 'Write to me if you can.'

This letter, remarkable under any circumstances, was even more impressive given the conditions under which it was written. Years later Read confessed to having missed the point of Jacob's message: 'I think that in my reply to this letter, I must have defended Cubism and the formal values of art, for I was not at that time sufficiently familiar with the alternative values which Kramer was expounding – those values we now call Expressionism. Kramer is and always has been an expressionist.'

Read felt that because of his excessive attachment to theoretical precision, he had missed what Jacob was actually trying to tell him about his own struggles to create. Subsequently Read was to re-appraise Jacob's letter as a 'remarkable self-realisation of a young artist's aims' in which Jacob had demonstrated that he was fully conscious of the movements surrounding him but had dismissed them as inadequate modes of expression. 'He had the strength,' Read concluded, 'in that time of disruption and reorientation, to stand on his own ground.'

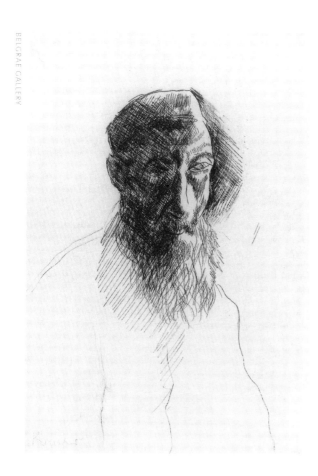

This exchange of letters wonderfully demonstrates the difference between these two creative artists, Jacob passionate and intuitive and Read, the poet and sensitive intellectual critic of his time. In his later writing on the psychology of art and the nature of perception, Read develops the message of the letter, but he does go on to add, 'The creative aspect of art… is a more complicated process.'

Read was already a published poet, but Gertler was to say about him, 'I like him very much, I think he is a nice man and very serious – only his instincts for painting aren't very strong – the result is that he works a bit too much from the head and is generally too theoretical.' It is significant and sad that nowhere in Read's books is there mention of his old friend, Jacob Kramer.

FIG. 45
Head of a Rabbi
*etching: 8 x 6"*
1918

Jacob did not go into the army until the first week of October 1918, and was therefore able to carry on with his work. He was very busy making portraits of many people in Yorkshire, including one of Sonia Rosievitch, Bruce Turner's wife, inevitably one of his mother as 'Old woman wearing a headscarf', and one of a patron, William Pilkington Irving, as 'Man with a white moustache'; also he gave a picture of Sarah dancing to Mrs Hardcastle, wife of the caretaker of the LAC. By this time Jacob had taught himself to etch in which his mastery of line is demonstrated, as in the 'Reclining Man' and 'Head of a Rabbi' (fig. 45).

By now Jacob's reputation had reached something approaching celebrity status, and in Ernest C Sterne's article on Leeds Jewry 1919–1929, he writes, 'Perhaps the best known Leeds Jew at the time was the painter Jacob Kramer.' Therefore it is not surprising that notices were sent out to members of the LAC inviting them to a Social Evening on 'Wednesday May 1st at Seven o'clock in honour of Mr. Jacob Kramer, who is leaving Leeds at an early date.'

But there were others who, knowing Jacob well, were anxious about the life he led. His friends in Leeds were well aware of his drinking

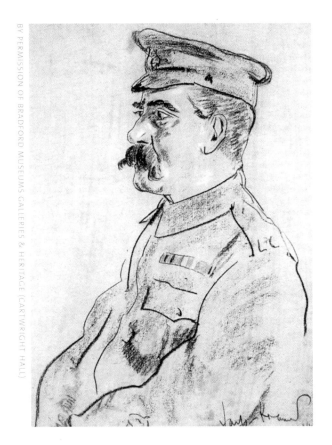

FIG. 46
Portrait of the
Artist's Regimental
Sergeant Major
*charcoal, chalk &*
*pastel on paper*
1918

and womanising as one of the bohemian set in London. Jacob had been in touch with his old art master, Haywood Rider, a man who was well aware of Jacob's youthful erratic behaviour and lack of reliability, and his reply to Jacob demonstrated the affection in which Jacob was held by many of his friends in Leeds. After commenting on two paintings that a client had purchased, 'The Japanese Maiden' and a portrait of a man 'fit to rank with the old masters,' Rider came to his main concern. Perhaps he was thinking of the temptations of his own student days in the big city when he wrote:

'…There is nothing to hinder you if you will be steady and work hard in making a big name,' and here the admonishing headmaster, the one who had threatened Jacob with expulsion if he did not stop absconding from school, took over: 'Now Jacob there is one point I should like very strongly to insist on, and that is, keep a good character – Artists many of them lead a free sort of life & there are many temptations, especially in London & I should like to beg of you that you have nothing to do with anything wrong in any shape or form – this will give you more happiness and satisfaction than anything else and I hope you will make a firm stand and resolve on this – Your dead father would say I am right I am sure…. So many have ruined a good career by folly and loose living – I have a special right to say this, *because you belong to us* and I want in the future that we shall always as now be proud of you – Your address reminds me of my student days in London as a number of my fellow students… lived in your terrace….'

No other words could better express the affection, pride and hope felt for this awkward and talented boy whom the citizens of Leeds had taken to their bosom than those few words, 'because you belong to us.' Jacob was almost twenty-six and one wonders whether Haywood Rider felt that the horse had already bolted.

By 1917 the Tsar of all the Russias had abdicated, and a moderate socialist government had been established, headed by Alexander Kerensky, but

then by 1918 Lenin's Soviets had begun to command the great cities
of Russia, and Kerensky had to flee to the West. There is no doubt
where Jacob's sympathies lay, and one of the paintings that he sent
to the Allied Artists exhibition was a portrait of Kerensky, the man
who had tried to hold his country together.

Jacob had given Kerensky a yellow face and this was the source of
much criticism, but the famous novelist, Somerset Maugham, had
met Kerensky, and notes in his *A Writer's Notebook* of 1949 that 'his
face was of a strange yellow colour, and when he was nervous it
went livid.' As John Roberts comments, the evidence seems to be
against Jacob ever having met Kerensky, but at that time he was
very much in the news and easily portrayed. Inevitably the picture
provoked much criticism from people who had never met the man
in the flesh.

One critic wrote about the exhibition generally: 'Here is debilitated
futurism…. here is sensationalism without a sensation; here are
nudes, clothed in suggestions of the old egg-timer stays… unoriginal
originality… the graveyard of all isms.' Another implied that anyone
who could pay for wall space would have their work hung because the
AAA had no selection panel; and of course Jacob's Kerensky came in
for special comment:

'I do not think that at a time of such critical relationship with Russia,
Mr. Jacob Kramer should be allowed to exhibit "M. Kerensky" – and
the accent on the first syllable, please! – in such a peculiarly lurid light.
Here is a bright green M. Kerensky, of most discouraging appearance.
I hope both for his own sake and for ours that this sea-green monster
is a figment of Mr. Kramer's imagination.'

'…of peculiar topical interest is Mr. J. Kramer's portrait of Kerensky,
impressive in its suggestion of feverish spiritual energy, in spite of
the entirely arbitrary and exaggerated tinge of jaundice which spreads
over the Russian ex-Premier's face,' and the portrait is 'an electric piece
of painting; the revolutionary is standing at tense and high pressure
at a table, his head yellow against a brown background…. The sharp
decided lines in the physiognomy tell something of the man who for
months held the fate of Russia in his hands.' A critic for the *Yorkshire
Observer* remarked that Kerensky, 'as painted by Mr. Kramer resembles
Frank Harris's description of Napoleon – "very weak looking with
a saffron-yellow face; but his eyes are extraordinary – observant,
imperious enigmatic".' Apparently the press cuttings were handed
to Kerensky, who expressed pleasure at the prospect of meeting
Jacob, but it seems likely that this was not to be as Kerensky went
to the USA.

Autumn arrived, the war was drawing to a close, and at long last Jacob was preparing to go into the army. But before that, only days before he joined up, the Leeds Arts Club put on an exhibition of his work, in which colour dominated the show and the centrepiece was a portrait of Kerensky with the strong, yellow flesh tones. There was also a brigand with a red face and red neckerchief, the two Japanese ladies in decorative colours of salmon against yellow and yellow against blue, a Spanish girl in a scarlet cloak, an old woman (his mother) knitting, and some early etching. An extensive review appeared in the *Yorkshire Post*. This commented not only on the 'searching draughtsmanship that has always characterised him, but a remarkable sensitiveness to the capacity of colour as a means of emotional expression.' 'Jacob's use of colour was not restricted to the "set palate" in which even the accomplished craftsman finds security, but approaches each subject with an open mind. This leads him at times into what may seem extravagance,' but the review goes on to say, 'Mr. Kramer has given us enough proofs of his intense sincerity to furnish an assurance that such departures from normal vision are not mere affectations.'

Art critics might with justification accuse Jacob of many failings but lack of sincerity was not one of which he could easily be found guilty. However, failings of quite a different nature became apparent in the next few weeks, for on 5 October Jacob enlisted and went to Bangeston Camp at Pembroke Dock in South Wales.

The transition from recognition and celebrity in his home town to the impersonal and alien conditions of an army camp must have been painful and disorientating, especially as his hopes of being a war artist had come to nothing. Also the war was soon to be over and any feeling that he was doing his patriotic duty could not be sustained. In despair he wrote to both Herbert Read and, as Sadler was in India, to his son, Michael Sadleir.

As always, Read, who was now with the 11th Cyclist Brigade at Canterbury, replied with a sympathetic and supportive letter. '… This is what I have done. I have written to your C.O. and asked him to give you some congenial work. I imagine there will not be too much scope for you in the battalion, but I suggested he might employ you in the orderly room. You will see. Let me know what happens. If nothing happens by Wednesday I will write (after hearing from you) to your Company Commander. But I think the C.O., unless he is an altogether impossible man, will help you. You are sure to be pretty sick with life at first – I went through all those feelings myself in 1914. But I expect you will gradually become indifferent to all the vulgarity and coarseness about you. And this good you will get out of it, you will come into contact with types of life which otherwise would have been unknown to you, and that is always

valuable to an artist. But cheer up! The war is over and you may soon get disbanded. Let me hear from you soon. Yours ever, Herbert Read.'

Read well understood his friend and his need for positive encouragement. In the event Jacob became the camp librarian, and as he had brought some of his work with him he was able to organise an exhibition at the camp.

Michael Sadleir's reply could not have been more different. He made clear that he was very busy and had many responsibilities as he planned to go to the Peace Conference in Paris. He pointed out that he had tried very hard 'about the War Artist job' but at least 'it is something to be Librarian and out of the squalor of ordinary life.'

On 7 January Lance-Corporal Kramer J was transferred from A Company 9th (Russian) Labour Battalion to the Dispersal Centre in Clipstone, and on 6 February transferred as a Private to the reserve. As he had enlisted on 5 October he had been in the army for four months and one day, in which time he had made at least one recorded work, a realistic portrait of his Regimental Sergeant Major in charcoal and coloured chalk, which might have been well received by the sitter's family (fig. 46). But as Jacob recorded the episode, 'I gave him that sketch, and he folded it into small pieces to put it into an envelope to send to his missus. Later a friend of mine bought it from him for a bottle of whiskey. He managed to get rid of the creases.'

By this time Sarah, now eighteen, and having corresponded regularly with William Roberts at the front, had moved to London to live with him in Percy Street. The house in Leeds was no longer crowded: Cecilia was there with her two younger daughters, and Millie at fourteen could leave school and go to work. She went to a secretarial college. There is no record of Jacob supporting the fees, but there was no one else to do it.

# 10  DAY OF ATONEMENT

Despite the brevity of Jacob's army service it was a hiatus he must have resented, especially as he had failed to be recognised as a war artist. However, freed by demobilisation, he pursued his work with dedication and energy to realise, perhaps, his most fulfilling year. Prior to his enrolment he had arranged to talk to the Bradford Arts Club on 'Symbolism in the Arts' and before his formal discharge from the army he made his way to Bradford to meet that obligation.

Many in the BAC were sympathetic to Jacob's ideas, indeed the chairman of the group, Dr J Campbell possessed several of his works. By now Jacob was well aware of the antagonism many felt towards his ideas and he went to some length to make his ideas more accessible. He introduced his talk by apologising for having to refer to his own work to illustrate his ideas and, no doubt with Herbert Read's comments in mind, he explained that some of the difficulty of understanding his work was caused by the limitations of the vocabulary. The 'modernity of the symbolic phase in art' made for some difficulty in conveying in words 'the spiritual idea he had in mind.'

He explained that symbolic expression followed a comprehensive study of the natural form, but it was only through symbolism that he could express all the ideas that accumulated in his head. Merely to copy nature did not constitute expression of the deeper feelings. 'While there were many decorators and illustrators, there were few artists whose devotion to their work was such that… it could be said that they had grasped the inner and ultimate conception of the soul of things.' He continued to explain that, 'the premeditated attacks directed against artists who endeavoured to interpret sincerely what they felt was a proof of the critics' inability to understand and appreciate what constituted a genuine conception of art.'

At this time Jacob felt that these ideas should be brought to a wider audience and he prepared an article entitled 'Form and Shape' to be published in Yiddish in the Jewish magazine, *Renaissance*. It seems

that he prepared the article in English and had it translated into Yiddish by Leftwich for publication in June 1920. The cover of that issue of *Renaissance*, a veritable gallery of talent, was designed by Bomberg, and the magazine contained a drawing by Modigliani, a 'Cubist Landscape' by Chagall, a woodcut by Lucien Pissarro, one of Meninsky's drawings, reproductions of Jacob's 'Pogrom' and 'Day of Atonement', and a photograph of Jacob Epstein's 'Christ' for which Epstein had used Jacob's huge hands. Apparently when Epstein saw the Chagall he shook his shoulders and said, 'Mad!' Subsequently the article, 'Form and Shape', appeared in English in *The Jewish Quarterly* of Spring 1962, where Jacob wrote:

'Whole libraries have been written about painting, and thousands of books about music, but there is hardly anything yet that explores their character and indicates the relationship between their elements. I don't mean the surface relationship, with which various technical problems are connected, but above all that symbolic, or let us say, transcendental conception of sound and colour that makes them not only technical but spiritual factors.

'Before I approach the subject more fundamentally I want to emphasise that there are two attitudes to sound and colour generally. The first attitude may be termed the physiological, and the other the transcendental or spiritual.

'For instance, a colour may to our eye be only a physiological sensation, rousing no particular emotion in our soul. In the same way a sound may be only a physiological sensation to the ear apparatus, of so many sound waves, and do nothing to excite the soul inwardly. But this is only the mechanical side of the question. On the other hand, the same sound and the same colour may move our inner self to the deepest and highest emotion, as soon as we approach them on a higher plane than the merely psycho-physiological.

'The question is: what is colour in the transcendental sense, and what is its relation to the form? But first, we must understand what is form. At the very beginning, we must differentiate sharply between shape and form. The shape is not yet the form itself, but only the outward or accidental manifestation of the form. On the other hand again, form in its transcendental sense is that inner and eternal essence of the object which indicates and determines all external shapes and aspects.

'The same distinction as between shape and form must also be made between tone and colour. Tone is part of the shape; colour is part of the form – in so far as it really is the essence of form and can't be

separated from it, as the soul cannot be separated from the body. In other words, colour and form constitute an organic whole.'

As Jacob had said in the talk to the Bradford Arts Club, there was need for a better vocabulary to describe the modern movement, and in this written statement Jacob tried again to make his ideas more accessible. Jacob and Herbert Read both agreed that naturalist representation cannot express realism, especially if one accepts Jacob's belief that 'symbolism and realism are almost interchangeable terms because I express in form the absolute reality as I perceive it.' But, as Tom Steele explains, Jacob appeared to believe in direct apprehension of the essence of the object, while Read remained sceptical, and as he explained in his letter from the front, maintained that the perception of 'the essence' was in the artist's head as a factor of his reaction to the object. Jacob's view of form tended to be more mystical, even gnostic, that the artist, especially the great artist, underwent a spiritual experience in the act of creation.

At that time Jacob had rather more banal problems to deal with. A new secretary had been appointed to the JEAS and had difficulty making contact with him. In March she wrote, 'you have had a large loan and according to your signed agreement you undertook to devote at least 10% of your earnings to repay this.' This letter was followed by one from the Chairman of the Society. It seems Jacob owed £175, and he replied that 'I am not yet in a position to repay…. I am making steady progress and can assure you that as soon as I am able I shall forward something towards the amount due.'

Yet at this time he was much in demand. It is possible that he was bearing the burden of supporting his family, but more likely that he could not organise his finances adequately. Demands for repayment came regularly from the JEAS, in the form of letters and personal calls to various addresses, as over the next few years Jacob moved from Leeds to London, from 18 Howland Street to nearby 51 Maple Street, and later to 14 Bartholemew Road in Kentish Town, Jacob was elusive. Even in 1924 the secretary was still knocking on his Maple Street door without catching him. 'I have not heard anything of you since last April,' she wrote, and then, 'I was so surprised at not getting an answer to my letter…. I hope you can now see your way to start repaying the loan advanced…. the committee would appreciate a sign of your recognition of the help given when required.' Hers was a hopeless quest; she must have been alerted to Jacob's unreliability but she could not know of Jacob's increasing dependence on alcohol. On one occasion he did write to say, 'I should be very glad if you would do me the favour of calling at my place this week… as I should like to show you a particular work of mine.' But there is

no record of the JEAS taking a piece of Jacob's work in lieu
of repayment.

In May 1919, Frank Rutter, recently released from his war-time
duties at the Admiralty and now running the Adelphi Gallery in
London, gave Jacob a one-man show, to which works by Bomberg
and Wadsworth were later added. But Jacob did not attend. In search
of a wider audience for his progressive ideas he preferred to go to
Glasgow where The Glasgow Society of Painters and Sculptors,
familiar with his work shown in the magazine *Colour*, had elected
Jacob the only non-Scot of its twenty-six members. Their exhibition
included sixteen of his works. These were all portraits including
that of Kerensky, which met with the usual comments on its colour.
The *Glasgow Record* said that 'Joseph (sic) Kramer sets the keynote
of the exhibition. He is a dangerous guide, working on theories which
were commonplaces a decade ago in Paris.' The *Scotsman* remarked
that Jacob Kramer's were the most distinctive works, the reviewer
especially noting the colours of his 'Russian Gypsy', but the most
perceptive review was by Bernadette Murphy in the *Arts Gazette*.
Before commenting on each of the works, she wrote, 'Mr. Jacob
Kramer is an artist who has discovered the secret of being effective.
He is more than effective – he is striking. This, in a way, is a pity,
for, after all, he is an artist and there is no need for him to be either
striking or effective; he can very well afford to be sincere.'

She had been to the exhibition at the Adelphi Gallery where
she found work of great strength, with their heavy black lines
and elimination of all the subtler shading 'as though the man had
a tremendous fist and went at it amazingly hard.' No doubt when
she met Jacob personally in Glasgow and saw his work on 'Boxers
and Theatricals' she realised the truth of both of her statements. She
considered his work 'brilliant, but to those who know his potentialities
and his worth, this phase is rather harassing and a little disappointing.'
His picture 'My Sister Miriam' she thought 'hypnotic' but 'studied' and
not as 'honest' as 'Study of an Old Woman'; 'The Jew' was 'immovable
and rocklike'; 'Jews Praying' (a preparatory sketch for the oil painting,
'Day of Atonement'), was 'fascinating – a strange hooded procession,
intent and absorbed'. Many of the paintings she thought very
successful: 'they cannot be ignored or hastily glanced at – they
are insistent' but in her comment on 'Sunday Morning', a satirical
picture of provincial Jewish bourgeois in tall hats and black coats
seen from behind, she touches again on what she thought were Jacob's
weaknesses: overemphasis, cleverness, letting the effect get in the way
of the drawing. 'Mr. Kramer is an artist, and he really need not be so
effective.' Her comments highlight the danger of Jacob falling into
caricature, a pitfall for any Expressionist artist.

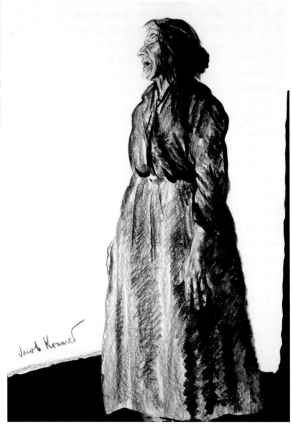

FIG. 47
Study for Pogroms
*mixed media on paper:*
*127 x 90.2cm*
1919

Henry Ainley, a famous British Shakespearean actor, had by 1919 become a movie star, and it is further testimony to Jacob's celebrity that he made a poster portrait of Ainley playing in *The Anatomist*. But for some reason Jacob was not happy with the drawing, and Ainley, understanding his anxiety, wrote to Jacob saying, 'don't worry.... If you wish to do another head I am agreeable.'

By now Sadler had returned from India and on 2 July he wrote to Jacob with a piece of bad news. The picture 'Death of my Father' had been stored unframed in sacking to protect it from air-raids, and had become stained where the battens had pressed the canvas. Sadler wondered whether Jacob would like to 'touch it up' or preferred to leave it as it was. Jacob gave first aid to what Sadler described as 'war wounds.' Despite his wife's criticism of his portrait Sadler now had this framed and asked Jacob for his opinion of the frame he had chosen. Apparently Jacob was not well at the time, and Sadler wrote to him, 'To be of any help to you in your creative work is an honour.'

Further evidence of Jacob's celebrity came when he was invited to open an exhibition of work by the members of the Sketching Club, many of whom were ex-soldiers, at his *alma mater*, Leeds School of Art. Jacob took the opportunity to offer some pithy advice: 'The only way to achieve anything of value is by work. Birth is the result of travail, in art as much as in nature. You must therefore be prepared to work and to suffer. The creative spirit will follow.' This counsel obviously gave satisfaction to his old headmaster, Haywood Rider, for whom in his time Jacob had been something of a problem. Rider wrote that the art world had gone to extraordinary lengths in freakish directions, and he was glad to see that Mr Kramer was taking a sound and sensible attitude. The maverick had apparently matured.

Jacob's work had great appeal for the Leeds Jewish community, and despite his complaints about the lack of support from his fellow Jews,

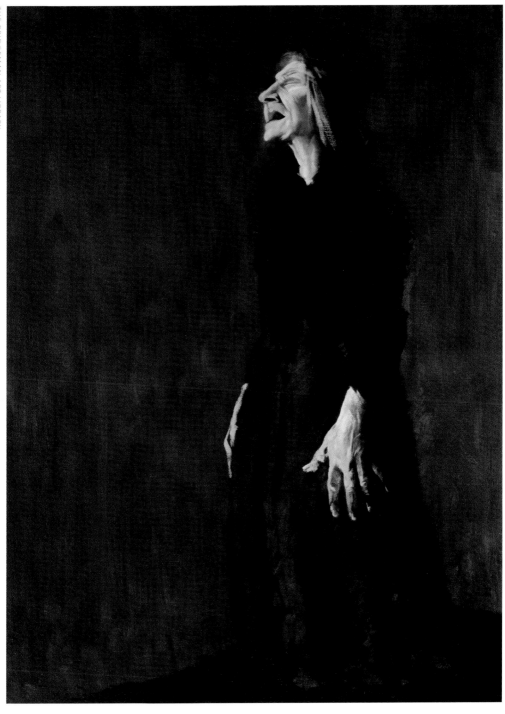

FIG. 48
Hear Our Voice, O Lord Our God
*oil on canvas: 101.6 x 76.2cm*
1919

many, as successful entrepreneurs and professional people, had him paint their portraits. His themes resonated with their own feeling of Jewish identity and suffering, and the Leeds Jewish Representative Council decided to commission Jacob to do some works to be presented to the Art Gallery. As always Sadler acted as an intermediary. He was in touch with the secretary of the Representative Council, Mr. Abrams, who on 10 July 1919 offered the works to the City Art Gallery. Jacob had already completed a preparatory work, 'Study for Pogroms', with his mother as a model (fig. 47) and at the end of that month Sadler felt able to tell Jacob that the Art Gallery Committee had welcomed the gift, but he added, 'The pictures, I expect, will be a pretty strong dose for the Art Gallery Committee and a test of their insight and of their willingness to recognise genius. Don't feel downcast if they feel hostile to these works. All really great things have to go through the ordial (sic) of being hissed by the crowd.' Sadler added that if, by being present at the presentation ceremony, he could be of any help to Jacob and the Jewish community, he would be happy to do so, but as he was badly in need of a holiday he would be away from the middle of August. He asked where Jacob's studio was and how to get there: the studio at Beecroft Grove in Chapeltown was for Sadler a socially-distant place. In the event Sadler was so busy that he did not see the pictures until after the press view of paintings and drawings that Jacob held on 8 December at Beecroft Grove. The invitation to the viewing announced that 'Mr. Kramer is shortly leaving Leeds to live in London, and Leeds Jews, through the Council, are desirous of recognising his work and stimulating interest in the artistic enrichment of the city.' Three works were to go to the Art Gallery paid for by the Representative Council. These were two oil paintings, 'Day of Atonement' (fig. 49) and 'Hear Our Voice, O Lord our God' (fig. 48), while the third was a simple chalk drawing of a girl's head.

The 'Day of Atonement' had taken Jacob nine months to complete. It represents a dramatic moment in the religious service when the congregants stand in silent prayer on Yom Kippur, the holiest day in the Jewish calendar, the Sabbath of Sabbaths. Leviticus describes how when Moses descended from Mount Sinai for the second time with the Ten Commandments, he found the Children of Israel worshipping the Golden Calf, and the Lord spoke to Moses and Aaron (Leviticus 16:34) saying, 'This shall become a rule binding on you for all time, to make for the Israelites once a year the expiation required by all their sins.' The Day of Atonement is a day of expiation and introspection.

In this painting, considered by many to be Jacob's masterpiece, we see a brotherhood of Jews in line at prayer. There is a strong Vorticist influence in the construction of the frieze of figures, which is tighter and stronger, more disciplined than in the preliminary ink and

charcoal drawing. Each stylised figure leaning slightly forward in the rhythm of prayer is enveloped in a rigidly folded prayer shawl from which the ritual fringes hang. The firm, vertical lines of the shawls contrast with the larger, horizontal structure of the band of worshippers, which is broken only by three raised heads, all with eyes closed in contemplation. The structural tensions in the composition perfectly reflect the emotional content of the picture. With subdued colours and tight control Jacob has created a picture of dignity in prayer, solemnity and peace, in which each individual is subordinate to the unified community at prayer, as it shall continue to be until the day the Messiah comes. It is a wonderful example of how, with restraint, sharp angular Cubism (Vorticism) can be used to express the spiritual. Outside the realm of landscape it is a rare horizontal picture, in the line of figures it is a narrative, that of the continuity of the Jewish faith.

Nothing demonstrates Jacob's versatility more than the comparison of the two oil paintings, 'Day of Atonement' and the expressionist 'Hear Our Voice, O Lord Our God'. In both these paintings, but using completely different styles, he achieves an equally powerful expressiveness. In the latter painting, he realises this effect by simplifying the preliminary ink and chalk drawing entitled 'Pogroms' or 'My Mother'. In the painting the figure of his mother is lengthened and simplified; she wears a black dress, her figure frail and thin, her agonised face drawn with anguish, the hands and fingers are stretched to emphasise her suffering, and highlighted against the black dress, a symbol of the affliction of the Jews in all pogroms, especially those recently committed in Ukraine by the White Russian Army. The painting is a timeless cry against persecution, and in the elimination of all background detail the 'essence' of suffering is emphasised. As in the very different picture, 'Job', Jacob asks the question, why? The image of his mother is as effective and immediate as that of 'Job'; and these two works reinforce the opinion of Bernadette Murphy that when Jacob is sincere he has no need to try for effect. In both works his sincerity is in no doubt. The exhibition included other portraits of anguished faces, testament to the suffering of the pogroms, but they cannot compare with 'Hear Our Voice, O Lord Our God'. In this picture of his mother, who had suffered the loss of her home, the death of her husband and of a young son, Jacob achieves, just as he had done in the earlier drawings of his parents sleeping, the sincerity of great love.

There were some critics who thought the exaggerated proportions of the figure, especially the length of the hands, 'absurd and unnatural,' but this seems to have been a minority view. Both the Leeds Jewish Representative Council and Alderman Willey, chairman of the committee of the Art Gallery, said that they would be happy to

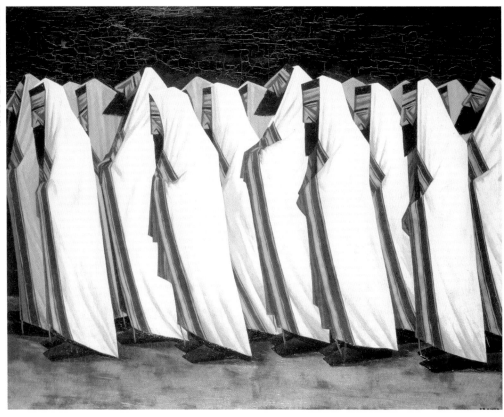

FIG. 49
Day of Atonement
*oil on canvas:*
*99 x 121.9 cm*
1919

have the collection offered. The review in the *Yorkshire Post* was very favourable, saying, 'The Leeds Jewish community are justly proud of the distinction attained by Mr. Jacob Kramer, who was not only brought up amongst them but received his early training at the Leeds School of Art.' Both oil paintings were described as 'typical of Mr. Kramer's forceful methods… and originality of conception,' 'Hear Our Voice, O Lord Our God' receiving special acclaim. Even the simple chalk drawing of the girl's head is 'none the less valuable as a study of Slavonic facial expression, revealing the artist's skill and resource in economy of line.' It was noted that both the oil paintings are for public exhibition rather than private ownership.

Sadler was correct in his prediction of the response to these works. As always Jacob's work provoked a very mixed reaction. A supporter of Jacob's work wrote, 'Lovers of art number among them many Jews, but he would be very bold, who could assert that Jewish artists have been appreciated by their fellow Jews,' while a detractor wrote, 'They are too ghastly for discription (sic)' and even as late as 18 January 1920 Jacob wrote in frustration to complain of the delay in the acceptance of the works by the City Art Gallery, and threatened to take them back.

Despite his good intentions Sadler did not see the pictures until the middle of December when he was finally able to visit Beecroft Grove. There, according to the dramatist, R C Scriven, the great man was so overwhelmed by 'Pogrom' ('Hear Our Voice, O Lord Our God') and the 'great hands' that he knelt down before the picture to pray. Subsequently Sadler wrote to Jacob, '"Pogrom" records with intense emotion a horrible event. It is therefore a horrible picture but it is a historical document of great importance.' However he wrote to Jacob that he thought 'The Jews at Prayer' (sic) a masterpiece. There is an oil painting of that title, a simplified and Vorticist picture of three seated figures, but Sadler obviously meant to refer to 'Day of Atonement', which he likened to a woodcarving, a great frieze in low relief. He warned that the Art Gallery Committee might be hostile to the work, but went on to write, 'if, by any chance, [they] feel that they cannot accept the picture of the Jews at Prayer (sic), please come to see me at once, as I should like to make another proposal to you about it.'

In Leeds at that time there was considerable antipathy between town and gown, and evidently Sadler's opinion of the artistic taste of councillors and aldermen was not too high. Some debate in the Council chambers did ensue, provoking a letter in the *Yorkshire Post* of 13 January 1920 from Wilfred Childe, poet and teacher of English Literature, who wrote:

'There is some danger, apparently, that the Leeds Art Gallery will not accept the sublime Hebrew pictures which Jacob Kramer has painted to the honour of his faith and people. Leeds, as far as I know, is the only provincial city that numbers a great artist among its citizens; and anyone who compares the splendid purity of the 'Japanese maiden' in her rose-coloured mantle, with the tumbled confusion and coarsely feeble colour of so many of the Victorian pictures about it in the same room, must earnestly desire that other works of the same master may speedily be added to a collection unfortunately largely lacking in specimens of the great modern English art movement. For a master Mr. Kramer is, and it would be sad if Leeds, which promises one day to be a truly great city, should reject her own son.'

This view carried the day, the Council accepted the pictures, and Sadler's alternative offer was never considered. The City Fathers as well as the art community of Leeds acknowledged Jacob as one of their own, and the artistic community of Bradford followed suit when Dr J Campbell presented five of Jacob's works to the Bradford Art Gallery. In the event the announcement that Jacob was leaving Leeds to live in London proved to be premature. On 26 December 1919 Jacob celebrated his twenty-seventh birthday. He had received due acknowledgement in his home town, but was that to be enough?

# 11 THE TOWN HALL FIASCO

After the war the traditional major industries – coal-mining, steel and ship building – were in decline, resulting in mass unemployment, poverty and unrest, especially in the north of England. The war had also brought about a relaxation in social attitudes and firmly held ideas such as temperance and respect for the sanctity of the Sabbath were being abandoned. It was against this backdrop that Sadler, that ardent believer in the salvation of the working classes through education and culture, proposed to Leeds City Council that a war memorial be created in the Town Hall, in the form of frescoes designed by young contemporary artists. To this venture he recruited William Rothenstein, now Professor of Civic Art at Sheffield University. Leeds could still be described as one of the ugliest cities in England and, from the point of view of these two men, its citizens were culturally impoverished. Sadler was so keen on the project that he proposed to pay up to £200 to cover Rothenstein's fee, and all the artists' first-class travelling expenses, as well as the costs of six preliminary sketches at twenty guineas (£21) each. Both the *Yorkshire Post* and the evening paper liked the idea, and wrote that Sadler was 'setting a noble example which should be followed by others.'

The City Fathers were sceptical but as Tom Steele points out, Sadler had the ear of Lloyd George and was not to be dissuaded by mere aldermen. Rothenstein was to organise the project, selecting artists, soliciting testimonials as to their virtues from influential directors of the nation's art galleries and critics and handling the fees and travelling expenses of those invited to submit designs. From the start both Rothenstein and Sadler were clear that Jacob should be one of the chosen artists.

His contribution to the Town Hall scheme was only a very small part of what was to be a very busy year. He had moved out of the family home and was now living in Preston Cottage in Little Woodhouse. Sarah, now a mother, was living with William Roberts, so Cecilia, Millie and Leah were left in Chapeltown, still dependent on Jacob's earnings.

Jacob was also doing his bit to promote the benefits of art, when on 25 January he opened an exhibition of children's art at the LAC.

'The drawings,' he said, 'were helpful towards an understanding of the minds of children and the great possibilities of development.' He was afraid that parents, and sometimes teachers, did not pay sufficient attention to things which were often priceless. Inner feelings for beauty had to be fostered. Influences which worked against this included lack of encouragement by older people, and 'the disgusting works that were seen at picture houses,' which did not represent life but detached the beholder from life and were therefore a decided menace to the younger generation.

He finished the talk by saying that the exhibition had shown that the children of Leeds were born with great artistic feeling, but throughout the city there was terrible evidence that love of beauty was either crushed or allowed to die, and it was the duty of parents, teachers and artists to endeavour to preserve and develop these gifts.

Early in February Sadler received a letter from the Lord Mayor telling him that the Property Committee had approved the idea of having panels adorning the Town Hall lobby and the Victoria Hall. On 12 February he gave Rothenstein the go-ahead and on the following day Rothenstein provided his first thoughts about the artists to be approached:

'The first who would come naturally to my mind would be Wadsworth (a Yorkshireman), Jacob Kramer as you rightly suggest, Paul and John Nash, Stanley Spencer, and either Kennington, Meninsky or perhaps Lamb… Albert [that is Rothenstein's brother, Albert Rutherston] would be enchanted to co-operate.'

In a letter from his home in Stroud, Gloucestershire, Rothenstein wrote to Jacob outlining the plans, explaining that the first draft design would have to be approved by himself and backed by the directors of the National Gallery, the Wallace Collection and the Tate Gallery, and that a sum of about £200 would be paid for each painting. He continued, 'As I am to act as a kind of liaison officer between artists and authority I should like to know whether I can count on your co-operation.'

However, on the basis of prices that the Imperial War Museum had recently paid, Sadler thought that a fair price for the final paintings could be £150 for a big one and £100 for a small one, and he hoped and believed 'that six men can be found in Leeds who would pay a fair sum' but Rothenstein suggested that the painters might not be satisfied with these sums. While Rothenstein, the painter, worried

FIG. 50
Rite of Spring
*oil on canvas:*
*63.4 x 76cm*
C 1920

mainly about his fellow artists, Sadler worried that the City Council
would not like the choice of pictures and that some people might
suggest other painters, so he assured the Council that the choice of
the works would be vetted by directors of the nation's famous galleries,
and Charles Aitken, Director of the National Gallery, offered to assist
the Council in their decisions. Ten years later in his autobiography,
*Men and Memories*, Rothenstein admitted that from the start he had
been doubtful of the success of the scheme: 'I knew the municipal
mind too well to be hopeful.'

A circular with further details was sent out. This stated that the fee for
each design was to be twenty guineas, the design being the property
of Michael Sadler, but the copyright of the final decoration – if not
accepted – would be with the painter; the completed designs would be
approved by Mr William Rothenstein and then Sir Michael Sadler, who
would submit them to the Art Gallery and Property Committee of the
City Council. The fee for larger paintings would be £250, for smaller
ones £200, plus expenses involved in carrying out the paintings. It was
further proposed that the decorations would be carried out on canvas
stretched on wooden frames to be fixed in the chosen spaces.

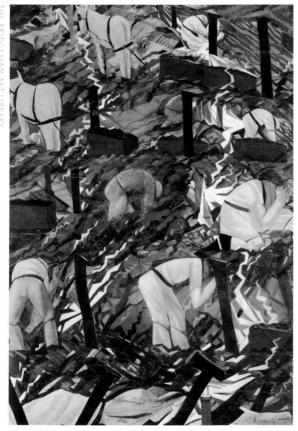

FIG. 51
Mining
*gouache on paper:*
*75.7 x 53.1cm*
1920

Applications came from many painters, some that Rothenstein considered second-class, and his provisional list was little changed; it included Percy H Jowett, Jacob Kramer, John and Paul Nash, Albert Rutherston and Edward Wadsworth; in a subsequent list Stanley Spencer replaced Jowett.

Meanwhile Jacob was busy with other matters and on 8 March he gave a talk at the LAC on 'Colour in Relation to Music'. Sadler, who chaired the meeting, had loaned Jacob some Kandinsky paintings to illustrate the talk, and in his introduction he spoke about the generosity of the Jewish community in presenting some of Jacob's work to the City Art Gallery.

Although Jacob was capable of playing the piano the music was provided by the pianist Kathleen Frise-Smith. Her interest in the subject had inspired Jacob's researches, and helped him to illustrate the theme. The walls were covered in Cubist and Futurist paintings, compositions in colour and form to correspond with scales and phrases from classical music played on the piano. As a review of the meeting recorded, 'pianissimo or forte… indicated in shaded tints on the wall were easily understood, but when it came to illustrations of concrete and abstract symbolism, as shown in Scriabin's music, a severe test was imposed upon the imagination of all but the erudite in such matters.'

Jacob sought to show exactly how colour values correspond to sound values. As the reviewer pointed out, Kandinsky had expressed music in colour designs and Scriabin in an orchestral work using a 'colour organ' to project colours on a screen. Jacob made the point that just as each sound can be transformed into a corresponding colour, so a melody can be transformed into a picture; further just as there is realistic and descriptive painting so there is realistic and descriptive music with imitations of storms and stamping dancers, all superficial and superfluous. He continued with his message that if they are to be worthwhile, both painting and music must 'bring our consciousness into mystical union with the inner transcendental essence of reality'

and not be photographs of petty external details. The most effective of all Jacob's paintings on a musical theme is his near-abstract 'Rite of Spring' (fig. 50) which in *Conversations with Tess Simpson*, Esther Simpson, one of Jacob's sitters, describes: '[Jacob] was very much affected by music, and the first time he heard Joe [Williams] play Scriabin he went back home and painted a terrific picture. It was in thick oils like little mountains, the background being a kind of ochre colour, with vermilion and black streaks across it.' There is no geometrical element in the picture and when examined closely it is seen to be a powerful and mystical depiction of a pogrom, its dark-red background is crossed by thin black lances and lightning strikes, galloping horses appear on the right and bodies lie struck down below the Cossack charge. It is difficult to believe that this was conceived spontaneously while Miss Frise-Smith played the piano.

A critic in the *Yorkshire Observer* suggested satirically that scents should be added to make a triple alliance; for example, red would evoke attar of roses, and blue with cheese at a particular stage of ripeness but as the *Yorkshire Post* commented, 'It may be difficult to follow Mr. Kramer in his theories, but it is impossible not to be deeply interested.'

Sadler wrote to Jacob to express his enjoyment of the lecture, but scolded him on not returning some Kandinsky pictures and drawings that he had borrowed for the lecture. Sadler also took the opportunity to remind Jacob that when he had lent him a Gauguin for an exhibition it had been returned damaged. These are further examples of Jacob's unreliability and lack of a sense of responsibility for other people's property. In this correspondence Sadler also refers to an alabaster carving, presumably by Jacob, but there is no further reference to this or any other piece of sculpture by him.

In April there was to be an official presentation of the Jewish community's gift to the Art Gallery, and Jacob wrote to the novelist, Israel Zangwill, to invite him to make the presentation, but Zangwill was too busy and suggested the names of Dr Max Nordau, a prominent Zionist, and from the art world, Marion H Spielman and William Rothenstein. Nordau was unavailable as with the assassination of a Zionist leader, Josef Trumpeldor, he also had too much on his plate. In fact there is no evidence that any formal presentation took place. For some reason, perhaps disappointment at the failure of the Art Gallery to proceed with this event, Jacob attacked the gallery in a letter in the *Yorkshire Post*. He had already had exhibitions in Nottingham and Derby, and had therefore become familiar with the art scene in those towns. His letter was headed ' Art Collections in Leeds' and continued:

'I have moved in many circles, and no city within my knowledge outside London can claim a deeper interest in matters of art than Leeds, in spite of the Art Gallery. But the deplorable fact is that, instead of being spread evenly over the whole community, it is concentrated in a handful of individuals, and even the intelligent mass of the citizens is left cold by it.'

In this Jacob continued the theme of his address at the exhibition of children's art: art should be available to everyone and not just to an elite, and the art gallery was failing in not putting on public show the great works that there were in the city. He cited the magnificent collection of Sir Michael Sadler, who had never been approached by the Art Gallery Committee to exhibit works by masters that other cities would have exerted them-selves to show. He continued, 'I have it on good authority that Mr Haywood Rider, headmaster of the Leeds School of Art, is about to put his collection [including a superb Rembrandt and a fine example of Titian's best period] under Christie's hammer… our local demagogues have shown themselves indifferent.' The editor added the information that for over thirty years Haywood Rider had acquired a collection of oil paintings of Dutch, Flemish, French, Italian and English schools, including Gainsborough, but that ill health and a view to retirement had influenced him to consider selling. Whether the Art Gallery 'demagogues' rose to the occasion is not recorded.

At this time Jacob was immensely busy preparing for an exhibition on 24 April at the LAC. Jacob's exhibition, with T A Lamb in the chair, was opened by the Rev D R Davies, who paid tribute to the personality of Mr Kramer and the spiritual significance of his work. He congratulated Leeds on having an artist like Mr Kramer in their midst, if only as a rebuke to the spirit of materialism, and went on to congratulate the Jewish community on having so gifted a son, and trusted that they would make a great deal of him. The reviewer in the *Yorkshire Post* described the work on show as falling into two categories, the realistic, 'depicting the subject as seen by normal vision,… and the symbolic… which assumes forms to express inner qualities… One naturally inclines to distrust the latter, for it may so easily be made the resort of incompetence… In Mr. Kramer's case, he has given us ample proof of his ability as a draughtsman of the normal type.'

Included in the exhibition were the portrait of Sadler, 'reconciling character… with decorative qualities very happily,' a cartoon for 'Hear Our Voice, O Lord Our God','a strong and impressive study which is to be reproduced as a poster' and several new works including a Romanian Jewess in amber and red and a 'vital' sketch of a party of actors on their travels, 'which has a touch of humour comparatively

rare in Mr. Kramer's works.' There was also 'a conventional painting of a dead man on a bier, stiff and archaic in treatment.' This might have been 'Death of my Father', which could hardly be described as conventional.

The reviewer of the *Yorkshire Weekly Post* described Jacob as a thinker first and a maker of 'pictures' last. 'His thoughts are not always tangible, nor easily put into words, but are in a sense telepathic.' However, in commenting on a picture of an old Jew, the reviewer did go on to say that once you realise Mr Kramer's ability as a draughtsman 'you are at liberty to enter into the spirit of the work... you no longer see the peculiarity of the drawing, but feel the pathos of the old man who asks: "How long, O Lord!"' It seems that gradually an increasing number of critics were beginning to understand what Jacob was trying to portray.

Rothenstein was now busy with the Town Hall project and after the painters had all agreed on the terms of the circular, Rothenstein suggested that they should come together at the Town Hall to agree on the hanging. Unfortunately when on 22 April the artists from London did come to Leeds, Rothenstein did not have Jacob's address, and despite trying to contact him by sending a telegram to Sadler, Jacob could not be found. However, Rothenstein took the artists on the tour of the Town Hall, hoping to meet Jacob there. Without him the group discussed the general scheme of the decoration of the eight

FIG. 52
Young Woman
Knitting
*oil on board:*
*76.5 x 63 cm*
1920

FIG. 53
Woman with
Headscarf
*pastel on paper:*
*96 x 66 cm*
1920

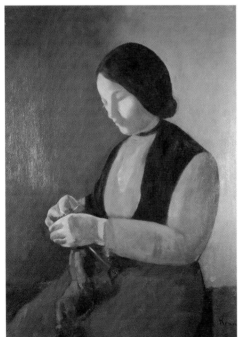

FIG. 54
Dancer Resting
*pastel: 75 x 43 cm*
1920

panels, and agreed that the four central panels should represent past or present industry in Leeds. Subsequently Rothenstein asked Jacob to send him a rough design on this theme.

Jacob's carelessness and lack of respect for Sadler's possessions, his continuing debt and failure to meet commitments and appointments suggest that by now he was drinking heavily and subsequent events were to prove this to be the case.

After the visit to the Town Hall the identity of the chosen artists became known, and not surprisingly, as had happened in 1917, conservative artists like Emanuel protested.

Mark Senior, a respected painter who had had work exhibited at the Royal Academy, sent a violent attack to the *Yorkshire Evening Post*, in which he wrote of the 'nightmare crudities' of modern art. Senior did not mention Jacob but 'young men who shall be nameless… whose sense of inspiration and grandeur is expressed apparently only by the distorted and chaotic effusions which… go forth as a monument of disordered mental outlook and indifferent artistic technique.' He described the 'fatuous jargon' of the silver tongues that speak in support of 'individual symbolism' and the 'hidden essence revealed with unerring creative impulse.' 'Futurist, cubist, vorticist and impressionist art is as ephemeral as the fevered times in which we live… We want pictures in our Town Hall of merit and balance, and not such as in years to come will reflect the abnormality of the times.'

This time Jacob replied in person, forcibly and at length. He attacked traditional art, its technical complexity, its crowded detail, its multiplication of trees which prevented it seeing the wood: 'modern art… is vital and spiritual, and provides a great contrast to the mere academy type of picture with its nice-ness… its frills and flounces.'

In the same week Jacob took the opportunity to make a further attack on traditional art, specifically as represented by the Royal Academy. This was when he opened an exhibition of watercolours by his old teacher at Leeds College of Art, W B Pearson. He said that he was sure that the audience had read Mark Senior's attack on modern art

and 'the defence he had been compelled to make', and then continued, 'Art is an expression of reality… its appeal was to the spirit, not to prejudice,' and finally he urged the visitors to buy Mr Pearson's pictures, although he 'has not the magic letters R.A. behind his name. I trust he never will…. It was a common belief that the stamp of the Royal Academy was evidence of great art. Whatever the Royal Academy might have been in the past; let them harbour no illusion as to its nature at the present. The Royal Academy is the enthronement of the vulgarity of the age, the degradation of the dignity of art, the ruination of the spirit of creativeness.'

Jacob's attack on the art establishment had reached a peak of vituperation. He had suffered years of mockery and vilification for his ideas about the nature and purpose of art, and now his celebrity afforded him a platform to strike back. Nevertheless his language was immoderate and his target an institution that had no connection with his work; but the Royal Academy represented the established church, the symbol of reaction and the enemy of the evangelist.

Whatever Jacob might have preached from the podium his voice was heard most clearly through his work, and particularly through his work on those Jewish subjects, 'Pogrom' and 'Day of Atonement'. These appealed to Israel Zangwill, novelist, playwright and Zionist leader. Among other writings, Zangwill was the author of *Children of the Ghetto*, perhaps the best portrayal of the Jewish immigrant. He was also the coiner of the phrase, 'The Melting Pot', which was the title of his play on America as a crucible. Zangwill had shown photographs of Jacob's pictures to the editor of a new literary magazine, *Voices*, who was keen to publish them, although as Zangwill said, there could be no payment. However, he assured Jacob that publication would pay in the long run, and the pictures were published in the June issue, but, alas, without any commentary.

Whether at this time Jacob felt that an academic post would give him security and status, and would allow him to spread his message is not clear but whatever his motives he wrote to Sadler to enquire about a teaching post. By chance Sadler knew that there would be a vacancy at the end of the term in the university staff at the department of education, and suggested that Jacob write to Professor John Strong, the head of the department. But he added, 'I am bound to say that I very much doubt whether the duties of the vacant post would at all suit you. I think you would find them irksome and too restrictive,' and he suggested that a teaching post at the Slade would be more suitable. In the same letter he wrote, 'Will you kindly at your convenience return to me the books you borrowed some weeks ago.' And there was a post-script: 'I am extremely sorry that you exhibited

the portrait under my name. My wife has been extremely anxious that this should not be done. I feel sure you acted in inadvertence, but the mistake has wounded her.'

This was the second time in those months that Jacob had met with Sadler's displeasure. Early in discussions about the Town Hall project Sadler had insisted that no publicity be given to the idea. In March he wrote to Rothenstein that before they contact the newspapers 'it is exceedingly important that nothing should appear in a magazine or other publication which might be construed as giving information to outsiders before those immediately concerned had been consulted. I am anxious to carry the Leeds people with us.' Sadler also insisted that all sketch designs be shown to the Chairman of the Council Committee 'on whose decision it would depend whether the proposed works shall be accepted.' But on 21 May Jacob gave an interview with a *Yorkshire Post* reporter and gave details of the plan, which appeared on 22 May. This revealed that four of the paintings would be 18 feet by 12 feet, that the theme of these decorations would be the leading branches of Leeds industry, engineering and clothing manufacture, to be executed by Wadsworth and himself, and that four of the smaller panels on either side of the orchestra would have landscapes painted by the Nash brothers.

Sadler was not pleased and Jacob apologised for talking informally to a reporter and ended, 'I can assure you that I shall be more guarded in future and fully appreciate the desirability of avoiding publicity.' Later Sadler wrote that no detailed descriptions of the drawings should be shown to the public until they could be presented as a whole to 'the authorities.'

Other signs of strain appeared when Sadler complained to Rothenstein that although he had agreed to support first-class travel for the painters he had not agreed to pay for their expenses while in Leeds. Rothenstein was anxious that the artists should not be out of pocket, and replied that any misunderstanding was his fault and not the painters. The apology was accepted and Sadler then agreed to send Rothenstein £45 5 shillings to reimburse five painters for their expenses, the sixth being Jacob who lived in Leeds. As stipulated Sadler was to bear the fees for the designs, and designs were now being submitted. Rothenstein wrote that he would pass Jacob's very interesting design as it stood, and he was sure that Jacob would wish to be paid. Happily Sadler agreed that Jacob's submission was 'particularly good.'

Sadler now realised that if the project was to go ahead money had to be raised, and for that publicity was necessary. He wanted critics like Roger Fry to write articles supporting the scheme, but although keen

to obtain publicity in art magazines, such as *The Burlington Magazine*, he insisted that he could not bear those expenses himself.

Further publicity was given to the project when the Prince of Wales planned to visit the Town Hall, but this too caused problems. The Town Hall had to be painted for the royal visit, but the walls could not be painted white as this would dirty quickly, and the Town Clerk delegated the choice of colours to Sadler and Rothenstein. These were not to conflict with the intended decorated panels, and Sadler suggested a neutral tint for the walls and dark red for the columns.

Throughout this time the artists were keeping in touch with each other. Paul Nash wrote to Jacob, 'your subject [the miners] sounds an excellent one. My brother is tackling two pastorals – one including Kirkstall Abbey, while I have made designs from the stone quarries and the canal.' Stanley Spencer, Jacob's old friend from his Slade days, had already written to Jacob that he was very worried about where to stay in Leeds, but when some months later Spencer did come on his own to Leeds, Jacob looked after him and took him on a tour, which included the back streets of working-class areas, where Spencer was inspired by the sight of washing hung out to dry. Subsequently on 21 June Spencer wrote to his sister, Florence, 'It would be impossible to describe the place…. I was in the worst slums most of the time. The smells were vile but it was very sad and wonderful. I am particularly keen on the washing day in the slum. I have a magnificent idea for the Leeds picture.'

Wadsworth, whose home was in the village of Cleckheaton, close to Leeds, had promised to visit Jacob, but wrote instead to say that he could not come as he was 'feeling rather seedy' and had to go to London the next day, but 'I must see your work the next time I come North.' Wadsworth was busy in London preparing for the publication of his book, and sent Jacob some flyers for distribution. Also he instructed the *Yorkshire Post* to send Jacob their review copy. Meanwhile Jacob was busy looking for a studio to prepare his drawings, and he had thought of finding a weaving shed to work in. Wadsworth went on to tell Jacob that he had seen Sadler, who 'is delightfully enthusiastic – intends to fight the thing out with every weapon he can get hold of.' He wrote again to tell Jacob that the artists were having a preliminary meeting on 17 June at Albert Rutherston's rooms at 11 New Square, Lincoln's Inn, and that he should bring his designs. He could not put Jacob up, and suggested that Jacob charge any expenses to 'the Leeds account'. To everyone's disappointment Jacob did not turn up, nor did he offer any reason for his absence.

Arrangements were made for a second visit to Leeds and Wadsworth wrote that the Nashes and Spencer were visiting Leeds and would

call on Jacob to discuss the various points agreed at the meeting. Wadsworth then went into some technical details, including the information that the doorway panels were to be painted by himself and Rutherston, the large panels by Jacob and Spencer and the side panels by the Nash brothers. As Wadsworth was anxious that his work and Jacob's should be in harmony, he enclosed a tracing of his design 'so you can see how yours looks with it and which side of yours fits best with which side of mine.' Wadsworth was ready to complete his design and hoped that he would hear from Jacob soon and before he set off for a trip to Cornwall.

There is no record of any reply from Jacob; indeed throughout these months work for the Town Hall project does not seem to have been uppermost in his mind. He was undertaking another portrait of Moynihan, Charles Marriott wanted to reproduce 'Mother and Child' for his book on *Modern Movements in Painting*, Sadler continued to insist on secrecy about details of the Town Hall project, and Jacob continued on his round of opening exhibitions. On 19 June he opened the annual exhibition of Castleford Peasant Pottery. This gave him another opportunity to decry much of what passed for art as 'utterly barren and windy,' while the people who had arranged the exhibition were 'sincere and genuine,' and not 'cursed by the rotting disease of cliquishness and given over to the worship of the ephemeral and obsessed by the ritual of mere words.' This was a curious reiteration of the criticisms thrown at him by Emanuel and Senior.

At the end of June Spencer and the Nashes came to Leeds and finally met Jacob at the Victory Hotel in Briggate, one of Jacob's favourite drinking haunts. Spencer's letter, written on 1 July, expresses great enthusiasm for the Leeds project: 'I am feeling very happy about my idea for Leeds and I feel that I should love to thank you for half that happiness. I should have seen nothing of the side of life in Leeds that I most wanted to see unless you had shown me. You were like a link between me and the people of Leeds which somehow joined me to them.... I enclose a drawing which I should like you to give to your dear mother with my love. Do not forget to send me your reproduction of the big picture [presumably 'Day of Atonement'] which you gave me. I shall be terribly disappointed if this Leeds idea does not come off now.... I hope your mother is better.'

In mid-July a letter arrived from Paul Nash, to whom Jacob had written but at the wrong address (because of misinformation from Rothenstein). Nash thought Jacob's subject excellent and he added, 'We were indeed sorry to miss you and I blame myself for not having written to warn you of our coming.... well we may all prosper in our several directions. I hope to meet you some day.'

Despite a postal strike, by August all the artists had submitted designs and been paid. On 2 September Spencer wrote again saying that he had received the reproduction, the conception of which he thought inspired, but 'you lost sight of the idea when you drew the heads: I like the position of the heads, but they do not seem to belong to one another spiritually like the dresses do…. P.S. I sent design to Rothenstein and he does not seem to like it so my chance I think is very small. But they won't get any other from me.' His drawing of washing on the line, inspired by his Leeds visit and possibly the finest of all those submitted, did not, so Rothenstein thought, fit the general theme; Jowett's drawing was accepted instead. Spencer's angry reaction to this rejection prompted Paul Nash to write to his brother John:

'Now by his stupid action he has let us all down & hung up the scheme. This is certainly not what [Desmond] Coke would call the Public School Tradition nor is it "cricket" so called nor is it anything but bloody non-sensical arrogance on the part of a very young man who has become enlarged in the headpiece. However that may be, Spencer has not fulfilled his undertaking.' Chinks in the project were becoming increasingly apparent.

Eight panels had to be filled and the designs of the six artists were now seriously considered for the final paintings; the Nash brothers submitted two drawings each. All the drawings portrayed some aspect of industrial Leeds, and in the summer of 1920 the *Yorkshire Post* published the sketches together with the reviewer's commentary. Paul Nash submitted a 'View of the Aire from Leeds Bridge', which was later called 'The Canal', and a geometrical drawing of 'The Quarry', which was described as 'Blakelike', the reviewer thinking it much the best drawing. John Nash's Cubist drawings of urban Leeds with rows of industrial cottages and smoke from factory chimneys, 'Landscape and Trees', later called 'Rhubarb and Coal', and his 'Kirkstall Abbey', 'sought for ugliness of form at the expense of truth.' Wadsworth's 'Leeds', later called 'Slag Heap', a semi-abstract of an industrial landscape with a whirlpool of smoke, was criticised as appearing to show 'Leeds being blown to pieces by a heavy gun,' but Rutherston's 'Building', a dramatic architectural rendering of a black church behind a building site, and Jowett's 'Woollen Mills', a geometric drawing of warehouses and workmen figures, were described as charming examples of 'clean drawing.' Jacob's design, entitled 'Mining' or 'Coal Mine' (fig. 51, page 109), a pattern of bending figures and pit ponies in a zigzag of coal seams, was described as 'unrestful'; it was very different from the other designs. The story went around that Jacob had actually gone down a coal mine to prepare for the drawing, but although the picture is dark, there is no feeling of the gloom or danger of a pit,

and despite the fact that it received initial approval from both Sadler and Rothenstein, the latter had his reservations, although he did not spell these out until a few months later. This delay is strange: Jacob's submission was obviously so out of character with the other submissions, in design if not in theme, that one suspects a subversive motive on the artist's part.

The painter, Harold Williamson, also submitted two drawings for the scheme, but these seem to have been rejected.

The process of approval was rather long-winded: after approval by Sadler and Rothenstein submissions had to be passed by the directors of the National Gallery, the Tate Gallery and the Wallace Collection, then they were to be put on public view before the final decision was made by the Leeds City Corporation.

In the meantime both Louis Golding and Epstein were in touch with Jacob. In the previous year Epstein had recruited Jacob and the musician, Cecil Gray, as models for a Christ figure, Jacob providing the hands and feet, and Gray the face for a figure that was exhibited in 1920 at the Leicester Galleries. Now Epstein was planning a group sculpture for a 'Risen Christ' and wanted Jacob to pose as St John. He wrote:

'if you are still in the mood to sit for me, I wish you would. You could be of immense use to me and I hope you will give me an opportunity to make a study of you. I would want to do your head, torso and arms. In return I will sit to you and you can make drawings or an oil study. I hope that you are well and that you have done work that satisfies you. Let me know how you are and what you think of the sitting. I hope you will come soon because I feel full of my idea and am eager to get at it.'

Louis Golding's novel, *Forward from Babylon*, was being published and Jacob had provided a cover drawing, but alas, as Golding wrote:

'I learnt with much chagrin this morning that my blooming old publisher finds your picture "unsuitable." O ye gods! O ye minnows, sprats, roaches, tadpoles and all petty fish! What! Shall I be graced with a picture of a little lady in gloves picking ducky cowslips? Or a big lady in a crinoline playing the harpsichord?

'But with me, Kramer, you'll not be annoyed! You don't know how I want that picture! I don't know what Christian's intended terms were, but I wonder if I could possibly afford it? Let me know there's a good fellow, and (if you'll permit me to say it) a damn good painter!'

This piece of blatant flattery obviously appealed to Jacob because he sent Golding the drawing without charge, and the novelist replied:

'You won't want me to slop out my gratitude. But really you have bucked me up enormously by your sending of that picture. It is not merely the intrinsic fineness of the picture (which a loving study of all your work makes me almost able to appreciate) but it is a symbol of so much more. It means that my book has meant something to one person at least beside myself. Much blood and sweat (however slight the book might seem) and a long and dirty breakdown were involved in its production. And both the quality of your picture and your sending of it shew you have understood. In a word, thanks!….
The first book that comes to me shall be yours!'

The November issue of *Voices* had a reproduction of the picture.

The year could not end without a letter from Sadler, to chide the unreliable Jacob once again, this time for the delay in returning Kandinsky's book, *Spiritual Harmony*, which Jacob had borrowed 'some time ago.'

During the year he had executed a large number of works, including a number of portraits. One of these was of the notorious cult figure, Aleister Crowley, known as 'The Beast', but apart from an upright lock of hair there is little of Mephistopheles about the plump head. If Jacob was still intent on portraying the spirit of his sitters the dangerous essence of Crowley seems to have evaded him. A much stronger portrait is 'Portrait of a Young Man', a dark and fiendish-looking young man with a moustache, the poet Harold Monro, a friend of the Sitwells. Jacob had been introduced to Monro by Epstein in a bookshop below Epstein's flat. The mask-like face indicates the influence of African masks, which under Epstein's influence, Jacob might now have been collecting. In 1933 the picture was used as the frontispiece to Monro's posthumously published collected poems.

In 1919 Bernard Meninsky, Jacob's friend, had exhibited twenty-eight 'Mother and Child' drawings, which were published in book form a year later, and perhaps this encouraged Jacob to repeat this theme. Cross-fertilisation is inevitable, and just as earlier Jacob was strongly influenced by Augustus John and then Gertler, and the strong colours of Ernest Procter, an older fellow-student at Leeds College of Art, he was also influenced by Meninsky's colour sense. Other works by Jacob at this time include two nudes, a red lithograph of Cecilia, again as 'Hear O Israel', and three of his most beautiful works of that time representing young women, which demonstrate Jacob's sophisticated control of colour. The tranquil, rather simplified oil painting, 'Young

Woman Knitting' (fig. 52) and the more naturalistic pastel, 'Woman with a Headscarf' (fig. 53) are both understated and serene studies, as is the pastel, 'Dancer Resting' (fig.54). Viewed from the back and completely devoid of any eroticism, it demonstrates Jacob's ability to draw the figure and his compassion for the vulnerability of the exhausted young woman.

Three years after the Balfour Declaration of 2 November 1917, Zionist organisations were extremely active in recruiting young people and collecting funds to build up Jewish urban and rural settlements in Palestine, and Jacob designed a poster for such an organisation. Very like a piece of Soviet propaganda art, in very simplified form in red and blue pastel and charcoal, it portrays a miner wielding a pick. Included in the top-left corner is a *Magen Dovid*, the Star of David; Jacob, a Zionist supporter like most Jewish artists of the time, was flying his flag. For an artist who rarely engaged with the important events of his time, this was a special gesture. While the work of Bomberg, William Roberts, Meninsky and Jacob's many contemporaries were infused by the drama of their time, Jacob remained absorbed in his personal philosophy of art and the need to express the Jewish soul. However, as his later work showed, either this did not provide him with a deep enough pool to be fished for much longer, or the intensity of his feelings had diminished. Although he continued to be busy and successful, after the work of 1919 truly powerful feeling seems to be absent. The passion and spiritual intensity that produced 'The Jew', 'Pogrom' and 'Day of Atonement' seem to have been replaced by a more peaceful mood. A gentler tone had entered his work.

# 12 THE EPSTEIN BUST

Jacob was continuing with his series of lectures at the Leeds Art Club on 'The relations of shape, form, melody, colour, abstract symbolism and realistic symbolism.' His first talk in 1921 was on the difference between melody and harmony. 'Musical melody,' he explained, 'could be defined as an organic succession of sounds, according to the law of inner rhythm, which must be distinguished from the mechanical time measure. Musical harmony could also be distinguished as an organic combination of various sounds into one synthetic whole, and these could be co-ordinated to a melodic design, but could also exist apart from it. One of the most interesting musical conflicts of our days was just the conflict between those musicians who took the melody as a most important factor, and those that took the harmony as the most important factor.' In describing Debussy's compositions, Jacob said that in most cases there was only a succession of impressive harmonious patches, and many modern musicians could be compared with those painters who had subordinated the design and even the construction of their paintings to the impressionistic principle of this self-sufficiency of colour. He completed the talk by saying that, 'Great painters possessed both of these qualities; and only an organic combination of both could produce work of great artistic value.' It is interesting that despite his constant emphasis on feeling in art this explanation about musical composition is surprisingly mechanistic.

The saga of the Town Hall decorations continued, and on 28 February Rothenstein wrote, 'I like your design in many ways very much indeed. It has excellent qualities, but there is general agreement that it is less suited to a wall painting than for a formal decoration in mosaic, pottery or tapestry. It is suggested that you consider making your figures less of a repetitive pattern, if that is not much trouble to you. The pit ponies also appear consciously toy-like: but perhaps when you carry out a design you give a closer representation of appearance. Of course I would have been happier had I been able to write that your design had been accepted by all as it stands.'

Although both Rothenstein and Sadler had stated their approval of the design, it looks as though the great directors of the national museums had persuaded them to arrive at that 'general agreement'. Jacob's design was different from anything he had done before, and very different from those of the other artists. Indeed it is a rather decorative representation of mining and miners. Jacob's semi-abstract 'Study of a Miner at Work' demonstrates his understanding of the energy and strength of the work, and it is difficult to understand the thinking behind his nursery-wall offering. The figures are indeed toy-like and impossible to interpret as symbols of the muscular and dangerous job of mining. Rothenstein pointed this out when he went on to suggest that Jacob should look at the other designs: 'you will at once realise that you have adopted a convention different from theirs: the designs are all at S. Kensington and if you are up again you may like to see them together.' Then two weeks later, presumably hoping that Jacob would modify the design according to his criticism, Rothenstein wrote to say once again that he had informed Sadler that Jacob's design had been approved, and hoped that 'when you come to work it out, you will find yourself able to give a more adult view of the men and the pit ponies.... I do not believe we are likely to get public decoration until a similar spirit can come into being among ourselves. But you probably disagree.' Rothenstein knew Jacob well, and indeed Jacob did disagree, and whatever reason Jacob offered for not accepting Rothenstein's view, it certainly made the latter more testy, for he replied, 'The important thing is to get away from the tendency to make gestures only; we must get into harness and really show we can pull a weight.' Then with the City Fathers in mind he added that they were dealing with 'men who know nothing... and it is no use frightening them too much at the outset.'

Rothenstein's accusation that Jacob had a tendency to make gestures recalls Bernadette Murphy's criticism that there was no need for Jacob to be 'striking', but that he should be sincere. Whatever his attitude to this commission, it seems unlikely that Jacob would have adapted his work to conform to any convention set by other artists. He would not compromise and the final gouache did in fact follow the initial design. His apparent casualness to the Town Hall project might be explained by his concern with other matters. He was preparing for an August exhibition at the Free Library in Harrogate. The town did not have an art gallery, and the Town Council was trying to convince the people of Harrogate that an art gallery should be part of the municipal equipment. Jacob was well known and therefore something of a draw for the townsfolk.

Jacob showed forty-one works, but before describing these the report in the local newspaper first announced that the Leeds artist was going

to take up residence in London. The collection demonstrated the great variety of styles that Jacob used and 'includes work which is pleasantly and sanely old-fashioned, with a full representation of the artist's experiments upon the lines called 'new'. Among the work which rises superior to the vagaries of fashion are several portrait studies of women clothed with a richness which gives Mr. Kramer full opportunity of displaying his remarkable powers as a colourist. 'An Italian Girl' is delicious for its blaze of hot reds and yellows against a background of brick-red.' The review extravagantly compared the 'Spanish Gentleman' to a 'Frans Hals expressed in the language of Murillo', but its comment on 'The Jew' was qualified. 'This picture is not without interest of a certain monumental quality, but it may be accepted as the Jew of one mood, certainly not the whole Jew… nothing here of the patriotic idealist, the Zionist, nothing of the radiant beneficence that hospitals and other good works know well, nothing of the clever and often flamboyant Jew that one meets in a Disraeli novel, and quite often in real life. The Jew as pictured is the Jew down-trodden, homeless, abject, hopeless, and without even the mentality adequate to the traditional trades of the lowest of his race.' The review continued to praise other 'frankly naturalistic portraits… the old fashioned… marred by no eccentricity.' Even the review in the *Yorkshire Observer*, always sympathetic to Jacob's 'new' work, was reserved in its comment. 'The number of slight portrait sketches in pastel… quite charming… exceeds that of works of a more serious character.' It too praised the vitality of the 'Spanish Gentleman' and 'An Eastern Woman' lent by Mr T Heron (father of the Abstract Expressionist, Patrick Heron) as the finest creation in rich, warm colours; it praised some of the portrait drawings as work of great subtlety and delicacy of line, finely modelled, but there was a hint of disappointment in the comment on the exhibition. Jacob cannot have been too happy, especially with the comments on 'The Jew'. To him the essence of the Jew was not clever, flamboyant, rich and generous, or abject and hopeless, it was contemplative in its spirituality.

Over the years Jacob's friendship with Epstein had grown, they were part of the bohemian community that met at the Tour Eiffel and Café Royal, and became intimates sharing models and girlfriends, but they were by no means equals. Epstein had already gained fame and notoriety, and in later years, when asked which artist he most admired, Jacob had no hesitation in naming Epstein. Jacob was one of the many that met regularly at the Soho public houses, an activity not always shared by his sister, Sarah and her husband-to-be, the anti-social William Roberts. Sarah has described the contrast between Jacob's careless and erratic ways and Robert's compulsive commitment to his easel, and her son, John, described his uncle's inability to sit still, to be solitary at his work, and his constant need for conviviality. It seems

unlikely that these common features of the drinker went unrecognised by his perceptive sister. In later life in Leeds Jacob's commitment to beer and to the whisky bottle were well known and the source of much gossip and amusement.

During 1921 Jacob sat for Epstein's group entitled 'Risen Christ', but the group planned was never completed. However, the bust he made of Jacob's head, chest and arms, now regarded as one of Epstein's finest, is an immensely perceptive portrait (fig. 55). Epstein knew his friend well, and the bust shows a highly-strung man in a state of some agitation. In reporting the sitting, Epstein said that 'Kramer was a model who seemed to be on fire. He was extraordinarily nervous. Energy seemed to leap into his hair as he sat, and sometimes he would be shaken by queer tremblings like ague. I would try to calm him so as to get on with the work.' Such behaviour would not merely manifest Jacob's anxiety at sitting for his respected friend, even though the sittings were very long and demanding. Epstein's description indicates something more urgent: sitting hour after hour Jacob badly needed a drink. By now he was an alcoholic, and his agitation was more than likely a sign of *delirium tremens*. Such a conclusion is supported by a piece of verse that Jacob wrote on the back of the invitation to the Harrogate exhibition:

> *Drink, drink, deeply drink*
> *Never feel and never think;*
> *What's love? What's fame? a sigh, a smile*
> *Friendship? But a hollow wile.*
> *If you have any thought or woe*
> *Drown them in the goblet's flow*
> *Yes! Dash them in this brimming cup;*
> *Dash them in, and drink them up.*
> *Drink, drink, deeply drink*
> *Never feel and never think.*

Although written in his own hand we cannot be sure whether this piece of doggerel was his own composition or remembered from elsewhere. Either way, it is immensely disturbing, indicating profound unease and anxiety, and that he used alcohol as a temporary 'tranquilliser'. A decade later Jacob said of the sittings for the bust that he sat for three weeks from nine am until the last bit of light went, with only half an hour for lunch. 'Epstein is a fiercely concentrated worker.' It was an experience that would have taxed anyone.

Although Jacob had enjoyed real artistic success and achieved celebrity status, at least in Yorkshire, it had been at considerable cost. The execution of the work and the need to satisfy his own aspirations

in the search to define the spiritual in the object, taxed his physical and psychological energies, while the critical comments, unkind invective and rejection of his work had taxed his spirit. Jacob had not simply adopted his own particular style, he was on a mission, and one of his sitters in later years described how he always wore a hat while painting, as though painting was a religious exercise. The exchange of views with Herbert Read in the letters of 1918 support this notion, and if Jacob felt that he was losing hold of his God-given ability to 'see', this would have reinforced his anxiety and increased his dependency on alcohol, which he may well have believed could actually enhance his special blessing. Thus the habit, as in all drug taking, became self-sustaining.

In his lectures Jacob was never content just to describe his work and his intention, but always emphasised his idea of what art should be. All too frequently his audiences were critical, even hostile, and there is no clearer picture of his frustration and feelings of hurt than in a talk that he gave to the Bradford Rotary Club in December 1922. By this time his work had been restricted almost entirely to portraiture, and there was little if any of what he would call serious art. The President of the Rotary Club, Mr Charles Ogden, introduced Jacob by saying that he was a gentleman who had risen from humble circumstances and achieved distinction by 'his own personal assiduity.' In those four words Mr Ogden summarised years of aspiration, dedication and intense work.

'Serious art,' Jacob said, 'was intensely tragic, and without an occasional break the artist could not carry on. It was pathetic and almost heart-breaking to strive with or without success to give an intensity of feeling, and then to realise the light-hearted feeling so frequently shown toward the work… the history of art showed that the greater the work the more frequently was it received with derision, if not with absolute contempt by contemporaries. Unless the artist could realise the humorous side of this treatment he was overwhelmed by its influences.'

Although he then made a joke about today's serious criticism being the jokes of tomorrow, it is impossible to believe that Jacob could view criticism so lightly. He described how as an art student in Leeds he had been devastated by the apparent rejection of his work for an exhibition in Bradford, for which other students' work had been accepted, and then the joy of finding that a mistake had been made, and that his six drawings had been accepted. His emotional investment in his work was enormous and difficult to maintain, and as Max Glatt writes in his book on alcoholism, 'a heightened degree of sensitivity may be one of the various factors leading to heavy drinking in creative artists.' Jacob's sensitivity, restlessness, unreliability, disorganisation and

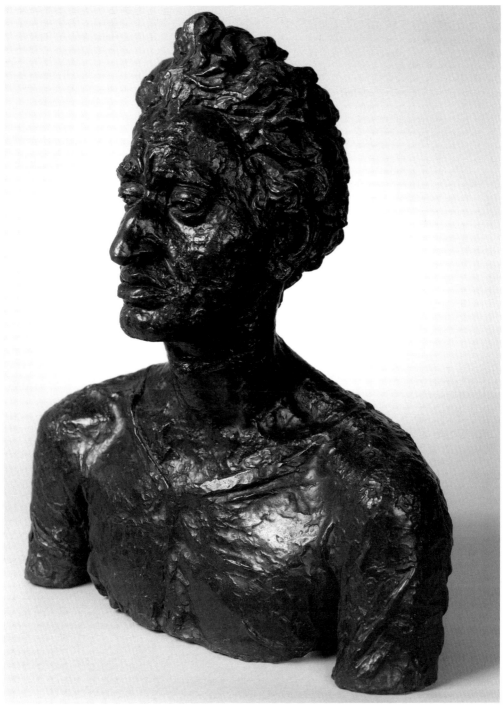

FIG. 55
Epstein bust of Jacob
*bronze*
1921

vacillation, all symptoms of anxiety, were to become worse over the years. His past had left him insecure, an insecurity masked by his courage and affability; then came the devastation of the loss of his beloved father followed by that of his young brother. Nevertheless, these hardships saw the transformation of a talented but insecure immigrant boy into a passionate artist and animated, if not always articulate, lecturer.

Jacob's year at the Slade, his release from the constraints of his family and the Jewish community and his involvement with the art community of the capital, the bohemian set with its 'advanced' views about sex, responsibility to each other and to society at large, were accompanied not just by tea and large slices of cake at Lyons teashops, but by beer and spirits, and the *jeu d'esprit* of the public bars, which in later years were to become his retreat. Many enjoy this progression through student life without damage, but Jacob's insecurity would make him vulnerable to alcohol.

Another bitter disappointment must have been his failure to be appointed an official war artist; after all, Spencer, Nevinson, Bomberg, Meninsky and Roberts, as well as others of his friends and contemporaries had been so recognised.

Jacob had to face a further personal dilemma, one faced by many artists, especially those from a poor background, and that is the conflict between family responsibilities and the drive to creative work. William Roberts responded to this by rejecting his parents, even crossing the road to avoid his father. His work came first and in this he enjoyed Sarah's total commitment for the rest of his life. Millie was seventeen, going to the Leeds College of Commerce and living with her mother and Leah at Beecroft Grove. Jacob was the breadwinner; nevertheless he was determined to go to London. Since his time at the Slade he had split his life between Leeds and London, and he felt that the capital offered greater opportunities than the philistine northern city.

By the autumn the Town Hall project was making rocky progress. Sadler worried about mounting expenditure, the City Fathers procrastinated, and Sir Charles Holmes, Director of the National Gallery, and the other gallery directors thought this time of depression 'unpropitious' for so large an expenditure of public money.

Another setback to Jacob and to his fellow artists came when in the October of 1921, after so much delay and uncertainty, the fate of the Town Hall decorations was sealed. Sadler wrote: 'I have now, for the first time, had the opportunity of seeing together the designs which you and the others have prepared for the proposed decoration of the

Leeds Town Hall. While greatly admiring many of the designs, and not least your own, I am clear that the designs, taken as a group, are discordant with one another and would not be suitable for collective decoration. In these circumstances I regret to say I am not prepared to recommend them to the Leeds City Council for acceptance.' He went on to say, 'My own conclusion has been reached after very careful study and will not be shaken by whatever anybody says.'

Two days later Sadler wrote to say that he proposed to give the designs to the British Museum Print Room, but they were turned down, and Sadler then wrote to the *Westminster Gazette* describing, with hindsight, the problems involved in such a work as the Town Hall project, in which each invited artist had been free to follow his own ideas. 'This freedom resulted in a number of works of great individual merit' and in this regard he singled out Jacob's design, but in future he suggested such a project should be in the hands of one artist, free to change his plans and not subject to restrictions from a committee. Sadler had laid great store by the project and invested quite a lot of time and money in it, and he placed the blame for its failure on Rothenstein's shoulders. Rothenstein apologised for any shortcomings on his part, but he resented Sadler's decision to call off the enterprise, which he felt was 'contrary to the original spirit of the venture,' and pointed out that he thought the directors of the national galleries, as 'referees', also had a say in the outcome. In response Sadler then redirected the blame for failure at the City Council.

Inevitably there was much ill-will from the rejected artists, who claimed that photographs of their designs in the newspapers infringed their copyright, and Rutherston threatened to take legal action against the *Yorkshire Evening News*. Writing to Jacob, Sadler said that his offering should be executed on a smaller scale than would be required in the large spaces of Leeds Town Hall, and when Rothenstein agreed and asserted that a smaller building should have been chosen, Sadler was piqued and thought Rothenstein an ass for keeping up the controversy. He seems to have been unwilling to acknowledge that it was his grandiose idea of bringing culture to the people of Leeds that might have been wrong-headed. As Tom Steele writes, it was 'typical of Sadler's grasshopper enthusiasm of skipping from one visionary scheme to the next, without seeing it through.' However, Sadler had an admirer in Roger Fry, who in letters to Vanessa Bell wrote, 'Every time I came to Leeds I got more and more impressed with the work Sir Michael is doing. He had civilised a whole population. Since I went to Leeds the first time more than ten years ago, the entire spirit has changed from a rather sullen suspicion of ideas to a genuine enthusiastic intellectual and spiritual life.' But Fry could not see that Jacob Kramer had in any way been an agent of that change, and after

visiting the Sadlers in 1923, he wrote off Jacob as a 'bloody fraud' who 'takes them all in by his high falutin.'

Jacob wrote to Aitken at the Tate. Sadler's son had the designs, but when Aitken sent a van to collect them the driver did not have a written authority to pick them up. Then there was talk of exhibiting the designs in Leeds Art Gallery, and eventually they went on tour to be shown in Birmingham, Leicester, the Royal College of Art and of course Leeds.

However, some good news for Jacob did follow. Lord Henry Cavendish Bentinck MP, a Trustee of the National Gallery and possessor of one of the most famous art collections in England, had seen and admired one of Jacob's portraits hanging in Sadler's home. The sitter was unknown and Bentinck's request for the sitter's name seems to have been ignored. Bentinck wanted to buy it and keep it for a year for his personal enjoyment before giving it to the Tate Gallery or the Contemporary Art Society. He offered Jacob £30, which was accepted, and the picture was sent to Bentinck's home in London. There was further confusion, however: Sadler had given Bentinck Jacob's address in Chapeltown, where Bentinck sent his cheque, but by then Jacob had left for London where he was to settle at 14 Bartholemew Road, South Kentish Town.

Further good news came from Selig Brodetsky, then lecturer in Applied Mathematics at Leeds University and a prominent Zionist. Brodetsky wrote that Lord Rothschild was prepared to give Jacob a sitting on the afternoon of Tuesday, 8 November. This presented Jacob with a problem. The little house in Leeds was not a suitable place for the eminent sitter, so Jacob asked Sadler if he could have the use of a large room in his grand house at 41 Headingley Lane. Sadler was agreeable provided the room was available at that time, but warned Jacob that the big room could only be heated inadequately and they must avoid giving his Lordship a cold. In the same letter he told Jacob that both Mr Aitken of the Tate and Mr Dodgson of the British Museum had spoken warmly of Jacob's design.

Even from such an eminent person as the Vice Chancellor, Lord Rothschild deserved respect and some small sacrifice, and because Lady Sadler had to be at a lecture, Sadler arranged to cancel some committee meetings and invite Rothschild and Jacob to tea, extending the invitation to Brodetsky. A satisfactory afternoon's work was concluded, for the portrait was included in Jacob's exhibition at the gallery of Messrs Leger and Son in January 1922.

Before the year was out Jacob was to make a new and valuable friend in the baritone, George Parker. The singer was due to give a recital of

songs on 11 December at Collingham Bridge, not far from Leeds, and Kester, cartoonist at the *Yorkshire Post*, arranged for Jacob to travel to the venue with Parker, who wrote, 'When I first saw Jacob, I was very much impressed with his well-dressed appearance and his dignified looks.' The recital included songs by Hugo Wolf, a composer new to Jacob and much to his liking and Jacob invited Parker to sit for him the next evening at his studio in Mount Preston. Apparently it took Jacob a long time to get him into a good position as the only light was from an incandescent gas mantle. During the sitting Jacob had him sing some of the songs he had sung the previous night. Parker said that this pastel portrait was 'a remarkable piece of work.'

While increasingly involved in the bohemian lifestyle of Augustus John and his circle the volume of Jacob's work reduced. His celebrity was now well founded, but the exhibition in Harrogate was his only show in that year.

# 13 THE BOHEMIAN LIFE

On 16 January 1922 a Certificate of Naturalisation was issued to Jacob, address 14 Bartholomew Road, South Kentish Town, and an Oath of Allegiance was sworn on 1 February before Brow Dickinson JP of Leeds. Despite the London address Jacob was in Leeds.

Before this year there had been a frequent correspondence between Jacob and Sadler, the latter usually offering advice and financial support, but in 1922 there were only two brief letters recorded from Sadler, one to say that he was too busy to see some pictures that Jacob wanted him to look at, and nine months later when Sadler sent him a message from a dealer. Sadler was a very busy man, and no doubt making plans to leave Leeds for Oxford, where in 1924 he became Master of University College. After the fiasco of the Town Hall decorations it is likely that Sadler had had his fill of artists and especially of the unreliable and stubborn Jacob.

Portraits now dominated Jacob's activity as they were to for the rest of his working life. He was not to return to Jewish themes until many years later. 'Some Views on Portrait Painting' was the subject of his talk to the Leeds '19' Club on 22 March at the Metropole Hotel. The talk elicited the headline 'Mr. Jacob Kramer chats about his art' in the *Yorkshire Post*, and it is testimony to Jacob's easy skills as a lecturer that he was able to amuse his audience while making his point that 'Portrait painting is one of the highest forms of art,' being next in his opinion to 'purely creative art… it comes in the realm of psychology.' Inevitably he claimed that 'to get to the highest results it is necessary not just to see a person, but also to get to the spiritual side of the man.' The popular painter, he described as too commercial, and this was reflected in his work. The photographic image was the popular ideal for portraiture, and the more photographic the portrait, the more popular its appeal. The expression of the inner values, the symbolism, often sets the portrait painter in conflict with his subject. He went on to make the point that, 'To be paradoxical, what is missing may be of more value than what appears. Cromwell's wart was interesting from

FIG. 56
The Philosopher
*lithograph: 45 x 30cm*
1919/1922

a literary and biographical point of view, but it was quite immaterial whether it appeared on the canvas or not.' He concluded by saying that he had had the privilege of painting a few distinguished Leeds businessmen, with varied success. 'The task is rather an ordeal, because they generally find that "art is long and time is fleeting" – and that telephones are ringing.'

Jacob could well have had in mind conflict with university vice-chancellors and surgeons as well as businessmen, for he was about to paint a second portrait of Sir Berkeley Moynihan. Another commissioned portrait was that of the aforementioned Mr Brow Dickinson, chairman and managing director of The Public Benefit Boot Company, and a magistrate. As to the fee, Jacob was paid in kind – twenty pairs of boots! The portrait was presented to Mr. Dickinson before four hundred of his employees on 24 May at Leeds Town Hall, on the occasion of the incorporation of the company. It was a happy occasion starting at noon and finishing at 11 o'clock, the last three hours spent in music and dancing. Unfortunately, Mr Dickinson, who had a little pointed beard, was not happy with the portrait. He said it gave him a devilish look, to which Jacob gave his almost inevitable reply that he did not paint the face, he painted the soul.

The second portrait of the great surgeon was painted in the studio Jacob had set up at Preston Cottage in Little Woodhouse, and it was received no better than the first. Moynihan wrote to Jacob, 'I showed the portrait to my wife and some friends today. Their verdict is confident. My wife said, "it is perfectly horrible" and that it is "absolutely wicked" to paint such a picture. That the face is the face of a corpse, with no resemblance whatever to mine. She will not have the picture in the house! This is serious to me because it was intended as a gift to her. Come down and look at it with me again.' A further letter followed, unlike the first, typed and signed with a rubber stamp: 'If you have any desire of rescuing your picture from the flames please

come and see me about it as soon as you can. Believe me, yours very truly.'

There then ensued an exchange of lengthy letters, in which each of the combatants provided their views on art in general and the portrait in particular. From the sitter, whose wife has been reduced to tears, 'Art cannot be false.' From Jacob, 'I feel I have depicted a man of force.' And from the press:

'The other night I had the good fortune to see Mr. Jacob Kramer's new portrait of Sir Berkeley Moynihan. I venture to prophesy that, if the portrait is ever exhibited in public, it will give rise to some fierce discussion.

'It is a powerful piece of work. The head stands out from the canvas almost as if it had been modelled in clay. But the first impression is that the face is too grim, and the flesh tints are not warm enough. Then, if you have time to study the portrait, a change seems to come over it. The sternness seems to melt away from the features, and the face becomes alive and smiling, just as Sir Berkeley does smile when he is standing with his back to the fireplace and talking about something that interests him. Much the same thing happens in the case of the hands, which are represented as folded one on top of the other on Sir Berkeley's lap. At first I thought that Mr. Kramer had… just scamped the hands. But, when I sat down and studied the picture from a distance, what looked like a mere dab of colour took life, and the long, supple fingers of the surgeon stood out distinct, even to every joint…. there is no denying there is something extraordinary about it.'

Like many of Jacob's sitters, the Moynihans were looking for the immediacy of the photograph, just as Jacob had described in his lecture. He asked Moynihan if he could exhibit the portrait without a name as 'Portrait of a Surgeon'. No doubt Jacob was comforted by the fact that Henry Bentinck was very pleased with the portrait he had bought, and still wanted to present it to the Contemporary Art Society.

Both Brow Dickinson and Moynihan lived in or near Leeds, which meant that Jacob had had to travel from London to do that painting. Given that the work on many paintings, such as the 'Day of Atonement', cannot be pinned precisely to one year, the record of this work can be dated fairly accurately, but the location of Jacob's workplace at this time is uncertain. Nevertheless, despite Jacob's expectations of London, it does seem that most commissions came from the Leeds area. Examples of these are the strong portrait of Sam Nagley, that of a Leeds GP, Dr Isaac Silverton, and a caricature of the Leeds solicitor, Louis Godlove.

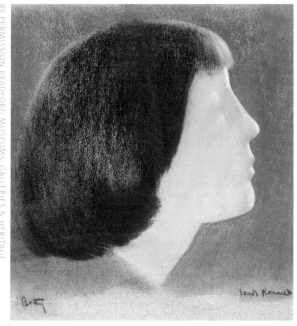

FIG. 57
Betty
*charcoal & pastel*
*on paper: 44.5 x 32 cm*

However, 'The Philosopher' (fig. 56), a tightly controlled Cubist lithograph from a woodcut, could have been made in either Leeds or London. This is one of Jacob's strongest works in which the philosopher's black figure is linked to scattered sheets of paper through his hands, the left on his head and the right on the paper.

Jacob's residence in London appears to have stretched over three or four years, in which time he renewed his attachment to Augustus John, Wyndham Lewis and the bohemian group. One recent member of this group was the South African poet, Roy Campbell, considered by many of his peers, such as T S Eliot, Dylan Thomas and Edith Sitwell, as one of the finest poets of the twentieth century. Aggressive, bombastic and mercurial, a great drinker possessing legendary power with women, and he was nicknamed 'Zulu' as he was fluent in the Zulu language. His wedding to Miss Mary Garman, also a great drinker, took place on 11 February 1922 at the 'Old Harlequin', a Soho night café on Beak Street, behind Regent Street, which had rooms above the café. The Harlequin had been established by a former Café Royal waiter and was a popular venue for artists. Mary's sister, Kathleen, became Epstein's model, long-term mistress, mother of three of his children and eventually his second wife. Mary drove a van for Lyons Corner House and both sisters were part of the bohemian set. During parties they lit their flat with naked flames from the gas jets, and at one party Jacob's hair caught fire. Kathleen screamed, 'Jacob, you're on fire' and Jacob frantically patted his hair to put out the flames.

The wedding of Roy and Mary is described in some detail by Joseph Pierce in *Bloomsbury and Beyond: The friends and enemies of Roy Campbell*, and by Wyndham Lewis in *Blasting and Bombardiering*. For the wedding Campbell had borrowed an old-fashioned frock coat from a waiter at the Eiffel Tower Restaurant in Charlotte Street, and as Lewis reports it:

'The marriage feast was a distinguished gathering, if you are prepared to admit distinction to the Bohemian… almost gipsy in its freedom from the conventional restraints. (In the middle of it Campbell and his bride retired. The guests then became unruly.) Jacob Kramer and

Augustus John were neighbours at table and quarrelling, Jacob Kramer showing Augustus John his enormous biceps [which] expanded convulsively under his coat sleeve. John was not interested but Kramer looked as if irresistibly attracted… a sort of symbol, he seemed to feel, of Power.

"I'm just as strong as you are John," he kept saying.
"You've said that before," John answered gruffly.
"Why should I put up with your rudeness, John – Why? Tell me that John. You're a clever man. Why should I?"

Augustus John ignored this when Roy Campbell entered in his pyjamas. Someone had slipped out to acquaint Campbell with the fact of this threat to the peace…. In dead silence the bridegroom with catlike steps, approached the back of Kramer's chair, who was still exhibiting his biceps.

"What's this Kramer," barked Campbell, fierce and thick, in his best back-veldt.
"What are you doing, Kramer?"
"Nothing," Kramer protested in injured innocence.
Campbell threatened to throw him out of the window.
"Well then leave my guests alone."
"I'm doing nothing to John…. I was talking about painting….
I get worked up when I talk about painting.'"

In his book, *Light on a dark Horse*, Campbell alludes to Jacob as that 'loveable Jewish giant who was a good boxer.' As Pierce points out, they were friends but with a healthy respect for one another's physical reputation. Campbell said that they were slightly afraid of each other. It was therefore 'a piece of bluff and bravado on the simple minded Jacob' which Campbell performed out of gratitude to Augustus John adding that 'few others would have risked so much.'

The Harlequin episode points up how labile Jacob's mood could be, especially when in drink.

At this time Jacob was about thirty, an age when his mother would have expected him to be married and giving her grandchildren in addition to Sarah's only son, John. Although Cecilia had readily accepted the non-Jewish William Roberts as son-in-law, according to Sarah, Jacob was reluctant to give his mother a non-Jewish daughter-in-law from amongst his girlfriends, some of whom were his models. One of these at this time was Betty May, a famous model, who wrote a novel entitled *Tigerwoman*. She had been Epstein's model and mistress. Photographs of Betty May taken in 1924 and signed 'To

Jacob, with love, Betty May', show a handsome young woman with
a strong face, dressed in a gypsy-type scarf, possibly when modelling.
Jacob made several weak pastel portraits of Betty May, but her strength
is best represented in a more powerful and sculptural portrait (fig. 57).
Betty May had a dubious reputation, and in Epstein's autobiography,
*Let there be Sculpture*, he describes an episode involving Betty May
and Jacob, 'the typical Bohemian, and I recall his waking me up one
morning to ask me to go to Marlborough Street Police Station to
speak for his model, Betty May, who had been in a café dispute, thrown
a glass at my enemy (?). I went, and there was the model with all her
friends in court.… I said in answer to the magistrate that Betty May as
to my knowledge was most gentle but temperamental, and must have
been provoked. The magistrate repeated: "Gentle but temperamental.
Three pounds." With that the happy band of Bohemians went to the
Café Royal for drinks.' Animosity between the women in Jacob's life
was demonstrated when in a drunken brawl the American painter,
Nina Hamnett (fig. 58), a great tippler, put Betty May in a dustbin.
Benedict Read, in his notes to 'A Centenary Exhibition', tells us that
Jacob's portrait of Nina Hamnett, once hung in the 'Restaurant de la
Tour Eiffel, a favourite haunt of London's avant-garde. The owner,
Rudolf Stulik, was one-time chef to the Emperor of Austro-Hungary,
and welcomed young artists to his restaurant, often allowing them to
pay for their meals with their works rather than with cash.' One wonders
how many meals Jacob was fed for the portrait, which Read describes
as brightly coloured with free brushwork recalling the work of Matisse
and that of Jacob's friend, 'the English Fauve, Alfred Wolmark'.

Jacob's association with Lord Henry Cavendish Bentinck MP resulted
in Jacob being elected an honorary member of the 'Little Movement',
of which Bentinck was the president. Like Frank Rutter and Michael
Sadler in Leeds, and William Rothenstein in Bradford, Bentinck was
keen to bring culture and patronage to industrial England. The objects
of the 'Little Movement' in Nottingham were to encourage conditions
for the unhindered development of artists and craftsmen, and to
emancipate the arts from commercialism. Jacob's persistence in
following his own ideas exemplified these aspirations. At about the
same time he was elected Honorary Secretary of the Northern Society
of Artists and Sculptors, and his attachment to the north was further
confirmed when he was invited to address the Bradford Rotary Club
at the Royal Restaurant in December. This was the talk referred to
earlier, in which Jacob discussed what he believed to be the 'intense
tragedy' of serious art, and opened his heart about his own difficulties
with rejection. He spoke of the role that many people in Bradford,
in particular Mr Arthur Gledhill and Dr Campbell, had played in
helping his career and that of other artists. In speaking of his personal
experiences he cited one very outspoken Yorkshire dealer who in his

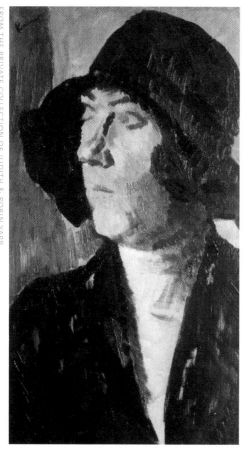

FIG. 58
**Nina Hamnett**
*oil on canvas:*
*53 x 30.5cm*
c1926

presence ferociously denounced his work but with equal vigour praised them to his customers. Jacob also described making several studies of a man who claimed to be a descendant of Disraeli, 'although it would be news to historians that Disraeli had any descendants,' and how he had painted the last of the London cabmen, who was so well known in the area around the Royal Academy and Chelsea that he greeted artists in the street with, 'Do you want my dirty mug today, sir?', and when the offer was declined, he would remark, 'No blinking Royal Academy this year!'

Jacob finished his talk by saying that a complete portrait should be a monument to the man's life, strongly moulded and conceived. The artist must feel as well as see, but there were few modern portrait painters who impressed by their sincerity, though many pleased by their dexterity.

These were uncertain years for Jacob. He seems to have been at work mainly in Leeds and at play in London. At this time the Roberts were living in Percy Street near the Fitzroy pub, where artists, except for Roberts, congregated. Betty May was a regular there and according to Sarah, 'She had an adventurous love-life,' and Jacob was very attached to her. They set up house in Soho, where Cecilia and the Roberts visited them. In Sarah's account it was a 'tumultuous relationship,' and in one of their fights near the bathroom Betty May hit Jacob so hard that his false teeth flew out and into the lavatory. Their relationship might well have lasted until Betty May was displaced in Jacob's affections by Dolores, as testified by a photograph of Roy Campbell looking happily at his wife Mary, with Jacob, his arm around Dolores in a headscarf, her face a picture of sweet rapture (fig. 60).

Dolores was one of the most intriguing women in Jacob's life. She was born in 1892, the daughter of the Reverend J E Schofield, and in her life knew wealth and fame but also poverty and obscurity. She modelled for many painters and sculptors, including Epstein and Augustus John. At eighteen she danced before the Kaiser and at twenty appeared at the Alhambra Theatre, where she scored a great success. Epstein called her the High Priestess of Beauty, 'her endless

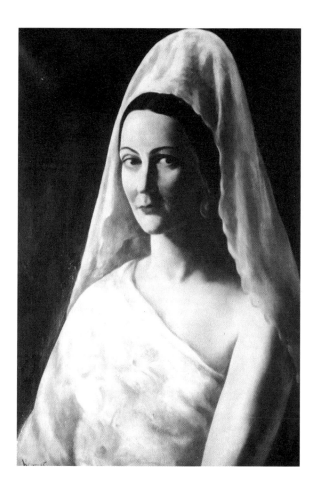

FIG. 59
Dolores in
Spanish costume

amours were a boon to Fleet Street journalists.' She was a model for perfume and cosmetic advertisements but not a model of propriety, and it seems that she appeared before a magistrate 'for some indiscreet conduct in Piccadilly.' Like Betty May she had been Epstein's model, but perhaps not his mistress, and in later years was to serve the familiar dual role for the painter, John Flanagan. Dolores was described as a dark-haired flamboyant woman who became known as 'Queen of the London Studios', and as June Rose writes in her *Life of Epstein*, an exhibitionist who enjoyed taking off her clothes. Her relationship with Jacob, which seems to have lasted several years, was also turbulent, as shown by a series of photographs taken in 1925 and found in a book on Epstein's work. On these she had inscribed:

'Jacob Kramer I kill (?) you. But I worship you [sic] work. Dolores 1925.'
'I love you always Jacob Kramer – but! Dolores.'
'You must have given to me the capability of sitting to you Jacob Kramer – because I've been happy and sad. Dolores.'
'Now that I "love you" Jacob – I understand. And I do! Dolores.'

ooooo

Jacob's pastel portraits of Dolores dated 1921/22 and 1930, both of which show her in repose with eyes closed, give no indication of the glamorous creature portrayed by Jacob in Spanish costume (fig. 59) and described by T A Lamb in the *Yorkshire Post* (August 1934). Lamb had first met her with Epstein, when she was dressed 'in a shimmering green robe, which emphasised her graceful figure,' and he remembered her at Flanagan's parties as charming with everyone, whether a notable or struggling artist, greeting every guest with a hug and a kiss. Lamb possessed a study of Dolores by Flanagan, and in 1933 Jacob and two friends visited his rooms wanting to buy the picture. Lamb refused to part with it at any price, and when Jacob asked Lamb whether the

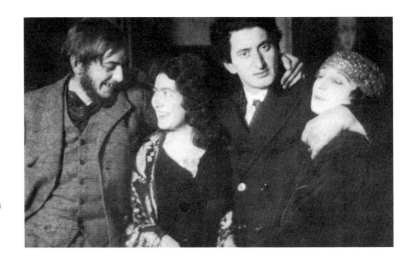

portrait looked like Dolores, Lamb replied, 'a glorified Dolores,' at which point Jacob revealed that the female visitor was indeed Dolores, much older but charming as always. This was not long before she was taken ill and in 1934 she died in poverty. Under the headline, 'Tragedy of Famous Model,' the *Yorkshire Evening Post* reported that her last public appearance was in the autumn of 1932 when she fasted in a barrel at a fun fair in the Tottenham Court Road. Before she died she called in some distress at the *Post* offices with a simple request, 'Please promise me not to publish anything about me. All I want now is quiet.'

In 1922 Jacob showed two works with the London Group. One was a portrait of a Lillian Shelley and the other a picture entitled, 'Drink Deep or Taste Not'; both are lost.

# 14 UNCERTAIN YEARS

For several years Jacob continued to travel between Leeds and London. The capital was the heart of the bohemian life and innovative artistic activity, but one sign that Jacob's heart was in Yorkshire was his continuing access to a rented caravan on the moors, to which he offered repeated invitations to Augustus John. But although John replied from both his homes in Chelsea and Dorset that he would like to take some walks with Jacob, sample some of the pubs Jacob mentioned, and even work alongside him, he was always too busy, and on one occasion wrote that he had hurt his foot. Jacob had not resolved his residential arrangements quite as positively as had John, but many people knew that he had taken up residence in London. In 1923 David Lascelles, the son of Lascelles Abercrombie, the poet and critic, who was at that time Professor of English Literature at Leeds University, wrote to Jacob to see if he could help him locate Jacob's portrait of Aleister Crowley. In that letter Lascelles added that his father had wanted to meet Jacob for a long time, and if Jacob had been in Leeds they must surely have met.

Jacob put forward many arguments for leaving Leeds for London, but his need to create a bridge across his divided aspirations was manifest when he told a London journalist that he was preoccupied with a scheme for forming a Society of Yorkshire Artists in London. Jacob knew that there were quite a number of such artists in London, some doing well but others living a precarious existence. As he said, while many Yorkshire artists were happy to stay in their native surroundings, others despairing of Leeds's lack of appreciation of the new ideas in art 'have been driven out of her gates… to sacrifice their most cherished aspirations for pot-boiling work in an artistically over-crowded Metropolis.' Nevertheless, despite the fact that a short time before Jacob had expressed the view that Leeds was 'hopeless' from the point of view of 'modern' art, he added that he was rather optimistic about Leeds becoming a centre of creative art. 'The canons of orthodox art,' he said, 'have been broken long ago by various movements which, though unpopular, have nevertheless afforded convincing proof that

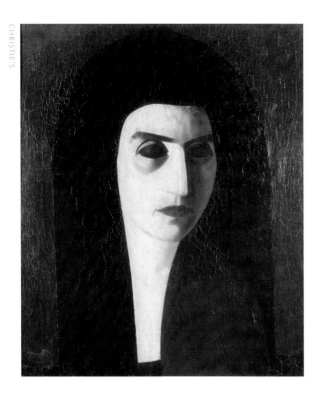

FIG. 61

The Jewess

*oil on canvas*

1923

the new generation of artists are being urged irresistibly towards new conceptions.'

It is possible that Jacob was thinking of Henry Moore and Barbara Hepworth, both young Yorkshire artists. Jacob went on to say that early encouragement is vital to an artist's career, that without it 'many have gone to the wall,' and that fortunately 'there are isolated places in Yorkshire where businessmen and dealers make sacrifices to help rising artists.' He blamed the big dealers for stifling young Yorkshire artists, but in declaring that other and progressive forces were at work – 'an opening out of minds to new ideals' – Jacob cited the case of the Leeds Art Gallery, now under Mr Kaines Smith, where 'improvement has become manifest to everybody and it is rapidly becoming the centre of a broader outlook. Recent acquisitions show that wealthy art lovers of Yorkshire are determined to remedy the shortcomings of the gallery and to make it worthy of a great city.'

Jacob expressed his great affection for Leeds, hoping to show some of his most important work there, as well as to organise an exhibition of the work of Yorkshire artists exiled in London, work which will have outgrown early Yorkshire influences without losing the virility of the Yorkshire character.

In 1923 Jacob had works in four exhibitions. Two of these were at the Whitechapel Gallery where a drawing of 'Millie, my sister' was shown in the 'Modern' section, and seven pictures were in the Jewish Exhibition. The portrait of Aleister Crowley that David Abercrombie was so keen to see was shown at the Goupil Gallery, but the picture that received most attention was 'The Tragedienne', shown at the Bradford Spring Exhibition. The reviewer in the *Yorkshire Post* described it as modern 'but its modernity does not detract from its beauty'; it is 'the finest bit of work of the kind Mr. Kramer has ever done.' He describes the picture as of a seated woman looking at the sky; a yellow scarf thrown over her head hangs down over her shoulder against a dark red dress, the figure standing out from a dark blue background. 'That

is all; but the simplicity of it, and the beauty of the lines and curves grow on one the more one looks at it… . I venture to prophesy it will be one of the outstanding features of the exhibition, though people will dispute with vehemence what it means.' Alas, like so much of Jacob's work it has disappeared.

In complete contrast to this multi-coloured work is 'The Jewess' (fig. 61) shown at the Empire Exhibition of that year, another powerful example of Jacob's Expressionist work, recalling such paintings as 'Ruhala'. It is an austere portrait in which the forbidding face with Jewish features, heavy-lidded dark eyes and aquiline nose are in a plane forward of the simple strong arch of her hair. An arch around the head gives the picture the structure of an icon. It is possible that Jacob, a young Jewish boy in St Petersburg, would have been familiar with the holy images of the Russian Orthodox Church, but he would certainly have seen the many icons in the National Gallery. Can the portrait tell us anything about Jacob's view of Jewish women? Unlike his Gentile girlfriends, did he see Jewesses as strong, unknowable, even frightening. Of his many girlfriends there is no record that any were Jewish.

His only exhibit in 1924 was at the British Empire Exhibition at Wembley Park where 'The Sphinx' (see fig. 43, page 86) was shown, and as in earlier years Jacob continued to have money worries. In a letter to his friend, Mrs Annie Redman King, who taught at the Department of Zoology at Leeds University and who became a great support and later purchased 'The Jewess', he wrote rather sadly, 'rent – pounds and shillings. A big knock at my door. A lady to see me. She will sit. Engagements. She sits. Oh the portraits!' They were his bread and butter, and now by far the major part of his output. Further confirmation of Jacob's financial problems comes in a letter that he sent on 16 October from Boyle Cottage, Thames Ditton, to Charlie Parker at the Progressive Bookshop, 68 Red Lion Street off Holborn. Jacob wrote:

'Dear Charlie, I hope to be in town on Saturday. I have already approached the box of books. Everything is alright. If you happen to be in funds tomorrow send me whatever you can – thirty shillings or a pound would be of help of getting them [the books?]. I shall expect to hear from you in any case by Saturday morning. Don't forget if you should have any cash tomorrow send along in an envelope with a note enclosed. In any case I shall expect to hear from you on Saturday morning. Yours ever, Jacob'

One of the most momentous events of 1924 was Jacob's move into two rooms behind an off-licence shop at 6 Little Woodhouse Street,

Leeds, not far from the university and the medical school. The owner was Mrs Ellen Louisa (Nellie) Smiles, and Jacob was to be Nellie's tenant until not long before he died. It was in these rooms that Jacob made most of his portraits. His financial problems did not reflect a lack of work at this time; in fact he was busy and producing a great diversity of work. Inevitably, apart from 'The Jewess', most of it was portraiture.

Jacob's work was to receive further praise when Kaines Smith, Curator of Leeds Art Gallery, in a series of articles in the *Yorkshire Post* (December 1924), intending to 'give the average man an insight into the beauties of the paintings' in the gallery, picked the 'Day of Atonement' under the heading 'A Rite Portrayed in a Picture'. In a detailed analysis of the structure of the painting, he wrote, 'No amount of ingenious combination of absolutely realistic forms could possibly have rendered for him his intense feeling of the monotony, and as it were the mass psychology which are so admirably suggested by this rigid, yet intensely fluid, sequence of swaying figures… as a general statement of common rhythm and emotion running through the whole group… it is a completely successful work of art.'

One of Jacob's most powerful portraits at this time is that of the writer, Israel Zangwill, in charcoal and white chalk (fig. 62). Unlike many of Jacob's portraits, where the eyes are closed or obscured, Zangwill's eyes behind the rimless spectacles are the dramatic focus of the picture, the realistic intensity of which illuminates the intellectual power of the man.

Nevertheless in an interview with the *Yorkshire Evening Post* of 13 November 1925, Jacob announced that he had practically given up portrait painting and had for the past five years been engaged on a work of importance, which he considered would take another five years to complete. He said the idea of the painting on a canvas 15 feet long and 10 feet deep, came to him after he had completed 'Jews praying on the Day of Atonement'. He went on to say, rather enigmatically, that he had modified somewhat the position he had assumed two or three years earlier, 'though on broad general principles he may be said to hold the same view.' Did he mean that he was retracting from his view that the artist must not compromise in his attempt to portray the 'essence' of his subject? If so this demonstrated a weakening of resolve in the face of the very urgent need to make ends meet.

Although Jacob exhibited twice in that year at the Ruskin Gallery in Birmingham, which bought his 'Portrait of a Girl' for their permanent collection, nothing is known of this big work. However, he did produce two further works of interest. One was a pastel portrait of the

distinguished painter, Frank Brangwyn, who generously wrote at
the bottom of the canvas, 'Kramer has given the real F.B.' A stronger
work was Jacob's realistic portrait of Matthew Smith (fig. 63), fellow
Yorkshireman and famous Fauvist painter of strong still-life paintings
and landscapes.

The variety of Jacob's work, his apparent ability to ride several horses
at one time, received an interesting tribute from Kaines Smith in an
article in the *Yorkshire Post* of 29 May 1926 entitled, 'Living Yorkshire
Artists. No. 4 – Jacob Kramer.' In it Kaines Smith points to the
traditional symbolism in Jewish painting and sculpture which has
persisted despite the freedom won in the past century to express
themselves in representation of the human form. 'Mr Kramer,' he
writes, 'has assimilated, in a degree remarkable in one of his race,
the freedom of line and boldness of draughtsmanship of the classical
tradition…. The portraits, it is true, waste no effort upon such detail
as is irrelevant, because it is purely representational, but they adhere
faithfully to the purposes of making a likeness – of being, as it were,
symbols of character…. In some aspects of his work, then, Mr. Kramer
is first and foremost a Jew, and therefore a symbolist; in others he is
an English artist. In both he is sincere.'

By now Jacob was back in Leeds. Whatever he had hoped to gain
from being in London had not been realised. The excitement of the
bohemian life was still there, but Jacob, now in his mid-thirties, had
not found the inspiration and stimulus that he had expected from the
vigorous art scene of the capital. Nor it seems had the capital taken
to Jacob. The English bourgeois Bloomsbury Group could not provide
Jacob with a comfortable community, and although the London
Group flourished Jacob had not found a home even in its broad
canvas, which stretched from Realism to Abstraction. His Jewish
peers were socially and artistically dispersed, and intent on making
careers for themselves. Bomberg was little interested in Jewish themes,
perhaps after *The Jewish Chronicle* had described his 'Scenes of Jewish
Life' as 'a waste of good pigment, canvas and wall space,' and was now,
with Duncan Grant, Vanessa Bell and others of the Bloomsbury
Group, part of their 'Alpine Club', while Gertler was even more
intimately connected with the Bloomsbury Group and one of Lady
Ottoline Morrell's social set. His old friend Epstein had become
a star, and Meninsky, a close friend of William and Sarah Roberts,
was, unlike Jacob, more interested in formal beauty to the exclusion
of religious or philosophical meaning. Leeds, Jacob realised, was his
home. Although he is sometimes regarded as one of the 'Whitechapel
Boys', and had rented a studio in the East End of London to try to
capture the spirit of Judaism, he did not belong to that community
as he did to the familiar, tightly-bound Jewish community of Leeds.

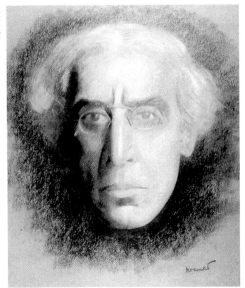

FIG. 62
Israel Zangwill
*charcoal & chalk:*
*45.5 x 44cm*
C 1925

FIG. 63
Portrait of Sir
Matthew Smith
*oil on canvas:*
*52.5 x 43.5cm*
1925

Also his mother and two sisters were there. His wanderings, which had started as a restless young boy, were in a larger sense over, but even back in Yorkshire his restlessness and his drinking continued.

One could speculate on the life he might have led and the work that he might have done if after his time at the Slade he had stayed in London. Some of his friends in Leeds believed that he might have made a national, even an international reputation, the stimulus of the London scene broadening his outlook. But, as this second return to London proved, this view seems unjustified. As Nellie Pickering, his friend and patron, recalled, Jacob preferred to be a big fish in a small pond. With time the limitations of his concerns became more apparent. Although he did produce many fine paintings, his attention became increasingly limited to portraits. Even images of Jewish themes were now rare. Other than his interest in people, his preoccupations did not seem to be with the outside world or with events, no matter how momentous.

# 15 BACK HOME

Exactly when Jacob left London to return to live in Leeds is not known. Timetables, schedules and the clock did not govern his life. A clue was provided by his landlady and lady friend, Nellie Smiles, after Jacob's death in 1962. Mrs Smiles moved from Leeds to London in 1960, and said that Jacob had been her tenant in Little Woodhouse Street and then in Kendal Lane for thirty-six years, that is from 1924. This date could well be correct; despite his many reflections on the disadvantages of the provincial life, unlike other Yorkshire artists, he never broke his connection with the North. In newspaper reports he was always referred to as 'Kramer the Leeds artist', and as he said, 'There is more freedom of thought for me in Leeds and in Yorkshire than in London, and I am very glad to see that a great many more London artists are visiting the county to work for periods.'

His mother and sisters, Millie and Leah, to whom he was devoted, were in Leeds, and although by this time Millie was working as a secretary, it is likely that Jacob did his best to help out. As the years went by, at 6 Little Woodhouse Street, Nelly Smiles became his watchful minder and his mistress, a dragon when it came to his welfare. Sadler had left for Oxford, and whatever their differences over the Town Hall project, Jacob must have felt the loss of a man who had become a surrogate father and financial support.

In 1926 Jacob's old friend, Israel Zangwill, died, but there is no mention of this in the *The Kramer Documents*; indeed the documents contain no entries for 1926. John Roberts' omission of the whole year hints at Jacob's inactivity at this time. In a brief introductory note to the documents John writes, 'I have presented my uncle's documents with very little comment, for they tell their own story.' Jacob's notes rarely contained anything personal or express emotion, and John could hardly comment on Jacob's mood as he did not know his uncle in any real sense. Such was Jacob's alienation from William Roberts that, by John's own account, he had met his uncle on only six occasions when Jacob visited Sarah. She must have talked about her brother, and it is

FIG. 64
Self-portrait
*lithograph:*
*50 x 38.2 cm*
1949

significant that John used Jacob's self-portrait of 1949 on the flyleaf of *The Kramer Documents* (fig. 64). It is the most enigmatic of all the self-portraits. Illuminated strongly from the left (as almost all his portraits are), the right side of the face is featureless except for the eye, while the left, except for the eye, is in deep shadow – it is a portrait of a divided self.

The antipathy between William Roberts and Jacob was certainly an expression of their different personalities and views of art, but also on Jacob's part a manifestation of his jealousy at having his beloved sister and regular model seduced by the straight-laced Roberts, a man who would rarely enter a pub, was the antithesis of the bohemian artist, and who was slowly to achieve great success. However, on Jacob's return to Leeds, at a time when Roberts received little recognition, Jacob's celebrity reached a point where any artist visiting Leeds had to pay him a visit. Indeed in his biography of William Roberts, Andrew Gibbon Williams describes Jacob as 'the most charismatic British artist outside London.' Alas, celebrity did not necessarily mean financial security.

Despite any antipathy, Roberts and Jacob did work together for Charles and Esther Lahr, owners of the Progressive Bookshop in Holborn and the left-wing publication, *The New Coterie*, for which Roberts designed the covers. In 1926 Jacob drew portrait heads of both Charles and Esther, but it is Roberts' portrait of Esther that is now in the Tate collection.

One of Jacob's recorded paintings dated 1926 entitled 'Woman', also 'Woman Undressing' (fig. 65), is a very striking picture and unusual in Jacob's work for the gentle eroticism evoked by the angulation of the limbs and the contrast between the skin tone and that of the texture of the simply rendered silk stockings. It was very likely painted in Leeds as it was in the possession of Jacob's Leeds benefactors, Mr and Mrs Rosenthal, who were great collectors of Epstein sculptures, and supporters of many artists, including Jacob's early flatmate, Philip Naviasky.

In 1928 an Exhibition of British Art was shown at the National Gallery in Washington, which went on to Boston and Ottawa. The exhibition included either one or two of Jacob's work; how many is not clear. One is called 'The Toilet', but this title is not mentioned anywhere else, and it may have been re-titled 'Woman Undressing'.

In 1927 Henry Ainley wrote to Jacob from the Grand Theatre, Leeds, to say that he would be happy for Jacob to paint him again. It seems possible Jacob had solicited Ainley to have another portrait made, a sign that he needed the money. A letter of 11 June 1927 from Rupert Lee, secretary of the London Group, to which Jacob had been elected in 1915, indicates that Jacob had let his membership lapse and that he had written to ask if this could be reinstated. A retrospective exhibition of the London Group was being arranged for the following year and Jacob wanted to be part of it. Lee replied on 22 June and pointed out that under rule 5 the committee had no power of reinstatement where membership had lapsed, but a general meeting of the membership could suspend or alter the rule. However, if they should decide to suspend the rule in Jacob's case, it would be equivalent to re-election, 'except as regards the payment of arrears.' Jacob must have paid, because in January of 1928, Lee wrote to say that they would like Jacob to send up to four works representative of his work from 1914, at least one of which should be for sale. Subsequently Jacob asked Sadler if he could lend Jacob some of his old work for the exhibition, and Sadler replied that he was glad to hear of the good news: 'I'll lend the pictures with pleasure and am telling Lymans, 23 High St Oxford to send them…. I'll pay for packing, carriage and insurance.'

In the meantime Jacob had sent an etching to Herbert Read, now at Broom House, Seer Green, Beaconsfield. Read thought that the medium suited Jacob's sensibility and encouraged him to do more etchings. He also wrote, 'I was glad to hear about the painting for the Washington exhibition and hope it will attract attention there. But don't follow Epstein across there! Let the dollars come to you instead, if you can persuade them.' Read was referring to the Washington exhibition of 1928 mentioned above, but whatever transatlantic hopes Read had for Jacob they were not realised.

Jacob had come back to Leeds to make another portrait of Lord Moynihan, and had five weeks to spare. Jacob's home at 6 Little Woodhouse Street was a short walk from the university and the medical school, where Jacob had made many friends; indeed it was the connection with doctors, young and old, that helped to support him for many years, especially later in life. Jacob also painted Charles Brotherton, the benefactor of both Leeds University and the Leeds General Infirmary, and in 1930 the House Physicians of Leeds

FIG. 65
Woman undressing
*oil on canvas: 30 x 25"*
1926

General Infirmary commissioned a portrait of their chief, Dr W H Maxwell Telling, whom Jacob described as most interesting and sympathetic sitter.

At the time of the Easter vacation of 1928, when the dissecting room at the Medical School was free of students and a place of quiet, Jacob made a pastel drawing of a cadaver. Originally it was entitled 'The Anatomy Lesson', no doubt after Rembrandt's great painting, and then 'Post-mortem', but unlike the well populated Rembrandt painting, Jacob's work was of a single corpse, which, as an oil painting, he finally entitled 'Clay' (fig. 67). 'Clay is earth and of the earth,' Jacob explained. 'From clay God fashioned the body of Adam, and into it He bequeathed His spirit, so that he was a man alive and sentient… Man is not bereft of dignity, even when death has touched him. Man was fashioned in the image of his Maker, and even the clay, the empty shell bears enough of the impress of the Divine Will to show forth still dignity.' In a newspaper interview (*Yorkshire Post* 17 January 1935) Jacob continued to explain the inspiration for the picture, ending, 'I have tried to show the glory and the spiritual greatness of death.' The Director of Leeds Art Gallery, Mr Philip Hendy, had no comment to make on the work, except to say, 'It is a remarkable picture.'

The body lies diagonally across the space in the opposite direction to both Rembrandt's corpse and to Jacob's father in 'Death of my Father', and is infinitely grimmer than either. The picture caused some controversy, but the doctors thought that it was a fine piece of anatomical drawing; perhaps the strong emphasis on the bony skeleton had something to do with Tonks' teaching at the Slade. According to a report in the *Leeds Mercury* of 9 July 1928, Jacob said that it was not pleasant working. 'I felt distracted by the presence of so many of the ordinary features of the medical dissecting room; but I found in the corpse itself a reflection of great tranquillity. A lifeless body is a very different subject from the ordinary life study. To my mind the dead figure is extremely beautiful; but I felt at the outset that my subject was a most difficult thing to grasp. Hour after hour I sat there alone with the dead, and as I worked the outlook with which I viewed my

FIG. 66
Mrs Rose Cowan
*pastel*
1928

work became a more and more spiritual thing. I got quite away from life. It was with the utmost difficulty that I reconciled the tranquil feeling of spirituality with the stark realism of the subject.'

This very powerful but disturbing picture was bought by one of Jacob's patrons, Dr Barnett Stross MP, who called Jacob 'the Modigliani of the North'. Stross went on to say that Jacob was a little more fortunate than Modigliani because he returned to Leeds, where 'intelligent people in the main attached to the University, gave him bread and shelter in his early days when he was doing brilliant things not then easily understood by everybody.' According to Jacob, Stross tried to sell the picture to the Tate Gallery, but thought that it was probably 'a bit too strong for them.' The question remains, why was Jacob attracted to draw a cadaver, and to expose so starkly the reality of lifelessness? Several years later (*Yorkshire Evening News*, 17 January 1935), when asked about this he replied, 'How else can the artist come face to face with its inevitability, which is the other twin to life?' and added that he was inspired by three factors: 'a) the essential dignity of the form of man – of the Temple that holds his spirit; b) by the mystery and tragedy of that which brings death about; c) by the problem that the dead body always suggests – the problem of the immortality of the man who has left his body.'

In a completely different mood was a delightful portrait of a friend, Mrs. Rose Cowan, sister of Mrs. Rosenthal (fig. 66) and sketches, often humorous, that for several years he made for the university magazine, *The Gryphon*, the most powerful being the vigorous charcoal, 'The Wrestlers' (fig. 18, page 51), and the cheeky cartoon, 'Tetley's Beer Drinker' (fig. 68), for *The Tyke*, a ribald magazine.

At this time Jacob reported that he was at work on a picture of Christ and intended to get ahead with it in August, but as with so many of his resolutions, especially when his intention was to depict Christ, nothing seems to have come of it. Frustration was inevitable; his portraits of Christ show old men, possibly rabbis, but it was impossible for Jacob to portray a divine Christ from his Jewish heart.

One of the benefits of Jacob's return to Leeds was the renewal of old friendships. One of these was with the baritone, George Parker, whom Jacob had met in 1921, and whose pastel portrait he had made. Subsequently they became close friends and in August 1928 Jacob stayed with Parker and his wife in St Anthony in Roseland, Cornwall, where, according to Parker, he was very happy and good company, painting portraits of George and Dorothy in oil. With the paint laid on heavily and its emphasis on anatomy, George's portrait is a strongly modelled image of a powerful man (fig. 69). By contrast in Dorothy's portrait the face, strongly lit from the left almost eliminating form, Jacob is aiming to illuminate Dorothy's soul (fig. 70).

In later years Jacob's endeavour to portray the soul of his sitter became an excuse for perfunctory and inadequate work, but that was not the case in 1928. Jacob did not let George see the portrait of his wife until it was finished, when at first sight of it George was very disappointed. However, as he wrote in the *Memorial Volume*, 'Since then, I have never ceased to rejoice that Jacob painted this picture and each year it has become more evident to me what a wonderful picture it is.' Subsequently Jacob made portraits of the Parkers' three children.

After Cornwall, Parker had singing engagements in Germany and Jacob joined the Parkers there. They made a trip up the Rhine and walked from Boppard to St Goar, with Jacob drawing towns and gardens on the way, as well as visiting art galleries.

'Art in Germany today,' commented Jacob, 'is rotten; awful. It imitates French Art and imitates it badly. It is either vulgar or ineffectual. It is

FIG. 67
Clay or Post-mortem
*oil on canvas*
1928

FIG. 68
Tetley's Beer
Drinker
1928

at a standstill – nothing…. Durer remains the one German artist about whom one can talk seriously.' On the tour Jacob made a pastel of a beautiful village called Neckargemund, and there he recorded, 'The first thing I saw was the landlord's name on a public house, and that name was Jacob Kramer.'

At the Yorkshire Spring Exhibition Jacob showed several pictures, 'Portrait of T Lamb', 'The Jew', Death of my Father' lent by Sadler, 'Post-mortem', which was priced at £100, 'Drink Deep or Taste Not', 'Study', 'Raquel' and 'Woman'. If Jacob had sold three or four of these that should have kept him in security and comfort; certainly he would have had money for the purchase of a picture that he found in the garret of a house in Kirkstall, which he was absolutely confident was a genuine Hogarth. He added, 'I know that sounds very obvious – masterpieces are always being found in garrets – very romantically – but I am sure that this is the genuine thing; a self portrait too!' It seems that thirty-five years before a Kirkstall man with a taste for good painting bought it from a second-hand dealer, with no thought that it might be a 'master', because he admired the workmanship. As Jacob reports it, 'There looked down from the easel with a sidelong glance and a hint of a smile, a round, but hardly chubby face which might very well have been a rather more mature Hogarth than he of the self-portraits in the National Gallery and the National Portrait Gallery.' When showing the portrait to a journalist (March 1929), Jacob placed the canvas on an easel near the window and rubbing the surface gently with a damp cloth, explained, 'I hardly dare touch it, but look at the colouring. That's extraordinarily fine work whoever did it, and the technique is exactly that of Hogarth in his later period. The firm touch of it, and the beautiful modelling of the head both suggest Hogarth, and there's a twist about the bottom lip which you'll notice in all his paintings.' Jacob went on to explain how he was certain of the portrait's origins. In the event he did not pay for the picture but exchanged it for one of his own. 'It is a pleasure to have it by me,' he said, 'and quite a stimulus to work. Only a very tempting offer would induce me to part with it.' He had been successful in selling the Reynold's portrait of Hazlitt that he had discovered as a student.

Now well re-established in Leeds as a celebrity painter, his opinions on the art scene were sought regularly by the newspapers, and Jacob was always ready with a positive opinion, especially about the critical

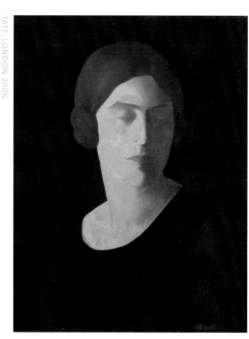

FIG. 69
George Parker
*oil on canvas*
1928

FIG. 70
Dorothy Parker
*oil on canvas*
1928

state of art in Leeds. His thoughts may well have been rehearsed beforehand with Jack, his canary. Jacob would never think of beginning a day's work without first having a talk with the bird that had shared his studio for many years. In the *Daily Chronicle*, a national newspaper, he complained that 'For the young struggling artist it is hell in Yorkshire.... If an artist is weak enough to paint simply to sell then it is spiritual prostitution for him. If he is strong enough to withstand the commercialism then he has to run away from Yorkshire.' He bemoaned the loss of Sir Michael Sadler. 'Since he left Leeds little or no stimulus has been given to art in Leeds.' In the *Jewish Daily Post* he was positive about the need for a Jewish art centre and suggested that someone should found a Jewish school of painting in Palestine. 'It is a great pity that men like Gertler, Brodsky, Meninsky and Pascine are not given the support they deserve. Brodsky is a case worth mentioning. Here is a brilliant Jewish artist who went to Palestine and received no encouragement there.... the Jewish artist has to live, and if he is unable to find a market for his wares among his own people, in what direction should he turn?... since I began to paint in Leeds, I have had only two commissions from the Jewish community.' But in the *Yorkshire Observer*, although he criticised the collection in the Cartwright Hall, he praised Bradford, where he had received early recognition and support, not least from William Rothenstein. 'I do honestly believe,' he said, 'that no similar city in the country has so many business men who have a real appreciation... of the art which is being produced today, as there are in Bradford.'

MEMORIAL

FIG. 71
Jacob aged
about 40

In June 1929 at the Harrogate Art Gallery Jacob exhibited a portrait, about which the reviewer made a significant observation. 'In this portrait study he has... made a very decided advance. He has not found it necessary to distort nature for the sake of expressiveness, which has always been his aim.' Jacob had already admitted to modifying his views about his earlier aims to portray the 'essence', and from about this time (he was now approaching forty) (fig. 71), changes appear in the style, the media and the content of his work.

By this time many of his contemporaries had received national recognition. Following their appointments as official war artists, Stanley Spencer, the Nash brothers, Nevinson and William Roberts had gone on to win acclaim in time of peace. In their work, in landscape and in portrayal of the urban scene, they had connected with the wider world. Jacob seemed unable to make such a connection. His Cubist-influenced paintings on Jewish themes had a limited significance for the world outside the Jewish community, and the best of that was now a decade in the past. His time in London had been one of disappointment, the art establishment had not taken him to its bosom, and as he wrote to his London friend, Emile Levin, on 30 June 1930, 'When I do come [to London] I hope to keep away from the artists or the so-called "arty" people – I have no desire to meet any of them.' In Yorkshire, and especially in Leeds, he enjoyed recognition, respect and friendship. There he was busy, but in the following year (8 October 1931) Herbert Read wrote, 'I am sorry you have been so unsettled again. It must be difficult to get any work done under such circumstances.' There is no record of the letter to Read that elicited this reply, or of any special 'circumstances', but it is likely that in that euphemism, 'unsettled', Herbert Read, an acutely perceptive old friend, diagnosed an alcoholic binge or a bout of severe depression.

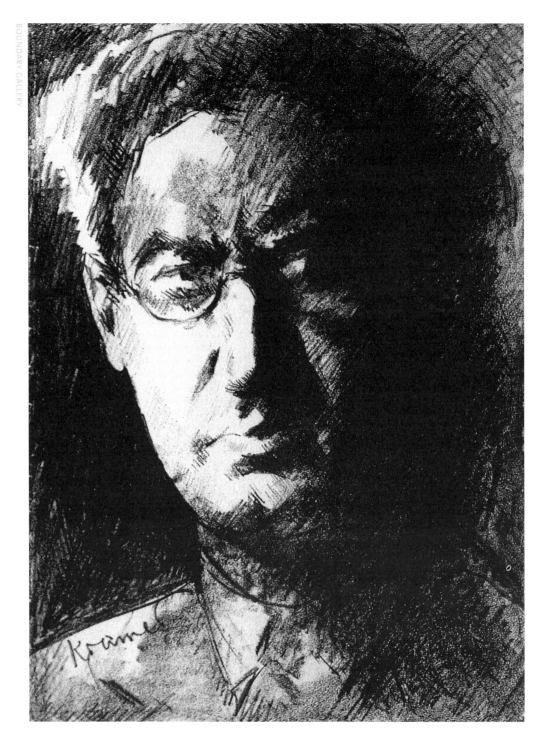

FIG. 72
**Self portrait**
*lithograph*
1931

# 16     PORTRAITS

The process of making lithographs, drawing on stone and pulling off multiple prints, appealed to Jacob. Although he continued to make a few oil paintings on demand, he could now add lithography to his usual methods: it was a technique that could enhance his income.

As he wrote to his London friend, Emile Levin, 'I have practically given up painting, except now and again doing drawings when a commission is offered.... I am spending my whole time in lithography, with the hope that I may establish myself as a lithographic artist.... There is great scope in its development and the medium seems to suit me.'

He was encouraged in his plan by a letter dated 21 March 1930 from Herbert Read, who was then an Assistant Keeper at the Victoria and Albert Museum: '...glad to know that you are settled in a good studio and getting ready for some good work. The lithograph is excellent. I would of course like a copy and enclose a cheque for two guineas. I have also shown it to the Keeper of the Dept. of Engravings at the Museum and he was quite interested. I think if you could let him have a copy at a special rate (say 25/-) he would buy one for the Museum Collection.' Read knew the system, and added that the museum expected modern artists to give their work, or sell it at a cheap rate; 'as it is an honour to have one's work in the national collection most artists do this.' Later in the year, almost twenty years after their first meeting at the Leeds Arts Club, Read invited Jacob to stay with him in Beaconsfield.

In June Jacob sent his mother to London for a few days, because she needed a change and preferred to go to London. With her he sent a lithograph of his self-portrait (fig. 72), one of forty made from a charcoal drawing of 1930 and signed 'to my dear friend Kalloway' (now in the National Portrait Gallery). It is a dramatic image (like most of his portraits lit from the left), in which Jacob looks scholarly and older than his years, his gaze searching and analytic, a man of experience and self-knowledge.

FIG. 73
Mahatma Gandhi
*pastel*
1932

Jacob informed Levin that his mother had with her a fine copy he had kept especially for Levin to add to his collection. This Levin could have at a special price of two pounds, which would help with his mother's stay in London. Jacob added the news that the Victoria and Albert Museum had indeed bought a lithograph of this self-portrait. Despite the good news, Jacob ended his letter on an angry and disappointed note, no doubt referring to Sarah and William Roberts: 'I don't hear any news from anybody, even from my bloody relations…. except for the new work everything is very dull here.'

The lithographs may well have helped to boost Jacob's income, but a letter from Henry Ainley suggests that Jacob continued to be unable to handle his finances. Ainley was to sit for another portrait and sent Jacob theatre tickets from the Theatre Royal, Haymarket, adding, 'and don't forget you owe me £137!' This was a huge sum of money, and can only be explained by the careless generosity of the actor together with Jacob's careless management of his affairs and shameless talent for extracting money from benefactors. His need was sympathetically recognised and once again Bradford provided help. The West Riding publication, the *Heaton Review*, was edited by George Hopkinson, who was keen to do a series of articles on famous Yorkshire folk, and who recognised that Jacob's talent for portraiture could be used to illustrate the articles, and provide Jacob with a regular source of income.

As a youth Jacob had the courage to go backstage and make unsolicited portraits of celebrities, such as the playwright, Weedon Grossmith, and the actor, Gerald du Maurier, but now, although still friendly and ebullient, he was, as the critic, Tom Bentley recalled, basically shy and insecure with strangers, and in doubt of his own artistic ability; although his portraits appeared to be made with effortless ease, they had to 'be dragged from the artist by the

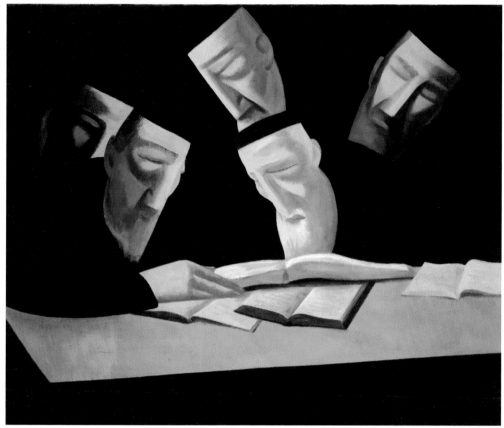

FIG. 74
The Talmudists
*oil on canvas:*
*63.5 x 76.2cm*
1932

importunities of his many friends.' Hopkinson's method was ingenious and effective. When he knew that Jacob admired someone, he would arrange a meeting. As Bentley reports, 'Confronted by someone whose work he enjoyed or revered… Kramer would visibly warm up. Once combustion took place, his pencil seemed to take on a life of its own.'

One of the people that Hopkinson introduced to Jacob was the Yorkshire playwright, J B Priestley, whose first novel *The Good Companions*, published in 1929, had met with great success. Jacob's charcoal portrait of Priestley has a freshness and immediacy which illustrates the eagerness of the young author. Then for the 1932 edition of the *Heaton Review* Jacob made a portrait of Jess Oakroyd, a character in Priestley's novel, to illustrate an article on the sterling qualities of the Yorkshireman. At this time Leeds had three theatres, and while concerts were held at the Town Hall, every other form of entertainment from classical ballet to burlesque, could be enjoyed at the Grand Theatre, the Theatre Royal and the music hall, the City Varieties, where a young Gracie Fields appeared as an earthy comedienne before she became a celebrated songster and film star. Virtually every celebrity in the British entertainment world performed

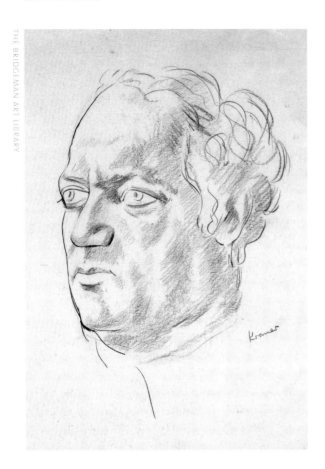

FIG. 75
Portrait of
Jacob Epstein
*lithograph:*
*50.5 x 35.5cm*
1930

in Leeds, and this was a world in which Jacob flourished. Gracie Fields, Alicia Markova, Sybil Thorndike and Louis Armstrong numbered among his many sitters. Even Amy Johnson, after her solo flight across the Atlantic, had a portrait made, and over the years Jacob made so many portraits in pencil, ink or pastels that when an exhibition of Kramer portraits was held in 1971 at the Middlesborough Art Gallery a hundred portraits were shown.

Perhaps Jacob's most well-known lithograph is that from the pencil portrait of Epstein, who at long last sat for Jacob in 1931 (fig. 75). Why the long delay since their agreement a decade earlier and why only a pencil drawing rather than an oil painting to match Epstein's magnificent bust? It is possible that Epstein was too busy to spare the necessary time, or Jacob reluctant to demand the many hours of sitting that were his due. Epstein was a formidable character, and in the strongly modelled drawing Jacob captures the strength of the sculptor. Although Jacob's self-portrait is drawn in a very different style from the Epstein portrait, both are forceful portrayals of strong male artists and very different from any of his images of women.

Jacob's ability to catch a likeness immediately was exemplified by his portrait of Lord Irwin, then Viceroy of India, who was on a visit to Yorkshire. Hopkinson wanted the Viceroy's portrait to appear in the *Heaton Review*, so he and Jacob motored over to Garrowby Hall where Irwin was staying, on the off-chance of catching his Lordship at home. They found him preparing to leave for London and Hopkinson was asked, 'Could Mr. Kramer do the portrait in 20 minutes, while his Lordship was dressing for the journey?' That was enough time for Jacob to make a sketch, which so pleased Irwin that he asked if he might buy the original after the picture had appeared in the *Heaton Review*. Irwin turned down a request for another sitting for a second portrait, if it would take more than an hour. Subsequently, when Hopkinson asked for an article on Ghandi for the *Heaton Review*,

Irwin declined. Gandhi was due to come to London in 1932 for the Second Round Table Conference with the government. When he arrived, Hopkinson, keen for Jacob to do a portrait of Gandhi for the *Heaton Review*, sent Jacob off to Darwen in Lancashire, where Gandhi was looking at cotton mills. Gandhi's secretary told Jacob that a sitting might be possible in London, and there Jacob visited the house where Gandhi was staying. He found two or three hundred people waiting to see the mahatma, but after a while the secretary said that Gandhi would receive him. As Jacob reported the occasion to the *Yorkshire Post*:

'I was with him from 10.30 in the morning until 6 at night. It was one of his silence days, and neither of us spoke a word. But one did not need to speak to Mr. Gandhi to be aware of his personality. Shrivelled little man though he was, he filled that room with an extraordinary spiritual force. He was the most impressive subject that I have ever had. The only man I can compare him with was Delius.' The portrait of Gandhi (fig. 73) is a beautiful pastel drawing of quiet contemplation, and as warm as his Delius is cold. Two years later Jacob enjoyed a postscript to Gandhi's visit, when his disciple, Miss Madeleine Slade, daughter of Admiral Sir Charles Slade, visited Leeds on a tour of Britain to explain Gandhi's non-resistance campaign. Inevitably Jacob made a study of Miss Slade at his studio.

A disappointment came in May 1931 when the Royal Academy (presumably for the Summer Show) rejected two of his works, and Jacob wrote to Eunice Levin, 'no doubt you know what a farce it has been this year, and no wonder of their incapability of understanding what constitutes a genuine conception of art.' He put the rejection down to his earlier savage criticism of the Royal Academy, and expressed his surprise that Epstein, such a great force, should be silent about the selection committee. Only Nevinson was 'really brave, and I am sending him my congratulations.' However, some recognition of Jacob's celebrity came in 1931 when Loris Rey, then head of sculpture at the Leeds College of Art, made a bust of Jacob. Towards the end of that year Leeds Art Gallery exhibited Epstein's 'Genesis' and his bust of Jacob, a cast of which the Tate Gallery already possessed. From the proceeds of the exhibition the Leeds Art Collections Fund bought the bust for the gallery for £200. Jacob was pleased and honoured, and said, 'I am pleased most of all that Leeds is to possess a piece of Epstein's work.' However, he was angry at the philistine reception given to 'Genesis', exploding, 'Their behaviour disgusted me.... It was really impossible for anyone to look at Genesis properly, with a parcel of silly, mock-modest fools walking around, some of them sniggering, and others afraid to take a good look at it.'

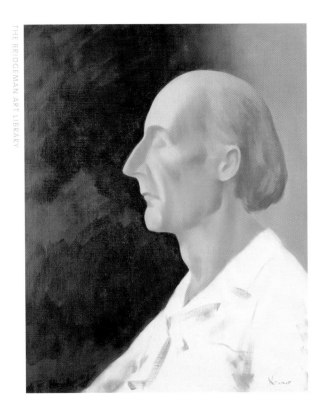

FIG. 76
Portrait of
Frederick Delius
(1862–1934)
*oil on canvas*
1932

Earlier in the year Jacob had been commissioned to provide eight illustrations for Israel Cohen's *A Ghetto Gallery*, in which the author, a *Manchester Guardian* writer, had collected stories of Anglo-Jewish life, featuring such characters as the *Chazan* or Cantor of the synagogue service; the *Shammas* or beadle; and the *Schnorrers* or beggars, ever ready for a hand-out. Jacob's illustrations, bold and distinctive caricatures of types familiar to him, must have given him much pleasure.

It is hardly an exaggeration to say that Jacob was cherished by the citizens of Leeds. The *Yorkshire Post* under the editorship of Sir Linton Andrews and with Jacob's friend, Bill Oliver, as art critic, gave Jacob's work and other activities full coverage. Jacob's persona contained those bohemian characteristics that many believed belonged to the artist. His portraiture was in demand, but year by year the quality of the work became more uneven and deteriorated. In order to simplify the making of a portrait he would place the sitter in profile close to the window of his tiny studio so that half of the face was in shadow and required no modelling at all while little modelling was needed on the brightly lit side.

However, on occasion he was able to produce creative work, as, for example, in his oil painting 'The Talmudists' (fig. 74). In this picture Jacob returned to the geometrical stylisation, the simplicity and power of his 'Shylock' and the 'Day of Atonement'. The picture, now in Leeds City Art Gallery, shows five old Jewish scholars poring over the Talmud, and although joined by their common focus on the holy books of law, each figure is self-contained, withdrawn and ascetic. As in the 'Day of Atonement', the balance of the composition provides a rhythm to a static scene. W T Oliver, art critic to the *Yorkshire Post* wrote, 'The sense of concentrated devotion of minds of men reaching out to God, is compelling – it draws the viewer into the act of devotion…. the withdrawal from all mundane concerns, is absolute. The picture is an act of homage to the patriarchs of the Jewish faith and declaration of the supremacy of the mind and spirit over material circumstances.'

The inspiration for this picture came from the teeming Jewish life of London's East End, where Jacob found a studio between Aldgate and Petticoat Lane. He had intended to keep in touch with that stimulating part of the world but Leeds was his home and his visits to London became less frequent.

Another individual important to Jacob entered his life when John Rothenstein was appointed Director of Leeds City Art Gallery. They became good friends and the intimacy of their relationship and Jacob's simplicity of outlook is well described by Rothenstein's report on Jacob:

'He lived in two tiny rooms in an off-licence house in Woodhouse Lane, yet whenever one met him he was in the throes of some complex situation which he would explain at length in a low conspiratorial mutter. One day he asked me to see him about a matter of extreme urgency. "My God, John," he murmured, "My God I'm in trouble. I'm in love." "But with whom Jacob?" I asked. "With two women," he explained.'

At about this time the Bradford School Teachers' Art Club was formed to enable elementary school teachers to experiment outside the limits of conventional art tuition, and in June 1932 Jacob was invited to the club. On the plain white walls of the club's studio he painted a mural, apparently not easily executed but a hard struggle over a few hours. It was an abstract design with vague hints of figure representation, as Jacob explained: 'The existing thing – the reality – is only the starting point.' In the headline of the *Yorkshire Observer* it was described as 'A Mystery of Modern Art', and although unintelligible to the reporter, 'extremely thought provoking' to the club members. One of these was one of Jacob's earliest teachers, S Pearson, who confessed that he had some notion of Jacob's idea, which was to 'symbolise the spiritual conception by very limited means of form, line and colour,' but no doubt he was as mystified as the rest. This was a time when abstraction devoid of representational imagery could be regarded as a legitimate objective, and whatever the shortcomings of this exercise Jacob was playing an important role in helping to open eyes and minds to the modern movement.

Having already had four portraits of himself made by Jacob, Henry Ainley, as popular a theatre idol as ever, wanted another drawing of himself, but this time not as a stage character but 'of me as I am.' He had been so pleased with the most recent of Jacob's pictures, framed in green and gold, that he wanted to make a Kramer corner in his wife's house in Highgate. Also he suggested that Jacob should submit the portrait of him as 'Dr Knox' to the Royal Academy show.

George Hopkinson continued his support for Jacob by canvassing the idea of celebrity portraits by Jacob for the *Heaton Review*. Ainley had been very pleased with his entry in the magazine, and another famous Yorkshireman approached by Hopkinson was Philip Snowden who, as Chancellor of the Exchequer in both of Ramsay MacDonald's governments, had just succeeded in having Britain abandon the Gold Standard. On being asked by Hopkinson to write an article for the review, Snowden thought that he might not have time, but would sit for Mr Kramer if he came to London.

Then Hopkinson wrote to the Bradford-born composer, Frederick Delius, who had made his home in France, at Grez-sur-Loing (Seine-et-Marne) near Paris, with the painter Jelka Rosen, who became his wife. Delius was a very sick man and almost a recluse, but he wrote to Hopkinson that he thought the *Heaton Review* a delightful publication, and he would be glad to give a short sitting to Mr Kramer if he would go to Grez-sur-Loing. So Jacob, with sister Millie and his friend, author and artist, George Jackson, went to France for ten days. As they did not know any French they had some difficulty in finding the best way to Grez-sur-Loing, so took a taxi from Fontainebleau.

Jacob was thrilled with the visit and gave a full account to the *Yorkshire Evening News*:

'My original intention had been to do a drawing, which was what I required for the Bradford publication…. But when I saw the blind composer there, I realised the inspiration in the subject, and decided that what I must do was to paint a portrait.

'The immediate difficulty was lack of materials. Mrs. Delius herself, however, is interested in painting, and she was able to provide me with practically everything I needed, and I managed to get a canvas from a French firm.

'The times for sittings were fixed, and I set to work on the verandah facing the big garden at the back of the house. The composer was not, as a rule, able to stand the strain of it more than an hour or so at a time, and I had little time for talk, as I had to concentrate on my work, if I was to do it justice. He was very kind to me, and talked pleasantly on several subjects.'

Delius was notoriously irascible and anti-social, but as Jacob suggests, the fact that Delius had known Gauguin, and Jacob had known Delius's friend, the composer, the late Peter Warlock, made their discussions pleasant. Reminiscences of the Yorkshire dales with George Jackson would have put the composer in a gentle and nostalgic

mood. Also Delius knew and liked Leeds, where he remembered seeing wonderful pantomimes at the Grand Theatre; and he knew Ripon, Jackson's home. Jacob said that he took great pleasure in painting the portrait, and did his best to convey 'the singular strength of the features and the beauty of the profile…. the portrait was painted direct, and… not from sketches previously made.'

A very different account of this visit to France is given by Jackson in the *Memorial Volume*, and one which reveals so much more about the important but unacknowledged role that Jacob's sister Millie played in Jacob's life. 'At King's Cross we were met by Millie, Jacob's sister. As things turned out it was very lucky that she went with us, for Millie is far more organized and efficient than either Jacob or myself, and she proved invaluable when it came to dealing with French currency and time-tables, to say nothing of Customs and other officials.'

Finding their way to Grez-sur-Loing proved to be more difficult than they had expected, but Millie sorted it out. Jacob had brought his colours and brushes but no canvases, so these were purchased in Paris. Then finding accommodation in Grez-sur-Loing was difficult and 'Jacob became fidgety and nervous. He had reached the main object of his mission and the prospect of making the first contact alarmed him.' But they were expected and Madame Delius received them with gracious kindness, and suggested that Jacob could start that evening, when the day was cooler.

'We were taken into the presence of the Master. He was sitting in a wheelchair in the open. Blind and paralysed, he could have looked a pathetic sight but for his monumental dignity and air of spirituality. One felt at once to be in the presence of greatness.

'His mind was clear and alert and when I was introduced to him as being from Wensleydale, he said, "Ah the lovely Yorkshire dales. I know them all – Wharfedale, Wensleydale, Swaledale. I tramped them from end to end as a young man. Tell me more about them, please Mr. Jackson." Meanwhile Jacob had been fixing up the easel which Madame Delius had found for him.

'The evening was hot and oppressive and Delius was so restless, first throwing back his head and then leaning right forward, that I didn't know what Jacob would make of him. Suddenly everything became silent, Jacob stood with the loaded brush poised. Then, swiftly, the large hand moved downwards and on the canvas appeared, first the forehead, in slightly, and then the profile of the nose and upper lip; the chin and throat-line followed and, lo, like a miracle the first image

of Delius was unmistakenly delineated. The first brush-stroke remains unaltered to this day.'

They stayed in Grez for ten days, making it, in Jackson's words, 'a memorable event of a lifetime. But the time came when we had to pack up for home. The portrait of Delius was complete but with the paint still wet. How was this precious work to be transported to England, I wondered. Jacob knew. With corks begged from the landlord of the estaminet, Jacob secured the spare canvas over, but not touching his painting…. We have been back many times, but alas, only in dreams and imagination.'

Jacob wrote a letter of thanks to Delius for his great kindness in sitting: 'It was a great privilege and one that I shall always remember. I hope the portrait will be a worthy presentation of the creator of works which are immortal, but feel quite incapable of expressing in words how deeply I appreciate meeting and painting you.' He also wrote to Mrs Delius to say thank you, and that the visit had been a unique and inspiring experience.

The most striking differences between these two reports are Jacob's omission of Millie's significant presence, and his familiarity with Paris and people there. Any reports of previous visits to France are merely hints that, like all young British painters before the First World War, he had to go to Paris to pay homage to the heroes of modernism. But Jackson's account leaves no doubt that he knew people in Paris and was well known there. That Jacob omits any mention of his sister and her important help on the trip may be simply a reflection of the brevity of his report and its concentration on Delius, but it could also reflect his attitude to his second sister. It seems that she had neither the beauty nor the vivacity of Sarah, and coming into his life when he was twelve and busy with his art, this infant may well have been little regarded. His several portraits of Millie do not indicate any particular attachment, except perhaps for the 'Dancer Resting' of 1920, which could be Millie.

The portrait of Delius (fig. 76, page 160), a simplified but strongly modelled profile, the forehead glowing in the evening light, is one of the most striking pictures that Jacob painted. It shows the blind composer, dignified and serene, and in its stillness is prophetic of Delius's death two years later. It was received with considerable approval, and W R Childe, the poet, whom Jacob painted in a more naturalistic style (fig. 77), and Lascelles Abercrombie proposed that the picture be added to the National Collection. A letter was sent to *The Times* newspaper appealing for funds (£200) to buy the portrait of this eminent English composer for the nation, preferably for the Tate

FIG. *77*
Portrait of
Wilfred Childe
*oil on canvas:*
*height 30"*
C 1932

Gallery, subscriptions to be sent to The Delius Portrait Fund, Westminster Bank, Harrogate. From Oxford, Sadler sent his contribution right away, plus the inevitable advice on how to go about the matter, but Lord Irwin felt that as he had added his name in the past six months to so many newspaper appeals that he must forego an additional one. Alas, the Trustees of the Tate would not accept the picture, and as the National Portrait Gallery did not exhibit portraits of living people, Sadler wrote to W R Childe recommending that they should accept the invitation of the Bradford Gallery to include the picture in their Spring Exhibition. He added that he was sure that in time the merit of the picture would be appreciated. 'There is genius in Kramer's pictures and I have no doubt that his reputation will steadily grow.' Henry Ainley replied to the appeal late, saying that Kramer was a very great friend, and 'I shall be proud to be connected in a humble way with your scheme…. If Bradford or Leeds Gallery wish to acquire the picture I shall be very glad to transfer my donation.'

The Libraries, Art Gallery and Museums Committee of Bradford Corporation decided that it would be appropriate for a portrait of Delius to be purchased for the Cartwright Hall, and as several other artists had painted portraits of the composer, Jacob's offering was debated. 'It might look crude to the general public, as sometimes his work does,' was one opinion, but that of Mr F V Gill, President of the Historical and Antiquarian Society, was more forceful: 'If the actual portrait looks anything like the reproduction of it in the Press, I certainly don't think that Bradford ought to buy it… it gives the impression of a death mask rather than the picture of a living man.' So the decision went against Jacob. However, Leeds City Art Gallery committee thought otherwise and empowered John Rothenstein to offer Jacob £80 less any subscriptions subscribed to the 'Sadler Fund'. Jacob agreed and Leeds bought the portrait. (In 1933 a portrait of Delius in oils was exhibited at the Liverpool Autumn Exhibition and sold for £200.) Once again Jacob found that he was appreciated only in his own backyard. Some further support came from the painter, Francis Watson,

who suggested that the Town Hall project be resurrected. The eight spaces in the Victoria Hall were still there empty, and Yorkshire had all the necessary talent. Nothing came of the idea; however, the Yorkshire Luncheon Group flourished.

# 17 THE YORKSHIRE LUNCHEON GROUP

On 3 June 1931 the *Yorkshire Post* announced that Mr Jacob Kramer was busy with a plan to form a new art club in Leeds with the main purpose of stimulating creative work. He believed that something more than the ordinary art training and guidance was needed to develop critical faculties, and went on to say that:

'The trouble with many art clubs is that they give too much attention to the social side. A club according to my ideas must consist of hard workers. This should be a club that is not afraid of any thing new...,' and when asked if he regarded Leeds as a good soil for the growth of artistic ideas, he replied, 'There are plenty of vital people in Leeds.... I believe such a club would succeed here better than anywhere else. I find more stimulus in Leeds than in London and even in Paris... one gets so tired of the superficial and conventional in art.'

Jacob seemed to be taking on the mantle of his patron, Sir Michael Sadler, although his plan had a different complexion. As with many of Jacob's plans reality was quite different from his enthusiastic rhetoric.

Essentially the club was Jacob's baby, but with Francis Watson's help it was 'formalised' in a 'manifesto', which stated that the group had no rules and no constitution. Its stated object was 'to provide a common meeting ground for men whose interests are not exclusively dependent on the movement of gold and the fluctuations of industrial values.' This statement was signed by Jacob and Francis Watson, and Dr H G Garland of Leeds General Infirmary was appointed treasurer. Members were asked to contribute the small sum of five shillings, 'the outlay of which will be fully explained as each item arises.' The group which came into being was of a different complexion from Jacob's university, the Leeds Arts Club. That was a sociable but scholarly forum where alcohol took no necessary part in the proceedings. At the YLG alcohol was a matter of serious indulgence, but it was serious concern about the arts and topics of the day that welded the group, and although special guests were invited to each meeting, the views of its

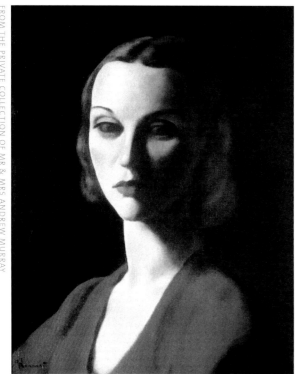

FIG. 78

Portrait of Peggy
the Barmaid

*oil on canvas*

C 1937

founder, the magnet at its centre, were listened to with respect.

By and large the prosperous middle class of Leeds were of a conservative inclination and rather proper, but some of the more 'liberal' folk, members of the artistic, musical and literary communities, and some of the staff of the *Yorkshire Post*, found a talking shop in the Yorkshire Luncheon Group. The group met at Whitelock's First City Luncheon Bar, a tavern in a little passage off Briggate, where Jacob was the most prominent and regular patron. Its proprietor, Lupton Whitelock, was a flautist in the Leeds Symphony Orchestra and a man of quiet benevolence. Rothenstein described the Group as a 'diminutive bohemia' and the unofficial opposition to the powers that be, that is the aldermen and councillors. So it must have seemed in the climate of the times. It attracted some medical students, bookmakers and assorted members of the fringe community. Not least of the attractions was Whitelock's beautiful barmaid, Peggy (fig. 78), whom Jacob painted, as well as Whitelock himself. In the striking portrait of Peggy, her pale skin against a deep red dress and a black background, Jacob has captured the smouldering nature and the dignity of this not unworldly girl, for whom he must have felt a considerable attraction.

Regular devotees of Whitelock's and its 'bohemian' set were Nellie and Philip Pickering, who at one time lived in a flat below John Rothenstein. Nellie was an artistic and energetic woman, who was the same age as Millie, and by coincidence had attended Leeds College of Commerce at the same time. Philip was an architect with a strong social conscience, who believed that struggling artists should be supported. Philip and his friends were responsible for rescuing Charles Murray from a Glasgow workhouse, where he was confined with delirium tremens, and for raising the money for Murray's rehabilitation.

Nellie was an attractive woman, and when in 1932 Jacob spied her wearing a brightly coloured scarf in Whitelock's, he insisted that she sit for him. Her oil portrait is rather dramatic and very similar in style

to that of 'Peggy', but as he asked £200 for it, a fortune in those days, the Pickerings could not afford to buy it. Nellie has described how Jacob would sit her near the window of his little room, and oblige her to set her head at a particular angle, which put her neck under a little strain. This lighting produced the necessary dramatic result, and as the pastels of Nellie sold well as 'Lady in Red', Jacob was always keen to draw her. In times of financial need he could rely on Nellie Pickering to sit for him. This she did four or five times, because when alerted by Jacob's lady friend, landlady and protector, Nellie Smiles, that Jacob was in debt, Nellie P would 'accidentally' bump into Jacob so that he could say, 'I must paint you.' Jacob offered the Pickerings the portrait of Delius for £20, but they possessed this prize for only twenty-four hours because when Nellie Smiles heard about the sale she insisted that they return the painting immediately as she knew the Art Gallery wanted it and would pay much more. The Pickerings obliged.

They often invited Jacob for a meal, an invitation that he would never accept, possibly because, even though he ate bacon and ham, it would not be kosher. Instead he would take Nellie to a kosher café, where she would enjoy traditional chopped liver topped by chopped hard-boiled egg. Nellie has described Jacob as very Russian and Jewish, and although his speech was very difficult to understand, she enjoyed his Russian expansiveness. There is no doubt that his friendship with Mrs Pickering was perfectly respectable – after all he had his very own Nellie, who, alas, has left only indirect evidence of their relationship. Sydney Smiles, Nellie's son, who pre-deceased his mother, left an autograph book addressed 6 Little Woodhouse Street, an ink sketch by Jacob of his mother and a photograph of an elderly Jacob and Nellie on holiday in Brighton, Nellie holding a white parrot on her wrist. It seems to have been a long-term relationship until 1960 when Nellie left Leeds.

Nellie Pickering has said that Jacob would disappear frequently, often for weeks at a time, to where she did not know, but the period of the Pickerings' friendship certainly coincided with that of Charles Murray's intimacy with Jacob. It is apparent that Jacob successfully compartmentalised his life. Most of those who knew him have said that his conversation was always animated but limited to art and never personal. Francis Watson and Tommy Lamb may well have been party to Jacob's more personal activity – Charles Murray certainly was – but they have left no record.

At the YLG Jacob was in his element and found renewed energy in his role as convener. Being his baby the group met largely at his whim. No one was too important to be approached to be the special guest. His letters of invitation flew out not merely to celebrities who

happened to be in Leeds but to anyone in the news. This even included the Prime Minister, Ramsay MacDonald, and the playwright, Arthur Pinero, both of whom found themselves too busy to accept. The list of people from whom apologies came reads like the Who's Who of the Theatre, and included Marie Tempest, Gracie Fields, Lilian Baylis, Nigel Playfair, Sybil Thorndike and many more. But very many luminaries in all sorts of fields accepted.

At its opening luncheon on 24 November 1931, the guest speaker, the first of a long line of distinguished speakers, was the biologist, Julian Huxley, whose wife Jacob had drawn and to whom Jacob sent a copy of his Epstein lithograph. In return Huxley sent Jacob his poem, 'A Voice in the Night', as well as the address of his brother, the author, Aldous Huxley, but there is no record of that remarkable man visiting the YLG or having his portrait painted.

The guest at the December lunch attended by fifteen men was the Director of the Art Gallery, Frank Lambert, who was to leave for the Walker Art Gallery in Liverpool. This was a job that John Rothenstein had failed to obtain, but he was to succeed Lambert in Leeds. In speaking about the history of the art gallery Jacob praised Lambert's support of the 'advance guard' of artists, but despite the presence of some beautiful watercolours by Turner, Cotman and Camille Pissarro, Rothenstein found both the building and the collection made 'a lamentable impression.'

The first guest in 1932 was due to be Herbert Read, now occupant of the Watson Gordon Chair of Fine Art in Edinburgh, but as Read was giving a lecture that evening on 'The Meaning of Primitive Art', his schedule was too tight except to have tea with Jacob. Nevertheless, the number of signatures to the meetings increased: Father O'Connor, the inspiration for G K Chesterton's Father Brown series, had 27, and the popular Sub-Dean of the Medical School, Professor Steward, had 33.

Two years of coping with the Leeds City Fathers was apparently enough for John Rothenstein, and he applied successfully for the directorship of the Sheffield Art Gallery. Jacob arranged for a farewell dinner for him and invited John's father, William Rothenstein, to attend. Initially the latter was not sure that he could make the trip – 'the long journey to and from Leeds is not to be lightly undertaken' – but he did come, and on 24 January his son was supported by 48 signatures in the Record Book. In his speech of thanks for the support of the Group, the 'unofficial opposition,' and for Mr Lupton Whitelock, John added a personal tribute to Jacob, whom he described as a 'vivid and exciting personality.' William was delighted with the warm reception he received and wrote to Jacob thanking him for his friendship and support

for his son, and added that he was more than glad 'to renew our own slight acquaintance, which I hope we may look on as something more than a casual one.' The fiasco of the Town Hall project could not easily be forgotten, and in the dispute with Sadler, Rothenstein had been on the side of his fellow painters. John maintained his contact with Jacob, writing from Sheffield that it was a long time since he had heard from Jacob, and he hoped that Jacob's plans for an exhibition were progressing.

While being the Group's enthusiastic convener and a regular patron of the bar at The Victoria, an hotel behind the Town Hall, Jacob had not entirely abandoned his art. Since 1914, when he exhibited his first portrait of Christ, he was still struggling with this obsession, and in March 1933 he discussed his problem in an interview with L Stephen Williams, a journalist from the *Daily Express*. In a wonderfully revealing report Williams tells how he found Jacob in his house, 'a tiny cottage in Little Woodhouse-street, a narrow old-fashioned street near the University, smelling of fruit and greengrocery, and lined with smoke blackened houses and little dusty gardens. I knocked at a door next to an off-licence and he showed me into a small room with an obsolete piano, an unbearably hot fire, and walls covered with his paintings and drawings.

'"I live here because, well it's a picturesque district of lodging houses. You know; one sees all kinds of people here – theatricals, foreigners, queer types," he said as I sat down on a chair without a back.'

'"I go away – yes, I go away – to escape – to escape, but I always come back!" He talks like that; in a nervous, excited fashion and in a deep cavernous voice that seems to swallow up most of his words.'

The reporter described Jacob at this time as a tall, loosely built man about forty years of age with a high nose, a keen deeply lined Jewish face, horn-rimmed spectacles, and wavy black hair streaked with grey. 'A friendly unaffected man with a sense of humour; as gentle and as courteous as a woman in social gestures, as obstinate as a mule in matters of art; a man not fluent in speech yet bubbling over with ideas, and whose hands move restlessly while he talks, as though continually seeking the handle of a brush.'

Jacob had only recently torn up his second attempt to paint Christ, and the third attempt, started seven years earlier, was still only half finished, because, as he explained, sometimes he cannot bear to see it. 'I go to it when the spirit moves me…. It is not a picture of Christ crucified…. I want to represent Christ as an expression of human nature… as an ordinary man, but who carries in his face all the sorrow of mankind.' Once again he explained why he a Jew, although not

FIG. 79
Joseph Kramer
and Charles Murray
with companions
at caravan in
Boroughbridge
1935

Orthodox, should spend nearly all of his mature life trying to express Christ – a theme universal to all mankind. But he would not allow Williams to see the canvas. 'No one but myself shall see it until it is finished.'

In talking about his family, Jacob said that when his father died he deliberately destroyed his father's photographic instruments, and was determined to support his family by his art, and continued, 'I have been lucky enough to succeed, my brothers and sisters have gone various ways successfully.' This is an extraordinary statement. His brother, Isaac, had died, and his youngest sister was mentally handicapped. But this is not the only sign that Jacob lived in an illusory land. In another newspaper report Jacob says that he has a beautiful home in the country, but if Jacob had a home in the country at this time it was a caravan, one rented from a farmer and next to that of his close friend, the Scottish painter and bohemian, Charles Murray, who had led an extraordinarily adventurous life. They were birds of a feather, drinking companions and often seen arm in arm, much the worse for wear, staggering around the streets of central Leeds. Katherine Fryer, then a young artist, describes how amusing it was to see the two friends, 'Jacob, huge, impressive, Oriental. Charles, small with a light voice that had a Celtic lilt. They both had one language in common – Russian.'

Murray was the same age as Jacob, and had been a student at the Glasgow School of Art. He had won the Prix de Rome for etching, but as Rothenstein writes, 'he felt uneasy beneath blue skies, was insensitive to the splendour of classical and renaissance architecture. Declaring that Rome looked like an ice-cream cart, Murray left Italy and went into the North,' where he joined the White Russian army as part of the British government's help against Trotsky's Red Army. He also joined the Black and Tans in Ireland, and enjoyed a stint as a farm worker in the Jura. Apart from the Russian language another link with Jacob was drinking and womanising. For a time he shared Jacob's two rooms in Mrs Smiles' house, and in the summer went with Jacob to the caravan on Kirby Hill outside Boroughbridge in Yorkshire. Their rural menage of 1935 is wonderfully shown in a photograph where Jacob and two happy ladies sit against the caravan, while at their feet Charles hugs another woman, whose serenity seems to suggest that

the painter has skills other than on canvas (fig. 79). No doubt a
third man took this sunny photograph. On one occasion Jacob, being
without money for the bus fare, was forced to walk back to Leeds from
the caravan, and had to sleep in a ditch. In marked contrast to this
bohemian figure, Jacob in 1936 painted another self-portrait, probably
the third, this time in oils, and unlike the previous three it is scarcely
recognisable as Jacob. This smooth-faced, bespectacled, very serious
professional person seems rather alien. Perhaps Jacob saw himself as
a German philosopher (fig. 80).

Murray married in 1939, became a reformed man, and his wife, Margaret,
daughter of a solicitor, remembers meeting Jacob one day in the street,
and the next day receiving a postcard from him apologising for not
raising his hat. As David Astor describes him at this time, he was
'a large, red faced, slightly clumsy man, with an old hat pulled well
down on his head; his shyness and buffoonery alternating with a love
of assertion,' especially when it came to art. But his interests were much
wider, concerts at the Town Hall, boxing and wrestling matches, the
theatre and the Music Hall – the Leeds City Varieties – and chess with
Tommy Lamb. And in many moments of reflection or depression he
would sit in empty churches, listening to Bach when the organ played,
or in any other large empty space.

Despite continuing to make portraits Jacob's intermittent preoccupation
with Christ was demonstrated when he was making a portrait of the
Reverend William Elborne, whom he drew in the act of prayer. He
gave Elborne a large unfinished oil painting of Christ, which initially
expressed his ideas of the subject, but then he asked Elborne to destroy
it. He was making portraits of people in both Leeds and London,
where on one occasion he stayed in the Roberts' flat while they were
on holiday in Wensleydale. In London he felt lonely and depressed,
and on one occasion felt very disappointed with a portrait, although
the sitter was happy with it. As he wrote to Eunice Levin, he felt so
lonely that he found his only consolation in visits to the zoo, where
he 'felt quite at home with the animals.' He hurried back to Leeds,
but promised Eunice that he would return to London to see and
draw some Indian dancers. He also wrote that he was still hoping to
exhibit in London, but 'difficulties of many kinds still prevent me from
doing so…' However, news of his hopes had got around, and he was
approached by Lilian (better known as Lily) Browse of the Leger
Galleries with an offer of a one-man show in the June of 1934. The
gallery could take forty or fifty pictures, she wrote, and she added the
gallery's terms: one third commission on all pictures sold, to bear all
expenses of advertising, etc, but not the cost of framing. Jacob agreed,
and Lilian Browse asked for a couple of pictures to put in her window
before the show. Ironically Jacob had been asked why he did not hold

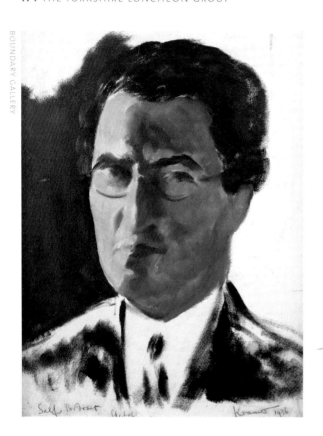

FIG. 80
Self portrait
*oil on board*
1936

exhibitions of his own work, to which he replied that he did not care to produce large quantities. 'The real artist must work when he can create,' and Jacob was not doing very much of that.

George Jackson was in close touch with Jacob, who told him that John Rothenstein wanted to spend a weekend with him at the caravan, and could he (Jackson) go to Ripon station to give Rothenstein and Jacob a lift to the caravan. However, when Jackson got to the station he found Jacob looking very anxious, and Rothenstein in a bowler hat, black jacket, striped trousers, wash-leather gloves and a rolled-up umbrella, with a large suitcase and a little wire-haired terrier dog. They drove up to the marketplace, where Jacob said he had a little bit of shopping to do. 'He made his departure and neither of us saw him again,' and when Jackson drove Rothenstein to the caravan they found it well and truly locked. They waited a long time, hoping that Jacob would turn up, but as he didn't arrive, Rothenstein asked Jackson if he could find him alternative accommodation. Jackson suggested the Blue Bell Hotel at Kirby Hill, but alas, although they had accommodation, they did not take dogs. So Jackson suggested telephoning Mary Ethel Hunter, a friend in Ripon, for accommodation with her family, and all ended happily.

Despite this breach of courtesy on Jacob's part, Rothenstein seems to have accepted his eccentricity; after all the outfit of a city gent must have seemed so alien to the avowed bohemian that his taking flight was not so unreasonable, and Jacob's relations with John and his wife Elizabeth continued to be friendly. Their move to Sheffield had not been easy, they had not found a house and were staying in a hotel. Elizabeth was ill, and John had neither office nor staff, but said that the new gallery looked fine. He wrote that he had wonderful memories of Jacob's kindness to him and his father at the YLG dinner, and that Jacob should visit them when he could. Elizabeth also wrote that 'John is very lonely as I am in bed,' and that they would be delighted if Jacob could spend Sunday with them. Jacob did visit them and

John saw Jacob when he came to Leeds. But when in August 1934 Rothenstein organised a tea party at his gallery for a number of people, including collectors, to meet Jacob, the latter sent a telegram to say that he could not come. This was not the first time that Jacob had not turned up when expected.

Another old friend who kept in touch was Horace Brodzky, who had published a book on his late friend, Gaudier-Brzeska, and was keen to have some publicity. He wrote to Jacob to ask him to boost the book up north, and to make sure that it was in the local library. Also he expressed keen interest in Jacob's forthcoming exhibition in London. Not long after Dolores died, Geoffrey Bemrose, curator of the Stoke-on-Trent Art Gallery wrote that his committee were prepared to offer Jacob forty guineas for his portrait of her. Jacob accepted. He had painted the portrait when Dolores had been very ill, and had captured her melancholy. Alas, many visitors to the gallery thought it sepulchral, even repulsive; beauty not truth, was what the art patrons demanded.

Jacob's earnings were boosted when he painted the portrait of a Keighley dress-goods manufacturer, Stephen Hartley, on the occasion of his seventieth birthday. Like the celebrations of the boot manufacturer, Brow Dickinson, over a decade earlier, Jacob's portrait of Mr Hartley was presented to him by his 240 employees, who were then treated to a day trip to Blackpool. In addition, four of his works were included in a sale at Christie's. A charcoal of a Russian peasant was priced at £14, 'Head of a Girl' £15, 'Cornish Farmer' £17, and 'An Indian Girl' at £20: all well priced.

Lilian Browse had been busy collecting Kramer pictures from private collectors scattered all over England. It was a task that Jacob himself would have found too difficult, and when he spoke to a reporter from the *Yorkshire Observer*, he said that finding a notice of his one-man show in an arts magazine was the first he had heard of it. The Leger Gallery's exhibition of forty pictures included oils, pastels, drawings and lithographs, some of it going back to what he considered his best period, 1918–19. Jacob was only forty-three, an age when many painters are exploring new fields of experiment, but he had little if anything new to offer. His pastels were well praised, one critic writing that no other English artist 'has quite that sensibility of touch and perfection of quality… in this medium.' His simplification and geometrical stylisation of form as in 'Shylock' and 'Jews at Prayer', were noted, in complete contrast to his romantic 'Falmouth Harbour, View from St Antony'. This is one of Jacob's few interesting landscapes, and was probably painted while on holiday with George Parker in 1928. Its peaceful mood could well reflect Jacob's disposition at the time.

By coincidence, across the street from the Leger Gallery, the Agnew Gallery was showing the work of Sir William Rothenstein on his retirement from the presidency of the Royal Academy. The two artists could hardly be more different, the reviewer commenting on Rothenstein's quiet but effective compositions, and Kramer's sometime over-dramatisation.

In April 1934 Jacob approached Rothenstein about the possibility of the YLG meeting at the new Sheffield Art Gallery, but as this was not to be opened until 5 July by the Duke and Duchess of York, Rothenstein made enquiries about obtaining a private room. As he had a friend, a Mr Davy, who owned several restaurants, this presented no problem, and Mr Davy's managing director wrote to Jacob to say that he was sure he could give every satisfaction, but their places were not licensed. However, he was sure that there would be 'no difficulty of making arrangements for the supply of everything needful.' The dinner was given for Philip Hendy, who had followed Frank Rutter as Director of the Leeds gallery, and thirty signatures were registered in the Record Book. Everything had been satisfactory, which meant that a sufficiency of alcohol had been provided. Not only that, Rothenstein, now installed as curator to the two Sheffield galleries, welcomed the YLG to the new Graves Gallery, to which Jacob had loaned the portrait of Dolores. Rothenstein's loneliness in Sheffield was expressed by his view that such visits helped to link Sheffield with the outside world. He felt that his new home was isolated, unlike Leeds, which he described as a maelstrom of small cities. Hendy too was dissatisfied with his new appointment, and wondered why Sheffield had two lovely galleries, while 'in Leeds we have nothing. Our gallery is a disgrace to Leeds.' He pursued this theme at a talk to the YLG in November at a dinner at Whitelock's with Jacob in the chair. 'Yorkshire people liked to tell him that it was hopeless, in fact wicked, to expect people to admire works of art before they were properly housed and living in really decent conditions.... But to say that we have got to be comfortable, clean and healthy first , and that art is a luxury for the rich, is quite the wrong way to go about it. Art may be a luxury for the rich, but it is certainly a necessity for the poor... you can escape from a slum if you have something above the slum spirit.'

The success of these meetings, now so important to Jacob, must have heightened his friendship with Rothenstein, but then the 'Deakin affair' occurred. In October 1935 Jacob asked John if he could find him a room in Sheffield. John found a very suitable room, indeed a 'unique' room, with Mrs Deakin at 2 Wilkinson Street, and recommended Jacob to contact the lady right away. This Jacob did by letter, and on his repeated assurances that he wanted the room and the reception of a small deposit, Mrs Deakin refused two or three other offers. Then

Jacob changed his mind, and ultimately when he decided that he definitely did not want the room, Mrs Deakin sent him a reduced bill. Jacob did not pay, nor did he answer any of her letters. Not unnaturally Mrs Deakin was very angry and threatened legal proceedings. John Rothenstein, feeling responsible for recommending Jacob, was also furious, but as he wrote to Jacob, 'that given my dislike of seeing you landed in the difficulties that must result unless the money is paid, I propose to settle the matter at once myself: so that by the time you receive this letter Mrs. Deakin will have received a cheque.' Jacob seems to have felt that he had no responsibility to pay Mrs Deakin, and some weeks later Rothenstein wrote again:

'I write to tell you that I think that your conduct… is beyond description…. Far from reimbursing me, you did not have the grace to write to acknowledge the fact that I had assumed responsibility for a debt of yours and saved you the unpleasantness of a county court case. And when I met you quite by accident all you had to say was that you would not have lost the case. Whatever the law may be on the matter your own moral responsibility is absolutely clear.'

Then Jacob suggested that they should meet and talk. Rothenstein agreed to this, and suggested that Jacob bring his cheque book with him, but Jacob did not turn up. Rothenstein persisted and advised Jacob to discuss the matter with his friend Tommy Lamb and his landlady, Mrs Smiles, adding, 'if I do not hear from you in the next ten days I shall know what a low price you put on our friendship which you have always told me you valued so highly…. unless I have a favourable response from you, no further relationship, not even the most casual, can exist between us.' Jacob's cavalier attitude to his responsibilities to other people had lost him a good friend, and it was several years before they met again.

# 18 WORLD WAR II AND AFTER

The activity of the YLG reflected Jacob's energy and mood, and in the years before the Second World War the meetings of the group became less frequent. Three suppers had been held in 1935, one for Jacob's old friend, the painter Francis Watson, to which only three people came, then a very popular one for Herbert Read (thirty-eight signatures), and the next for the architect, Ernest Procter and his wife. In 1936 the Lady Mayoress, Blanche Leigh and then Walter Starkie were honoured, and for the two meetings of 1937 Jacob bagged national celebrities, Charles Nevinson and the composer and conductor, Constant Lambert. In that year on 28 April the Leeds Women's Luncheon Club held a Coronation Lunch to which several 'Yorkshire Notables' were invited, and Jacob was one of these. Then in 1940 Jacob arranged something different for the YLG, a celebration of the birthday of the famous cartoonist, Phil May, a Leeds man, born in 1864, who died aged only thirty-nine. He had been one of the greatest and most popular cartoonists that the magazine, *Punch*, had ever had. He was a man who had suffered harsh poverty in his youth and his work showed great compassion for the plight of the poor, a wonderful sense of fun, and an economy of line that was an example to later cartoonists. His work certainly influenced Jacob's own cartoons, which appeared in *The Tyke* and *The Gryphon* magazines. Jacob arranged for a small gathering to visit the house where Phil May was born, and then with May's brother Bert, now an old man, 'to repair to a hostelry where over a glass of beer we shall indulge in a little reminiscence and discussion of the work of one whom we honour for his genius as well as for the fact that he was a Leeds man.'

Tributes came from the editor of *Punch*, and from famous cartoonists of the day, including David Low, who promised to come to the YLG the following year. A small exhibition of May's drawings was held in the Queens Hotel, where Jacob, Bert May, Tom Lamb, Ernest Musgrave, then Director of Wakefield Art Gallery, and many others paid tribute to the artist. The YLG did not meet again until 1949, when a memorial meeting for Phil May was held.

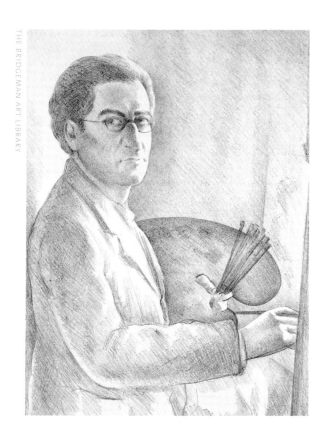

FIG. 81

Self portrait

*pencil on paper*

1940

In 1940 at the Harrogate Art Gallery Jacob had an exhibition of about forty works, mainly on loan from private collectors, but two of his most important new works of that year were his self-portrait as the artist at work (fig. 81) and his portrait of Selig Brodetsky, highly respected Professor of Applied Mathematics at Leeds University and a great Zionist. In this painting Jacob has recovered some of his former power and skill, and Brodetsky is portrayed as the forceful yet benevolent personality that he was (fig. 82). Unlike so many of Jacob's portraits where part of the face, usually the left side, is shadowed, Brodetsky is seen in left profile, his rather dainty hands balancing the lightly modelled but lively head. The portrait was included as an example of Jacob's work in a *Lexicon of Jewish Artists*, edited by Malula Sagall, who asked Jacob for his biography and other samples of his work, as well as inviting him to tea if he came to London, as she was 'eager to acquaint myself more fully with your great Art.' Jacob obliged and Mrs. Sagall sent him a letter of thanks on the back of which Jacob made a shopping list: 'Butter and Margarine Sugar Meat Bacon and Ham Tea – *anywhere* – Cheese.' His favourite meal was bread and cheese washed down with a glass of beer.

Jacob was keen to make portraits of important Yorkshire individuals engaged in war work, and wrote to John Rothenstein to ask for suggestions. Rothenstein replied warmly and suggested that Jacob contact E M O'R Dickey, Secretary of the War Artists' Committee at the Ministry of Information. Stanley Spencer, who was engaged in making huge murals of war workers, also provided him with another contact at the Ministry of Information. Although the Ministry did make use of his services, as in the portraits of Flight Lieutenant Percy Dalton (fig. 83), and Sergeant-Major Hollis VC, Jacob failed to be acknowledged as an official war artist for the second time. He did go to London where he met old friends, including Rothenstein, who expressed a wish to see something of Jacob's latest work and a photograph of 'The Corpse', and as an inducement he sent Jacob a railway ticket.

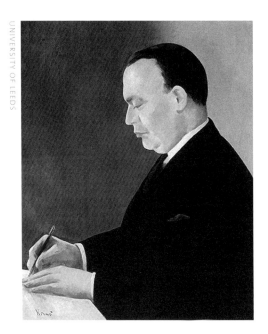

FIG. 82

Portrait of Professor
Selig Brodetsky

*oil on canvas:*
*height 30"*

C 1943

Five of Jacob's works were shown in January 1943 in the Russian section of the Allied Nations Exhibition for the Forces. These were: 'Clay A Dissecting Room Corpse', a pencil drawing of Delius, 'A pastel of Gandhi', 'Talmudists' (lent by Dr Stross) and a picture mysteriously labelled, 'Portrait of my Wife'. There is no name attached to the picture, but it is more than likely that it is the ink portrait of Nellie Smiles.

He was obtaining portrait commissions, though not many, but he was nevertheless still sufficiently well respected to be mentioned in a radio discussion in January 1944, and have some of his drawings in the *Radio Times*. These prompted an old friend, Ethel Warwick, to get in touch with him. She wrote from Somerset where, she said, a Major Maggs, a former Leeds solicitor and very big landowner, had told her that Jacob was dead, news which upset her very much. So she was delighted to find him alive and invited him to join her in Somerset, where she had two cottages. She added, 'Don't you think I have a wonderful memory to remember your address after all these years?' and she asked to be remembered to 'Mrs. Smiler' (sic). The whole tone of the letter suggests that they had been very good friends indeed; but Nellie Smiles was taking good care of Jacob.

About this time (1944) Jacob wrote a list of addresses, revealing his many contacts. They included his sister Sarah, then the editor of the *Radio Times*, in Oxford, Elizabeth Welsh, the singer, Bomberg then in Kensington, Dr Vaughan Williams, with a reminder to himself that to get to Waterloo for Dorking he had to change trains at Piccadilly Circus, and 'Harold J. Lasky' (sic) of London W14, with an appointment for the first Monday in June at 12.15.

This famous wartime sitter was the influential political scientist, who served as assistant to Clement Attlee, wartime Deputy Prime Minister to Winston Churchill. Laski was one of the most prominent teachers at the London School of Economics, and when Jacob approached him to have a portrait painted Laski replied, 'You do me great honour, for I have seen some of your expert work at Dr. Stross's house.' The latter, who was knighted that year, was, like all Jacob's patrons, familiar with Jacob's indigence. Sitters there were, many famous people among them, but Jacob's alcohol addiction was taking considerable toll. His debility was well known and some unscrupulous buyers took

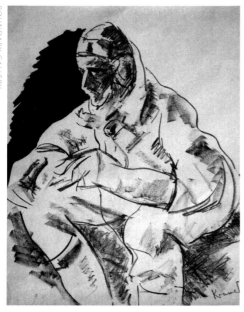

FIG. 83
Flight Lieutenant
Percy Dalton,
156 Squadron
*lithograph:*
*55.5 x 46.8cm*
1940

advantage of his vulnerability. It seems that this situation came to the attention of an amateur artist, John William Hare, who, while sitting enjoying a beer, was in the habit of sketching people in the bar on bits of paper which he then threw away. By chance (so the story goes) Hare met Jacob in one of his regular pubs, and as it was raining Jacob invited Hare to shelter in his studio nearby. There Hare found some of his discarded drawings, which Jacob had admired and retrieved, pinned on the wall. They became friends, and Jacob told Hare that some wealthy industrialist was taking unfair advantage of him by bargaining him down on the price of pictures after getting him drunk. Hare and his friends decided to take matters into their own hands. It seems that the unnamed industrialist was having a formal party at Leeds Town Hall, to which Jacob was not invited. The conspirators hired evening dress for themselves and for Jacob, whom they found the worse for wear in his room. After sobering him up and putting him in dress clothes, they obtained entrance to the Town Hall by bribing the doorman. Then by the simple ruse of saying that the industrialist was wanted on the telephone they were able to pin down the miscreant in private and confront him with a sober, elegant and accusatory Jacob. Apparently the shock treatment worked.

Jacob was not a well man, and apart from opening an exhibition of children's art selected by Dame Laura Knight, in August 1946, little is heard of his activities. For two years, as John Roberts wrote, 'there is silence in the documents.' However, Jacob was not entirely unproductive. His preoccupation with the bible and biblical characters was given an outlet when the Soncino Press commissioned him to design book jackets for their series on the Bible. The Soncino Press, established in the village of that name in northern Italy, was probably the first Hebrew printing press in the world. It specialised in English translations of Hebrew classics, and it was no mean honour to be invited to design for them. In the period 1946–50 Jacob made thirteen bold black-ink drawings of bible characters and events, and in these strong drawings, very like woodcuts, in contrast to his delicate pastels, Jacob demonstrated that he retained his skills as a draughtsman. Their style and power is reminiscent of his Cubist 'Philosopher' of 1922. Jacob's drawings show Job, Kings, Jeremiah, Daniel, Ezra and Nehemiah, Ezekiel, Psalms, Chronicles, Joshua and Judges, Samuel, Isaiah, Proverbs, Twelve Prophets, and Five Megilloth. Especially

MEMORIAL

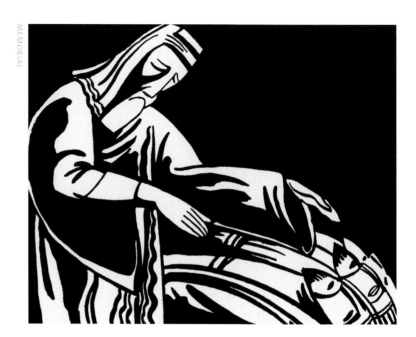

FIG. 84
Ezekiel, Soncino
book jacket
1949

with Ezekiel (fig. 84), Joshua and Judges, and Samuel, the drawings illustrate Jacob's deep knowledge and profound feeling for the Old Testament. These drawings were to be among the last of his works of any importance. Through the Soncino Press Jacob also made a drawing for the International Liberal Association, but this was turned down as too narrow in outlook for the work they were doing. The only recorded correspondence of this time came from John Rothenstein, who sent a postcard showing the latest picture of Epstein's bronze of Jacob.

As always Jacob needed money, and thinking that sales of the lithographs of his portrait of the solicitor, Hubert Firth, might be a source of some income, he suggested that an extensive number of prints be made. Firth demurred, 'I am not happy about it. I only want about 25 myself, but I agreed to take and pay for 30. I should like you therefore to keep the prints to 30 and number them all – and then spoil the stone and let me have a print of that, so that I am sure there are no more.' So spoke a man of the law, and apparently one who did not trust Jacob.

A few months later Jacob underwent minor surgery at Leeds General Infirmary, and recovering well, with his drawing of Gandhi as a mascot on his locker, he started work on an abstract entitled 'Anaesthesia' (fig. 85). When a reporter from the *Yorkshire Post* visited his bedside he found Jacob preparing to colour the picture, watched by Ernest Musgrave, now Director of Leeds Art Gallery, and the ward sister. Despite being bed-bound Jacob was enthusiastic. 'It has been a most

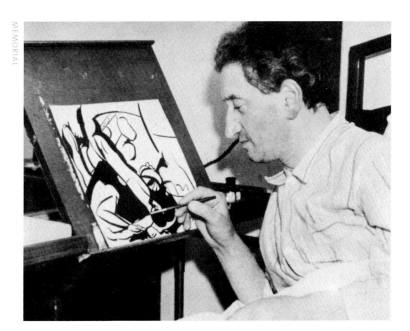

MEMORIAL

FIG. 85
Jacob in hospital
working on
'Anaesthesia'

stimulating experience,' he said, 'and I am reverting to the style of my
earlier works in order to give it full expression.'

Still a celebrity, his opinions were received with respect, and well
before art in hospitals had become commonplace Jacob was discussing
with his doctors the possible curative effects of colour tonalities on
patients. 'Lying here has convinced me of the bad effects of gazing
at a blank wall. As soon as I am able to get out of bed I hope to have
permission to give a practical demonstration of some of my theories.'
The irrepressible Jacob had returned, but the reporter wrote, 'not
everybody, I fancy, will follow him all the way in his desire to have
the walls of the hospital wards covered with bright paintings.'

On 19 November 1947 Cecilia, thirty years a widow, died, and Leah
became the responsibility of the reliable Millie. This important event
appears as a parenthetical note of five words in *The Kramer Documents*.
As with the death of his father, it is one more example of Jacob's failure
to express his feelings, except about art, in writing. What he felt about
his father's death he expressed in paint, but no such expression followed
the death of his beloved mother. Jacob was an unwell, middle-aged man
and such a task demanded spiritual resources that he no longer possessed.

Despite his usual openness of heart and mind Jacob could be stubborn
and at times mean-spirited, as in the case of Mrs Deakin. For some
years Michael Sadleir had been collecting material for a biography
of his father, and since 1946 had made several approaches to Jacob
through their mutual friend, Mrs Redman King, for letters that Jacob

had received from Sir Michael. Jacob had refused to send them on the grounds that he wanted to use them himself. Sadleir was angry, and in his letter of 5 April 1949, protested on two grounds: First, he made the claim that the copyright of all his father's unpublished letters belonged to him, and could not be used by Jacob for his own purposes, 'neither you nor anyone else can print them or parts of them without my permission. If any such printing be attempted I shall instantly take legal action.' Secondly, in view of his father's past generosity and support for Jacob, he felt that refusal of the letters was 'discourteous and disobliging…. there must be material which would help me to convey to others my father's feelings about painting and painters.' In any case, it was too late 'to undo the results of your original lack of generosity, for my book is finished and I cannot now add paragraphs or even sentences to it. You will I am sure understand that it disappoints me greatly…. I am sending this letter by registered post and would ask you without fail to acknowledge it.'

Three weeks later Jacob replied: 'Regarding your father's letters to me I certainly intended forwarding them to you and enclose a letter I had prepared, and unfortunately did not forward to you. The main reason is that after re-reading them I considered they would not be suitable for that purpose, and as they were dealing with private matters which I think you will agree it was undesirable from a personal point of view to publish. I did contemplate writing a book in which I hoped to pay tribute to your father's kindness to myself and many other artists, supported by one or two quotations from your father's letters. This idea in no way influenced me regarding sending the letters to you, but I now greatly regret not having submitted them for your consideration. If I should at any time write a book, which is doubtful, I should certainly consult you regarding anything referring to your father.'

Sadleir proceeded no further. His book was finished and could not be enlarged, and one is left wondering whether Jacob ever intended forwarding those letters. After all, Sadleir had offered no help in Jacob's attempt to become an official war artist.

Jacob was now fifty-six and had not had a one-man show for fourteen years when to the delight of his friends in Leeds, on 21 May 1949 Mr R W Gelsthorpe, Curator of the Batley Art Gallery, opened a show of thirty-nine works, mainly portraits. These included the paintings of Delius and Dolores, as well as a portrait of Matthew Smith. Also exhibited were the early 'Mother and Child', 'Hear Our Voice, O Lord our God', 'The Day of Atonement' and the brightly coloured 'Japanese Lady', but there were no new works. An introduction to the exhibition was written by Jacob's old friend, Tommy Lamb, and it was reviewed in the *Yorkshire Post* by another friend, the art critic, W T (Bill) Oliver.

The works, he wrote, showed the strength and dignity of Jacob's art, and it was 'A blot on Leeds' that Jacob was ignored by his home town, which cramped and frustrated artists by neglect and prejudice. After the exhibition Gelsthorpe sent pictures back to Jacob, expressing his view that the show had been a great success, and that 'you have made many friends in Batley district and all of them have a warm corner in their hearts for you and your painting.... I have always reckoned you as one of our leading Yorkshire artists and I always shall. Sometime, when we can afford to start purchasing pictures, you will be one of the first to be represented in our collection.'

Money had to be made, sometimes by unorthodox means. In August 1949 the circus came to Leeds and set up its tent on Woodhouse Moor, not far from Jacob's home. The principle attraction was Nicolai Poliakov, or Coco the Clown. Jacob took part in the public entertainment by making a drawing of Coco, while exchanging repartee in their common language, Russian. When most of the head had been completed, Jacob said, 'Hair up,' and Coco flicked his thumb to make his scarlet wig stand up on end. No doubt the audience found this act funny, but this sad scene, reminiscent of Dolores sitting in a barrel at a fun fair, indicates Jacob's parlous state. Soon after, Jacob was interviewed enjoying one of his favourite entertainments, an all-in wrestling contest, where he said that a ring-side seat 'gives you all the elusive mysteries of the human form at a sitting.'

In that November Matthew Smith wrote to Jacob about taking part in a forthcoming show of the London Group, and in an encouraging PS added, 'It is I think people like you that the Group really needs.' But nothing came of this.

A further sign of Jacob's debility was that the Yorkshire Luncheon Group had not met for almost ten years until April 1949. The Phil May exhibition had been a singular event. At this time Councillor Eric E Bullus, Chairman of the Leeds Art Gallery sub-committee, announced that the Leeds Art Gallery collection, which had been moved temporarily to Temple Newsam House, was to return to central Leeds at the City Art Gallery, and the first works to be included would be those of the war artist, Stanley Wilson, and the second those of Jacob Kramer, 'to whom public tribute should be paid for the work he had done for art in Leeds and elsewhere.'

The first proper meeting of the YLG was held in October with Frank Dobson, the sculptor, as guest. In comparing the art scenes of London and Paris, Dobson said that in London there was much talk about art and not enough art; nevertheless there was greater opportunity for art among the young people of London than in Paris. However, he asked,

'Why have we got to be hurt by works of art nowadays? In one room I saw 65 pictures by Picasso – absolutely dreadful.'

Jacob's influence on art in Leeds was evident when in May 1950 Mr and Mrs George Dent, landlord and landlady of the Jubilee Hotel, one of Jacob's haunts, decided to put pictures on show. On holiday in London they had visited the Six Bells in Chelsea, seen pictures exhibited and were greatly taken with the idea. They got Jacob to organise the show and decided to make it a permanent feature of the house.

'I have waited a long time to open an exhibition in ideal surroundings,' was Ernest Musgrave's response. The work of many prominent Leeds artists was on display, including a portrait of a beautiful brunette by Jacob. One art critic remarked, 'I would rather see bars in public art galleries.' But the Dents' idea proved to be a great success and very many shows of artists, both famous and local were held regularly. At the ninety-fourth show, in June 1958, Jacob organised an exhibition of the work of Augustus John. This was opened by Flora Robson, because she loved John's work and as a tribute to Jacob. At the ninety-fifth show, also in 1958, Jacob was missing, said to be too shy to attend. After Jacob's death, one oil painting hung at the Jubilee was a portrait of him by a Mr Bailey Clubb, price £10.

In the 'fifties famous guests at the YLG included the great cricket commentator, Neville Cardus, the ballet dancer, Anton Dolin, and Jacob's friend of many years, the chest surgeon, Professor Philip Allison. The most significant meeting was the dinner for Ernest Musgrave in January 1951. A few days later Musgrave wrote to Jacob:

'In all our twenty-five years friendship, this is perhaps the first time I have ever written you a letter…. What I want to say is a *very sincere* "thank you."… I am deeply conscious of the honour you paid me Monday last, I am sincerely grateful for it, as for many other things. During the whole of my career I have treasured your friendship.' And in August Musgrave sent around a circular headed, 'Hommage à Jacob. A Yorkshire Luncheon Group Requiem' to be held at Temple Newsom House.

It read: 'For years past the Yorkshire Luncheon Group, fathered and mothered by Jacob Kramer – his only known legitimate offspring – has existed precariously on the slender chance of someone being able to arouse (and sustain) his enthusiasm for a meal which includes at least some modicum of solid food. Now, for too long, this wholesomely unethical and truly fantastic disorganisation has lain fallow. There appears to be no possible way of goading the ungoadable Jacob into making the necessary effort to keep it alive. For this reason I presume

to write you this letter hoping to arouse your interest in a project of which I sincerely hope you will approve.

'If this vital torch of reality is to be extinguished can it not be mercifully snuffed rather than be allowed to gutter out miserably as it's so painfully doing at present? I feel sure that if we give the Y.L.G. a decent burial service it will be the most certain way to bring this strange anti-natural phenomenon to life again. What an opportunity this would be to pay homage to its lovable begetter, to whom we all owe so much (and perhaps vice versa). A character who has contributed so much to the cultural life of the city and the north of England.

'In any gathering of artists, poets, actors, musicians or writers at which he is not present the question will be asked sooner or later, "have you seen Jacob lately?"

Musgrave concluded his long tribute to Jacob by announcing that he had booked a room at the Guildford Hotel on Friday 26 October. 'It will cost us about 12/- each for dinner, service and one or two guests.' He concluded, 'P.S. Item of importance. Please do not impart this information to Jacob. He knows nothing about it so far.'

Over fifty artists and art lovers attended the dinner, and tributes were paid to Jacob from Musgrave and others, including Maurice de Sausmarez, lecturer in Fine Art at the university, who described Jacob as 'one of the most brilliant painters that have ever come out of the Slade School of Art.' Jacob was elected President of the YLG unanimously.

# 19 THE LAST DECADE

The coronation of Queen Elizabeth II on 2 June dominated 1953, and in opening a Coronation Arts and Crafts exhibition in Horsforth, Jacob said, 'In the second Elizabethan age, we find the true torch of art burning with enthusiasm and brightness.' Alas, that could not be said for his own artistic activity. He had been reduced to earning some money by painting the background panorama for zoological specimens in the museum showcases. The YLG continued under Musgrave's paternity, and Jacob played a diminishing role. He was a sick man, but always to be found in the Victoria, the Jubilee or Whitelock's. There, as ever, he would buttonhole some likely prospect for a portrait. As the journalist, Geoffrey Winter recalled, 'it was a wondrous moment when he gazed at me across the table in the Vic and murmured, "I would like you to sit to me, Geoffrey." Numbed by such flattery and before I became capable of asking: "Whatever for?" he added, "I will charge you nine guineas, and that will include framing." He knew and I knew that the offer could not be refused.' (Author: in my case, a few years later, it was ten pounds without framing.) One hour or two half-hour sittings in his studio produced a very good likeness in pastels. He had reduced his art to a simple formulaic process, and if the sitter wasn't flattered Jacob would assure him or her that they would grow into it. Winter also recalled Jacob raising his huge cyanosed hands to frame a friend in forefingers and thumbs across the pub table and saying, 'I would like you to sit to me, Michael, I see you in blue,' when blue was the only drawing paper he had left.

Jacob lived not far from Winter's flat, and from the street Winter's mantelpiece could be seen topped by his collection of bottles of assorted spirits. This was a magnet for Jacob who would sample whatever there was available. He was a regular meal-time visitor to the Rosenthals, his main benefactors at this time, where he would eat little, drink to his satisfaction, and before he left offer drawings for sale, some of which were not his own. When short of funds he would borrow money on the lender's expectation of having a portrait, and too often the future saw neither portrait nor money returned.

At some time in the middle 'fifties Jacob's sister, Leah, lost her sight and was put in the care of the Jewish Blind Home. Thus released, Millie, who was an efficient secretary and personal assistant in some commercial enterprise, went to the USA. She was an energetic and abrasive character, well suited to business life in New York, and may well have had plans to marry there. When she left the Trumpf Distributing Co in New York in May 1957, her reference described her as a 'Very capable and efficient secretary,' and when she returned to England in 1960 for Jacob's big retrospective exhibition they had not seen each other for five years. Sarah now lived in London, and Jacob had no family left in Leeds. He kept body and soul together by part-time teaching at the Leeds and Bradford art schools, and the Leeds College provided him with a small pension. The Medical School helped by having him make the occasional drawing of operations and cadavers, and also by providing many of his sitters. Art students described him as big, slow, quietly spoken and always smiling, the living example of a man who did not need to shout to make himself heard. He commanded respect from everyone, and in talking about art, artists, and his own work and life, he proved to be an inspiration to the students. The artist, Ron Lipman, who came to know Jacob well in these years, described him as a very gentle man, a teacher who would inspect the student's work, then, saying 'Stand up,' would take the student's place and add magic to their work. Jacob spent much of his time sitting in Leeds library looking through art books, or sitting quietly in the art school, where Katherine Fryer, as a new art student, first encountered him. 'I chanced one day to go into the sculpture room. This was empty except for a large check-over-coated figure sitting in the centre on the model's throne. He was monolithic and impressive, I knew that this could only be Kramer. I was so overawed that I fled.'

In August 1956 Jacob presented the library of Leeds University with a portfolio of his works, and as Maurice de Sausmarez had been ill it fell to Quentin Bell to sort out the pictures in their large and dilapidated folio. There were seventy-two drawings covering most of Jacob's career, 'luckily with a fairly high proportion of early work, some of which is very good indeed.' Bell went on to comment that Jacob was an extremely unreliable source, having great difficulty in remembering anything, especially to do with the sale of his work.

As always his appointment keeping was unreliable. Three months after he would tell Lipman that he would be in touch, he might make contact and offer to sell him a drawing. Jacob's fingers, always large, became like sausages due to liver disease, and he was unable to hold a piece of chalk. Often Lipman would meet Jacob in the Victoria pub, where, holding his brandy glass between his two hands as though receiving welcome warmth from the vessel, he would talk, always

about art, about the Impressionists, and about his favourites, Picasso and Braque, revolutionaries and bohemians. There he would sit, a distinguished figure with a large hooked nose and a far-away look in his eyes recalling his youth in London, parties with drink and song, wild and bohemian, and the great occasion of the year, the Chelsea Arts Ball; then he would describe himself as a happy man.

Jacob continued to make summary pastel portraits, and the Yorkshire Artists exhibition of 1955 included two of his flower studies. His was still a name on the Northern art scene and his help was sought to give advice and to open exhibitions. He helped a group of young artists calling themselves the 'Sevens Group' to have a show at the Jubilee. As well as opening the Horsforth Exhibition of Arts and Crafts, the Otley Arts Club asked him to join Bill Oliver in selecting works for their 1956 exhibition, for which he was able to borrow a portrait of Dolores. Salford Art Gallery asked for two of his works to be shown at their 'Cream of Northern Art' exhibition, and requests for his work came from Newcastle upon Tyne and Scarborough galleries. His friends rallied round, and even as late as 1958 George Parker was putting him in touch with the well-to-do who wanted portraits. A George Seebohm, one of whose daughters had been painted by Laura Knight, offered Jacob twenty-five guineas to paint one of his children. In 1960 Huddersfield Art Society offered five guineas for his services selecting pictures.

One day Jacob took Lipman to his old studio, opened the door with a large rusty key and mounted a flight of stairs thick with dust. This studio behind Leeds Town Hall was a large room with bare walls, and on an easel was a canvas, half painted, with a portrait of Christ. Opened drawers were found to be empty as Jacob had sold everything, but when asked if he was a happy man, he would say that he was because he was a true artist who had tried to express the Jewish spirit in himself and in his portraits of his mother.

Perhaps the saddest and most revealing report of Jacob's condition in his later years is by Alan Bennett in his 1993 Christmas diary, where he recalls seeing Jacob in the art gallery and library, probably in the early fifties:

'Someone I took for a long time to be a tramp wasn't at all. Dirty, often drunk, in a greasy overcoat and very Jewish, he would hang around the Art Gallery or slump over a book of paintings in the Reference Library where he would be periodically woken up by the staff and told, "No sleeping." This was the painter Jacob Kramer, an early Vorticist and contemporary of Nevinson, William Roberts and Wyndham Lewis. I had often looked at his portrait of Delius in the

Art Gallery without knowing that, like Elstir, this down and out was the painter.'

Jacob's health continued to deteriorate, and in February 1957 and then in 1959, he was back in Leeds General Infirmary, subsequently recuperating in a convalescent home. But health was not his only problem. In 1951 his address had been at 22 Kendal Lane, but when in 1960 Nellie Smiles, after thirty-six years of being his carer, moved to London, that year found him at Blundell Street, unwell and unhappy. In July he wrote to the Leeds Housing Director asking to be put on the list for a building scheme initiated by the Jewish Board of Guardians. He also approached Paul Rosenthal for support, but Paul's mother, Mrs Gertie Rosenthal, doyenne of the Jewish women's community, told him that there was very little hope of a vacancy on that building scheme. However, she wrote to Councillor (later Sir) K C Cohen, Chairman of the Housing Committee for help:

'I would like to help Jacob Kramer to get some accommodation, namely, a tiny flat just for himself, as he is most anxious to have a little peace and his way of living has been very difficult hitherto. I am informed by the Board of Guardians that his name must be down on the Housing List before they can consider the possibility of him acquiring a little place…. I cannot help feeling that his last few years will not be spent so peacefully if we have to wait for this…. It would be nice if we could do something for him to make him happy. I think this is a responsibility that we should consider necessary, don't you?'

Cohen's reply was not encouraging: forms had to be filled in first. All his career Jacob had complained of the lack of support from the Leeds Jewish community and this was just another example of their indifference. However, he did conform to the regulations, writing, 'At present I am beholden to others. I should therefore deem it a privilege if you would put my name down on the Housing List of the Leeds Corporation.'

But he had not been forgotten by the wider world. Friends and admirers decided that Jacob's contribution to art and to the cultural life of Leeds should be recognised in a full-scale Kramer Exhibition as part of the Leeds Tercentenary Celebrations. Lascelles Abercrombie was delighted to be asked to serve on the Superintending Committee. 'It is good to know that [the celebrations] are not to be without some recognition of the work of one of our greatest citizens.'

It was a huge retrospective exhibition of over one hundred and eighty works, which was opened on 7 September 1960 by Dr Barnet Stross MP, and drew over 10,000 visitors, a record attendance for the Leeds Art

Gallery. Abercrombie and his colleagues had collected work from all over the country, and as a review in the *Guardian* reported, rather than being selective, the sixty oil paintings and more than one hundred and twenty pastels and drawings presented the complete man, 'warts and all.' The long review seems generally fair, praising the early work, in which Jacob had used his family as models to make 'a strongly impassioned plea for his own suffering race; a cri de coeur that reaches its culmination in the intensely moving "Hear Our Voice, O Lord Our God".' It went on to note that the impact of this early work is 'not completely destroyed by what came after, the need to earn his bread and butter in the lean times of the '30s…. recording features of various celebrities who came his way… he devised a rather formal approach to portraiture that recalls the Sovereign's head upon the coinage of the realm.' However, the review noted that the work of the late 'forties took on a new vigour and freedom, especially in the male portrait heads, and concluded with the sad comment that the exhibition had come thirty years too late. Much earlier it might have 'provided him with the fillip for his flagging enthusiasm.'

In his review for the *Yorkshire Post*, Jacob's friend, Bill Oliver, took a more sympathetic line, emphasising what Jacob had achieved. He pointed out Jacob's early experimental work, such as the 'Mother and Child', and expressed the view that: '"The Day of Atonement" has greater strength and authority than anything I have seen by other members of the [Vorticist] group. In it Kramer demonstrated how the new geometric-abstract style with its simplification of form could be employed to serve the ends of an intense spirituality…. The impression that the best of the work here leaves is of an artist not only of conspicuous natural gifts but of a fine integrity, with a deep sympathy and respect for his fellow human beings and a firm determination to express something of the spiritual significance underlying our fugitive and often trivial lives.' Jacob was a beloved figure in Leeds, and a legend.

After the opening of the exhibition a dinner was planned by the YLG for 30 September at the Victoria Hotel, with Sir Herbert Read as guest speaker. That day Nellie Pickering came from London to see the exhibition and found Jacob sitting in the gallery, bleary eyed and complaining, 'I am so tired I don't want to go to the dinner.' But the dinner did go ahead with Jacob. Walter Partridge presided, many tributes were paid to Jacob, and fond reminiscences came from his many friends. Sir Linton Andrews, Editor of the *Yorkshire Post*, said that Jacob had been one of Leeds's great public benefactors in bringing beauty to the city. In his speech, Herbert Read spoke about the letters they had exchanged in 1918, and quoted Jacob's memorable explanation of his credo. 'The degree of expression in a work of art is the measure

of its greatness – a spiritual discernment is more essential than the reproduction of the obvious….' Read explained that this was at a time when the cults of Futurism, Cubism and Post-Impressionism thrived, but 'Jacob stood on his own ground.' Then Read made perhaps the most perceptive summary of Jacob's place in art when he said, 'Kramer is and always has been an expressionist and that has been his misfortune for, as a style, it has never been accepted in this country since the Middle Ages.'

Despite his increasing debility Jacob was still in the public eye, and on 5 October he was invited by ABC Television in Manchester to appear on a programme, 'A.B.C. of the North'. On 9 October he was interviewed by Mr A Tucker, Art Critic of the *Guardian*, and talked about the future of art in Leeds. John Rothenstein wrote to congratulate him on the exhibition, which, unfortunately, he could not attend. However, he did repair their relationship, writing that he would always be grateful for Jacob's friendship in the two years that he was in Leeds. Rothenstein wrote a year later (30 November 1961), having heard that Jacob was ill, a fact reported in the *Yorkshire Post* of 3 October. Jacob was never forgotten by his friends in the press.

In December Jacob was taken into Leeds General Infirmary with a respiratory infection, and as his health was extremely poor full-time care became necessary. Millie was now living in Wandsworth, and being involved in community affairs that efficient lady was able to get Jacob admitted to the Jewish Home of Rest in Balham, London in January 1962. A regular visitor to Jacob was his young friend Corinne Bellow, personal assistant to John Rothenstein, then Director of the Tate Gallery. Jacob died in the home on 4 February. Millie registered the death of her brother, the retired artist, from cerebral arteriosclerosis, Parkinson's disease and chronic bronchitis. He was sixty-nine. His body was moved to Leeds and on 7 February the funeral took place. The cortège left the New Synagogue in Chapeltown Road, a stone's throw from the early family home, for the service and interment at the bottom end of the Jewish Cemetery at Gildersome.

Obituaries in the *Yorkshire Post*, written by Bill Oliver, Herbert Read and Philip Allison, paid tribute to their old friend, emphasising different aspects of this complicated man. Oliver wrote, 'When we think of the rich contribution which Jacob Kramer made to the artistic life of Leeds we are reminded of how much Britain has profited from political and religious persecution in other countries.' And in his eloquent tribute, Philip Allison, now Nuffield Professor of Surgery at Oxford, wrote, 'One of the joys of knowing Jacob was that he could never be reduced to something fully comprehensible that could be labelled and filed away. He was too big and too various to be catalogued. Few knew him

intimately, but some fortunate people knew him well.' One of these was Herbert Read, who wrote:

'He represented an alien tradition, Russian and Jewish…. He thought emotions should be symbolised; that the result should be, to use his own words, "purely spiritual". "The more conscious I become of the element of spirituality, which is inherent in everything," he wrote to me in 1918, "to that extent I am filled with a sense of abiding happiness which I am only capable of understanding when I express myself to the uttermost". I think Kramer always remained filled with this sense of abiding happiness…'

Read went on to describe Jacob's contentment with the provincial life, and concluded: 'It is too early to assess his position among the artists of his time, but I believe he left a few masterpieces, such as 'The Day of Atonement'… which will survive the confused values of our time.'

More humble people in the art world also remembered Jacob, and his portrait in oils by a member of a Leeds group of artists was sold in October at the Jubilee Hotel. Further tributes were paid to Jacob at a memorial meeting in Leeds City Art Gallery on 30 April, attended by members of the Leeds Jewish community, the artistic world of Leeds, and members of the YLG. Alderman J S Walsh, who had known Jacob for over forty years, presided, and Leeds's debt to Jacob was acknowledged by the presence of the Lord Mayor. Rabbi Dr S Brown gave an address and the cantor, The Reverend Samuel Knopp, said prayers. Philip Allison spoke of the Jacob they had known and loved.

It is usual for a gravestone to be set up one year after a Jewish burial, but in Jacob's case this event was delayed until June 1967. Millie was determined to have Yorkshire stone and spent years looking for the right piece in the quarries around Leeds, Bradford and York. Finally, thanks to the Leeds Co-operative Society, she found a stone in one of their quarries where it had fallen and broken. 'When I saw it, I knew it was exactly what I had been searching for…. Already it was becoming weathered and almost taking on the spirit of Leeds. It is as rugged as Jacob could occasionally be, but it is not harsh and its colour is beautiful. When I see it I see Jacob.' The simple inscription reads only 'Jacob Kramer, Artist, 1892–1962' and surrounded by more conventional headstones, it commands attention. Both Sarah and Millie were at the ceremony, which was conducted by two rabbis, S Brown and J Apfel.

Millie presented Jacob's palette to the Art Gallery, and in return the Gallery gave her permission to reproduce free of charge the pictures 'Clay' and 'Miners at Work' in a biography of her brother that she intended to publish. Her first and very natural thought as to an author

was the art critic Bill Oliver, but he replied that although very touched and pleased, his commitments at the *Yorkshire Post* were so heavy as to make the task impossible. Apparently Millie had suggested an alternative author, one called X in the *Documents*, to which Oliver replied, 'I have given very serious thought to X's qualifications – as one who knows X's personality and work pretty well. Though I have not discussed with him your approach to me, I know from what he told me earlier that he is extremely eager to write about Jacob.' However, Oliver had reservations about X because he went on to suggest that Millie plus several of Jacob's friends would 'give a little tactful guidance.' The identity of X is never mentioned, but it could well have been the poet and radio dramatist, R V Scriven, who was to contribute a passionate essay to Millie's *Memorial Volume*, which was published in 1969. Her efforts to collect material for this lovely book manifest her love for her brother, and were applauded by everyone she approached. Herbert Read thought it a wise decision to publish and allowed his tribute at the great exhibition dinner to be used. John Rothenstein thought it a good idea, Sybil Thorndike and George Jackson wrote to help, but the most moving letters came from the relatives of sitters and ordinary folk whose lives Jacob had touched, such as his barber. The many essays in the *Memorial Volume* by Jacob's distinguished friends bear testimony to the love and respect that Jacob drew from people. They speak eloquently of his impact on all who knew him and the contribution that he made, not only to the artistic life of Leeds but to the perception of art by its citizens.

In 1960, following a recommendation by the National Council of Art Education, many colleges, including Leeds, began to run courses in art and design leading to a diploma (now a degree), as well as vocational courses. These were housed in the Leeds Branch College of Art, established in 1966, and in recognition of Jacob's contribution to the artistic life of Leeds, this new college was called the Jacob Kramer College. But the years have brought further organisational changes to the art teaching institutes, and on 1 April 1993 the college became independent of Leeds City Council. The new college authority, aspiring to recruit students from the national and international pool, dropped the name 'Jacob Kramer', which had become little known in the wider world of art, and the college reverted to its earlier title, as on the 1903 mosaic on its wall, 'Leeds College of Art.'

Until recent increased interest his name and work have been referred to only in occasional newspaper articles and exhibition catalogues. Indeed without Millie's efforts to have her brother remembered he might well have received even less attention and be known only through Epstein's magnificent bust. But he was known, loved and respected by the wider world. At Sotheby's in July 1986 over two hundred of Jacob's letters

came up for sale. This correspondence included letters from Herbert Read, Michael Sadler, Stanley Spencer, Augustus John, Jacob Epstein, William and John Rothenstein, Paul Nash, Bomberg, Brodzsky, Wadsworth, Frank Dobson, David Low, Julian Huxley, Flora Robson, Sybil Thorndike and many others.

Sadly the intelligent and energetic Millie was to suffer premature senile dementia and was looked after devotedly by Sarah and William Roberts. With the death of Sarah's son, John, the line of Cecilia and Max Kramer came to an end, but Jacob's work remains and bears witness to an important part of the story of the Jewish people in Britain. Perhaps his best epitaph was written for the Ben Uri Society exhibition of 1984, by his great friend and supporter, W T Oliver: 'Jacob Kramer performed his greatest service for art in Leeds simply by being in the city.'

# TAKING STOCK

Jacob Kramer's pictures hanging in Leeds City Art Gallery are dominated by two works which should be seen together – together they tell the story of the Jewish people in a profound and potent way. In the Expressionist work, 'Hear Our Voice, O Lord Our God' the pain and suffering of Jacob's mother symbolises the anguish and protest of her people, and through the strength of the Vorticist style, the 'Day of Atonement' demonstrates the spiritual solidity of the Jews by way of the community of prayer in the face of two thousand years of persecution. Other Jewish painters have portrayed Jewish characters, rituals and symbols, but Jacob Kramer sought to express something deeper: the Jewish soul.

 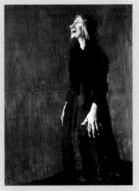

While most of his Jewish contemporaries were children of poor families, Jacob was the son of a successful and respected artist, but fate decreed that his father could not be his model for long. Once in exile, the prize of recognition could not be the father's but was fought for by his son, Jacob. As the first-born and only child for eight years before being displaced by four siblings, conflict about his beloved mother was inevitable. This emotional separation from his father and mother, combined with Jacob's compassion for the condition of their exile, produced the tenderness of much of his work, especially in the portrayal of his family.

Jacob was an outsider attempting to find identity, significance and recognition in a new home. How was Jacob, an alien, to say something significant? Although he loved the Yorkshire countryside he seems to have been unable to internalise it and successfully portray its landscape. The industrial scene was all about him but scarcely ever exploited.

He claimed that he was a revolutionary, an experimenter, and so he was in that journey through various styles, Realism, Post-Impressionism, and Cubism, movements that touched him but did not absorb him, as Vorticism did William Roberts. At the heart of Jacob's belief about the purpose of art is the idea that reality is to be found in the soul or spirit behind the surface of his subject matter, and in Expressionism he found a means to this end. He was not alone in insisting that one had to simplify and stylise to expose the truth behind the surface, but in this preoccupation he travelled his own road. As demonstrated by the correspondence of 1918 with Herbert Read, by the age of twenty-five he was thinking deeply about the nature of art. The essence was not, as Read asserted, to be found in psychological interpretation, but directly by a special mystical perception. In Jacob's work this had many sources. Russian spirituality was entwined with Jewish mysticism, and these ideas were reinforced by his experience at the Leeds Art Club, many of whose members were Theosophists, and finally by the mystical ideas of Kandinsky to which he was introduced by Michael Sadler.

Jacob's skills, his draughtsmanship and colour sense were equal to that of his contemporaries, and he used these gifts with care and sensitivity. Nevertheless he has been largely ignored by art historians and even by his friends, Herbert Read and Frank Rutter. His work does not fit comfortably into any movement or style. Inspirational he certainly was, both in his work and in his person; he was unique and his images cannot be ignored.

ooooo

His bohemian persona fitted the general idea of an artist, but arguably even more important was his evangelical espousing of art, especially the modern movement, in a philistine and conservative city. This contribution brought just acknowledgement when the branch Leeds Art School was named the Jacob Kramer College.

In his work Jacob rode two main horses, portraiture and expressions of Jewish themes, both sharing a common denominator: the search for the spiritual in the material. While many of his portraits are powerful insights into personality, and in their time original in conception (for example those of Delius, Israel Zangwill and Peggy the Barmaid), in

others the search for essence deformed reality to produce caricature, even phantoms. Also his work was intensely personal and had little resonance with his time. While there is narrative there is often little expression of activity. The energy of 'The Wrestlers' is completely absent from 'Mining', a theme that Jacob reduced to decoration. Then as the years of his general deterioration took pernicious hold, carelessness and work done by rote dominated. Even in his portraiture he became disengaged from his subjects.

And who could follow him in his search for the Jewish soul, which is neither sentimental religiosity nor the ecstasy found in ghetto life and Jewish worship that we see in Chagall and others? One might say that it requires a particular neurosis, a profound internalisation of what it is to be a Jew, an obsessional search for identity. Unlike his contemporaries, Gertler, Meninsky and Bomberg, Jacob could never confront his dual identity, that is of the British Jew. He was an exile all his life. Once he crossed the North Sea with his parents he never set *firm* foot on dry land again.

# CHRONOLOGY

**1892** • Born Klincy, Ukraine

**1900** • Arrived in Leeds

**1907** • Started evening classes at Leeds School of Art

**1908** • Junior Scholarship to Leeds School of Art

**1909** • Adopted by Jewish Education Aid Society (JEAS)

**1911** • Senior Scholarship to Leeds School of Art
• Met Michael Sadler, Vice-Chancellor of the University
of Leeds

**1912** • Attended Leeds Arts Club and met Herbert Read

**1913–14** • Studied at Slade School of Art with financial support
of the JEAS

**1914** • Exhibited in Jewish section of *Twentieth Century Art*,
Whitechapel, London
• Exhibits controversial painting *Mother and Child* at
New English Art Club winter show

**1915** • Solo exhibition in Bradford.  Elected member of the London
Group.
• Exhibits at Goupil Gallery, London and included in Vorticist
exhibition at the Doré Galleries, London
• Possible visit to Paris

**1916** • Group exhibition at Alpine Club, London
• Death of his father and probable (undated) death of his
brother, Isaac
• Solo exhibition at Bradford Arts Club and joint show with
Fred Lawson at Leeds School of Art
• Started etching – self taught

**1917** • Joins Allied Artists Association
• Controversy over painting *The Jew* reproduced in *Colour*
magazine

**1918** • Lectures at Leeds Arts Club
• Exhibits controversial portrait of Kerensky at Allied Artists
Association and Leeds Arts Club
• Brief service in 9th Russian Labour Battalion, posted to
Bangeston Camp, Pembroke Dock, South Wales

1919 • Discharged from army
   • Lectures on 'Symbolism in Art' at Bradford Arts Club
   • Becomes member and exhibits with the Glasgow Society
     of Painters and Sculptors
   • Solo exhibition at Adelphi Gallery, London
   • Leeds Jewish Representative Council donate *Day of Atonement*
     and *Hear Our Voice, O Lord our God* to City Art Gallery
1920 • With other artists, Paul and John Nash, Stanley Spencer,
     Jowett, Albert Rutherston, and Edward Wadsworth, invited by
     Michael Sadler and William Rothenstein to provide work for
     abortive scheme to decorate the Victoria Hall, Leeds Town Hall
   • Sits for Epstein's famous bronze bust
   • Lectures at Leeds Arts Club on 'Colour in relation to Music'
1921 • Exhibition at Harrogate Public Library
1922 • Obtains Certificate of Naturalisation
   • Elected honorary member of *The Little Movement,* Nottingham
     and honorary secretary of the Northern Society of Artists and
     Sculptors
1923 • Exhibition at Whitechapel Art Gallery, London
1924 • Exhibits in Fine Arts section of British Empire Exhibition,
     Olympia
1926 • Group exhibition at National Gallery, Washington DC, USA
1928 • Included in Retrospective Exhibition of the London Group
     at the New Burlington Galleries, London
1931 • Founder member of the Yorkshire Luncheon Group
   • Travels to France to paint Delius, and to London to paint
     Gandhi
1935 • Solo exhibition at Leger Galleries, London
1938 • With Bomberg and other Jewish artists plans to re-organise
     Ben Uri Gallery
1940 • Exhibition at Harrogate Art Gallery
1943 • Exhibited in Russian section of Allied Nations Art Exhibition
     for the Forces, London
1946–50 • Book jackets for Soncino Press
1947 • Death of mother, Cecilia
   • Illness and hopitalisation
1949 • Solo exhibition at Bagshaw Art gallery, Batley (his first one-man
     show for fourteen years)
1950 • Exhibited at Yorkshire Artists' best contemporary artists show
     at the Jubilee Hotel, Leeds
   • Elected Vice-President of Leeds Fine Art Club
1951 • On selection committee for Yorkshire Artists' Exhibition at
     Leeds Art Gallery
1952 • Two flower studies in Yorkshire Artists' exhibition
1959 • Elected President of Leeds Fine Art Club
1960 • Retrospective Exhibition at Leeds City Art Gallery

**1962** • Dies 5 February aged 69 at Jewish Home of Rest, Balham,
London

∞∞∞

**1968** • City of Leeds Branch College of Art renamed 'Jacob Kramer
College of Art'
**1973** • Kramer Exhibition at Parkin Gallery, London
**1984** • Exhibition 'Jacob Kramer Reassessed' at Ben Uri Gallery, London
and at Leeds, Bournemouth and Kingston-on-Hull galleries
**1986** • Exhibition of Kramer and Wolmark works on paper at the
Boundary Gallery, London
**1990** • Kramer exhibition at Belgrave Gallery, London
**1991** • Centenary exhibition at University Gallery, Leeds
**2003** • Exhibition 'William Roberts & Jacob Kramer; The Tortoise
and the Hare' at the University Gallery, Leeds and the
Ben Uri Gallery, London

# BIBLIOGRAPHY

- Artmonsky, Ruth *William Roberts and Jacob Kramer: The Tortoise and the Hare*, The University Gallery, Leeds and Ben Uri Gallery 2003
- Brodsky, Joseph *On Grief and Reason. Essays*, Hamish Hamilton 1996
- Cooper, R.M. (ed) *Refugee Scholars. Conversations with Tess Simpson*, Moorland Press 1992
- Cork, Richard *David Bomberg*, Yale Center for British Art 1988
- Cork, Richard *Epstein*, Tate Publishing 1999
- Denvir, Bernard *Jacob Kramer: The Outsider who came Home*, Parkin Gallery 1973
- Dickson, Rachel 'Jacob Kramer – The Hare', in Artmonsky, Ruth *William Roberts and Jacob Kramer: The Tortoise and the Hare*, The University Gallery, Leeds and Ben Uri Gallery 2003
- *Encyclopaedia Judaica*, Keter Publishing House Ltd, Jerusalem 1972
- Epstein, Jacob *Let there be Sculpture: An Autobiography*, Michael Joseph 1940
- Freedman, Murray *Essays on Leeds and Anglo-Jewish History and Demography*, Murray Freedman 2003
- Freedman, Murray *Leeds Jewry – The First Hundred Years*, Quacks Books in association with the Leeds branch of the Jewish Historical Society of England 1992
- Fry, Roger *Vision and Design*, Pelican 1937
- Fry, Roger *Letters Vol. 2. Letters to Vanessa Bell (14 February 1923)* ed: Denys Sutton 1972
- Gibbon-Williams, Andrew 'William Roberts: The Tortoise', in Artmonsky, Ruth *William Roberts and Jacob Kramer: The Tortoise and the Hare*, The University Gallery, Leeds and Ben Uri Gallery 2003
- Gibbon-Williams, Andrew *William Roberts, An English Cubist*, Lund Humphries 2004
- Glatt, Max *Alcoholism*, Hodder and Stoughton 1982
- Golding, Louis *Forward from Babylon*, Victor Gollancz 1932
- Gray, Rosalind P. *Russian Genre Painting in the Nineteenth Century*, Oxford University Press 2000
- Grose, Irving *Jewish Outsiders of Great Britain 1845–1945*, Belgrave Gallery 1978

- Hoffman, Eva *Lost in Translation*, Vintage 1998
- *Jacob Epstein to Arnold J. Haskell*, Heinemann 1931
- Kampf, Avram *Chagall to Kitaj. Jewish Experience in 20th Century Art*, Lund Humphries 1990
- Kramer, Jacob 'Form and Shape', *Jewish Quarterly* Vol. 9 No. 2 at pp 24–27 1962
- Kramer, Millie *Jacob Kramer: A Memorial Volume*, E.J. Arnold & Son Ltd 1969
- Krausz, Ernest *Leeds Jewry*, W. Heffer and Sons Ltd, Cambridge 1964
- Lamb, T. A. 'A Leeds Artist – Jacob Kramer in Leeds Arts Calendar', *A Quarterly Review*, Winter 1950
- Lewis, Percy Wyndham *Blasting and Bombardiering*, Eyre and Spottiswoode 1933
- Lowe, Rebecca *Past into Present. A Commemorative History of Leeds College of Art and Design* 1993
- MacDougall, Sarah *Mark Gertler*, John Murray 2002
- Miller, Corinne, ed. *Behind the Mosaic – One Hundred Years of Art Education*, Leeds Museum and Galleries 2003
- Paraskos, Michael 'English Expressionism' MA Thesis, University of Leeds School of Fine Art 1997
- Paraskos, Michael 'Herbert Read and Leeds' in *Herbert Read: A British Vision of World Art*, ed. Benedict Read and David Thistlewod, Leeds City Art Galleries in cooperation with The Henry Moore Foundation and Lund Humphries, London 1993
- Paucker, Pauline 'Sarah (1900–1992)' in Artmonsky, Ruth *William Roberts and Jacob Kramer: The Tortoise and the Hare*, The University Gallery, Leeds and Ben Uri Gallery 2003
- Payne, Brian and Dorothy *Leeds As It Was in Photographs. Vol. 1* Hendon Publishing Ltd, 1974
- Pearce, Joseph *Bloomsbury and Beyond The Friends and Enemies of Roy Campbell*, HarperCollins 2001
- Raisman, Geoffrey *The Undark Sky*, Harehills Press Ltd 2002
- Read, Benedict. *Introduction to Jacob Kramer 1892–1962: A Centenary Exhibition*, University Gallery, Leeds 1992
- Read, Herbert *Art Now*, Faber & Faber 1933
- Roberts, John D. *The Kramer Documents*, Privately published, Valencia 1983
- Rose, June *Daemons and Angels: A Life of Jacob Epstein*, Constable and Robinson 2002
- Rothenstein, John J. *Summer's Lease, Vol. 1*, Hamish Hamilton 1965
- Rutter, Frank *Art in my time*, Rich and Cowan 1933
- Rutter, Frank *Evolution in Modern Art: A Study of Modern Painting*, Harrap & Co. 1932
- Sadler, Michael *Modern Art and Revolution*, Hogarth Press 1932
- Silman, Julius *Signifying Nothing*, Minerva Press 1997

- Snowman, A.K. 'Kramer, Victim of Theory',
  *Jewish Chronicle Literary Supplement*, 19 June 1970
- Spalding, Frances introduction to *Jacob Kramer Reassessed*,
  Ben Uri Gallery 1984
- Speaight, Robert *William Rothenstein: The Portrait of an Artist
  in his Time*, London 1962
- Steele, Tom, *Alfred Orage and the Leeds Arts Club 1893–1923*,
  Scolar Press 1990
- Taylor, John Russell *Bernard Meninsky*, Redcliffe Press Ltd,
  Bristol 1990
- Teeman, Louis *Footprints in the Sand*, Private publication 1976
- *The Heaton Review. A Northern Miscellany of Art and Literature*
  ed. George G. Hopkinson. Vol. v 1932
- Valkenier, Elizabeth *Kride. Ilya Repin and the world of Russian art.*
  Columbia University Press NY, 1990

# INDEX